Andrew Wyeth: The Helga Pictures

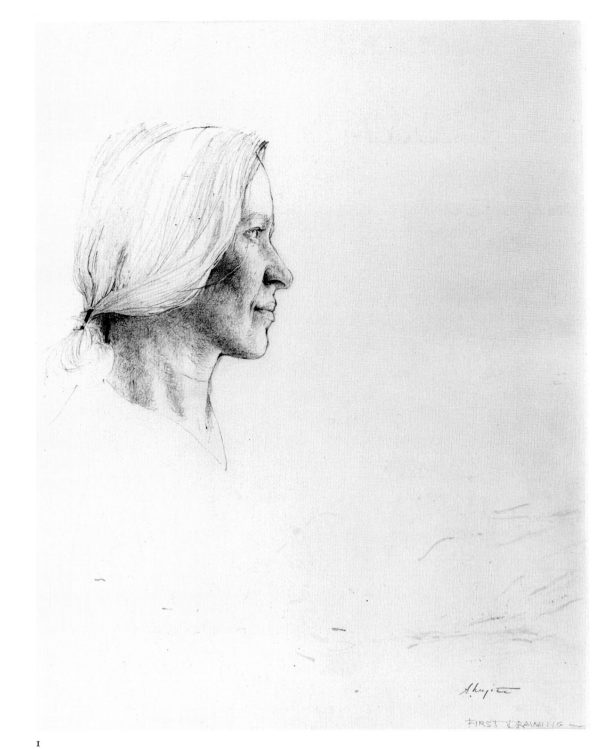

FIRST DRAWING

I

Andrew Wyeth

The Helga Pictures

Text by

JOHN WILMERDING

Deputy Director, National Gallery of Art, Washington

HARRY N. ABRAMS, INC., PUBLISHERS, NEW YORK

Editor: Margaret Donovan
Designers: Katy Homans and Samuel N. Antupit
Photo Researcher: Jennifer Bright

Color photography by Peter Ralston; black-and-white
photography by Peter Ralston and Richard Amt
Bibliography by Heidi Colsman-Freiberger

Frontispiece: The first drawing, 1971

Library of Congress Cataloging-in-Publication Data

Wilmerding, John.

Andrew Wyeth: the Helga pictures.

Bibliography: p.
1. Wyeth, Andrew, 1917- —Criticism and
interpretation. 2. Wyeth, Andrew, 1917- —Relations
with women. 3. Testorf, Helga—Portraits. 4. Andrews,
Leonard E. B.—Art collections. 5. Art—Private collections
—Pennsylvania. I. Wyeth, Andrew, 1917- .
II. Title.
N6537.W86W55 1987 759.13 86-32037
ISBN 0-8109-1788-2

Times Mirror Books

Printed and bound in Japan

List of Exhibitions

National Gallery of Art, Washington, May 24, 1987–September 27, 1987
Museum of Fine Arts, Boston, October 28, 1987–January 3, 1988
The Museum of Fine Arts, Houston, January 31, 1988–April 10, 1988
Los Angeles County Museum of Art, April 28, 1988–July 10, 1988
Fine Arts Museums of San Francisco, August 13, 1988–October 16, 1988
Detroit Institute of Arts, November 13, 1988–January 22, 1989

CONTENTS

FOREWORD

J. CARTER BROWN

Director, National Gallery of Art, Washington

Andrew Wyeth: The Helga Pictures brings to public view for the first time a significant new body of work by one of America's best-known painters and, moreover, represents a fascinating look at the working methods of an artist in a fresh phase of his career. The Helga group actually adds up to a whole that is more than the sum of its parts: viewing the pictures, we begin to feel – as the artist must have during the fifteen years of their making – a sense of growing power and richness of imagery.

Wyeth, of course, has been the subject of several major exhibitions presented in the last few decades. Important surveys were organized in 1966 by the Pennsylvania Academy of the Fine Arts and in 1970 by the Boston Museum of Fine Arts. In addition, the Fine Arts Museums of San Francisco mounted a broad-ranging selection in 1973, as did The Metropolitan Museum of Art in 1976; both museums published catalogues that have extensive personal interviews with Wyeth himself and stand as enormously useful sources of firsthand information.

The National Gallery is delighted to inaugurate this new show of Wyeth material, different from its predecessors in its very circumscribed focus, and yet, we believe, impressively substantial in its own way. After being shown at the Gallery, it will travel to a handful of other sites in the United States and eventually will be shown abroad. We are especially pleased that we can hold this exhibition in tandem with a large selection of twentieth-century American master drawings and watercolors, on loan at the same time from the Whitney Museum of American Art. Thus, during this period the public will have an unparalleled opportunity to enjoy this great celebration of modern American draftsmanship in both breadth and depth. In yet a further felicity of timing, our audience will be able to benefit from an exhibition of works by three generations of Wyeths – N. C., Andrew, and Jamie – to be shown over the same summer just a few blocks away at our sister institution in Washington, the Corcoran Gallery of Art, and also traveling elsewhere thereafter.

This book is a handsome visual record of an unusual creative achievement. I am pleased that its author is the National Gallery's deputy director, John Wilmerding, still a scholar in his spare moments, who has written the sympathetic and probing essay included here. We are all grateful to Paul Gottlieb, president of Abrams, for initially calling our attention to this group of pictures; to the collector and owner, Leonard Andrews, for his great generosity in making them available for an extended loan tour; and to Andrew and Betsy Wyeth, respectively the creator and loving caretaker of this artistic outpouring. Finally, we are also grateful to The Du Pont Company, whose generosity has made possible the exhibition at the National Gallery of Art, together with the survey of twentieth-century graphics from the Whitney Museum of American Art.

The National Gallery has on view in its permanent collections one of Wyeth's most beautiful temperas, *Snow Flurries,* and possesses as well a few exemplary watercolors by him. In 1984 we had a preview of one Helga work when *Day Dream* was exhibited among the American paintings from the Armand Hammer Collection, in conjunction with President Reagan's second inauguration. With the Helga pictures we welcome the chance to explore again a set of fascinating documents in the odyssey of the American artistic achievement.

A NATIONAL TREASURE

LEONARD E. B. ANDREWS

In his text here, John Wilmerding, deputy director and former curator of American art at the National Gallery of Art, discusses the place of Andrew Wyeth's Helga pictures in the history of European and American art and in the artist's own previous work. I consider his views those of an objective, learned scholar and observer, and I know his colleagues do also.

However, it has been a revelation to me to see certain critics come out against the artist and the Helga series before they have even seen the pictures. Likewise, it has been interesting to see those who appreciate the work of this great American artist say uniformly and enthusiastically: "Let's see the work, let the work speak for itself."

The collection itself is, to my mind, a major extension – indeed another dimension – of Andrew Wyeth's achievement. While "art speaks for itself," as the saying goes, this work speaks volumes for Wyeth's world-class artistic execution, balance, and talent.

Wyeth obviously demonstrates his superb touch with the brush in the Helga series. Yet this technical skill is accompanied by a distinguished subtlety, a sensitivity, a grace, a respect, and a purity that rank him with the great masters of the past. I personally feel he is so far ahead of any other living artist that it is hard to name the second best.

But then, I am certainly no art critic. True, I have collected for several years. I owned, along with the works of other artists, six Wyeths – a tempera, two drybrushes, and three watercolor drawings – before I bought the Helga Collection, but my total collection was a minor one until now.

When I learned Betsy and Andy wanted me to see a "large private collection," I was interested, of course, but I had no details and no concept of what I was about to see. Because of my prior purchases, I had met the Wyeths, but I did not know them well at all. I assumed that *they* assumed I was a serious collector and that the invitation was strictly a collector's opportunity to see something no one else had seen.

In Chadds Ford, the Wyeths live in a complex of three eighteenth-century fieldstone buildings along the banks of the Brandywine River, not far from where the English troops were billeted during the Revolutionary War. The Americans were at Valley Forge, only twenty miles away, and the area was of strategic importance during the famous Battle of the Brandywine. The complex contains a house, an apartment/studio, and a gristmill.

The gristmill, which Andy has carefully and authentically restored to working order, consists of three floors. The "works" of the mill – a massive set of grinding stones and a very large waterwheel that turns them – occupies the first floor. The second floor is reached by climbing a suspended stairway and pushing up through a sturdy barrier door in the ceiling. The third floor, reached by another stairway, contains an office, filing, and storage area. The building is about 110 feet long by 50 feet wide.

I first heard of the collection on a Wednesday evening and drove out to see it the next Saturday, March 15, 1986, with Kathleen Jamieson, the interior decorator who had told me about it and had encouraged me to buy Wyeths before.

While it all may sound a little dramatic in the retelling, it was at the time just another visit to the Wyeth complex on a beautiful Pennsylvania morning. Andy came out to the car to greet us and told us to go over to the gristmill and have a look. He and Betsy stayed in the house in order that I might study the collection completely

Leonard E. B. Andrews
and Andrew Wyeth

unaffected by their presence. I walked over to the mill and went up the stairway by myself and pushed the barrier door up and open, and there, on the second floor, was the Helga Collection. I was absolutely awestruck.

Sixty-seven framed paintings and drawings were hanging or leaning at random against the walls and posts. The four temperas were on one wall along with several drybrush and watercolor works. The other walls were filled with watercolor, drybrush, and pencil drawings. On two tables were stacks of unframed, matted drawings – preliminary sketches, studies, and finished works in pencil, watercolor, and mixed media. The room was very quiet and well-lighted and, as I walked slowly around, I almost couldn't believe what a rare artistic genius I was seeing and that I actually had the opportunity of owning the collection! My immediate impression at the time continues to be my firm belief today: The Helga Collection is a national treasure.

I spent two hours looking at the collection and trying to absorb what I was seeing. Just the idea of having a private look at the unseen personal collection of a major international artist, 240 drawings and paintings of one subject, executed and stored over a fifteen-year period, was mighty heavy for this simple collector.

There is something quieting about seeing such an astounding body of work in such circumstances. Maybe, when you see the full collection, you will feel as I did then, somewhat at a loss for words; my thoughts raced from picture to picture, trying to pick out highlights, only to find myself faced with such an abundance of them that I was almost mute.

I finally raised the door and went down the stairs and across the drive to the Wyeths' home. Andy came out and I shook his hand and said, "Mr. Wyeth, congratulations, you have created a national treasure, and I want to protect it and show it to the American people. I want the collection." Betsy came out then and I repeated to her what I had just told her husband.

They invited Kathleen and me into the house for a glass of wine. We sat around an eighteenth-century Pennsylvania Dutch dinner table and talked about the collection, its impact on the public, its personal importance to Andy, and the fact that Betsy had not known the extent of the work until Andy told her earlier that year. She knew, of course, that he had been painting models for all those years, but she was totally unaware there were so many pictures of Helga alone. (Since Andy works with various models during a year and regularly sells several

pictures a year, the number of Wyeths of other subjects was not significantly diminished during that time.) In the living room Betsy showed me the three superb Helga paintings Andy had given her – *Lovers, Night Shadow,* and *Autumn.*

I have been asked many times what I was told about Helga when I bought the collection. The truth is, I never asked about her. I consider the relationship between any model and artist to be a professional one of their own making and important to the finished work of art, and I respect that. Helga is a German woman with a proud and close family who worked on the nearby farm of Karl Kuerner, himself one of Wyeth's most famous subjects.

It was clear as we talked that one of Andy's main interests was that the Helga Collection be shown to the public in a respectful and dignified manner. Of course, there is no better place in America than the National Gallery of Art to begin a public exhibition of such a precious national asset. It is a tribute to J. Carter Brown, the director, to John Wilmerding, and to the splendid professional staff at the National Gallery that they immediately recognized the importance of this new body of Wyeth's work and eagerly set about making plans for exhibiting it.

I had to go out of town the next day and did not get back until the following Sunday night, March 23. Two days later we had agreed to the terms of the purchase, which included my buying the Helga Collection, including full copyrights, and Betsy's leaving her three Helga paintings to the Leonard E. B. Andrews Foundation. The Foundation sponsors the National Arts Program, an annual national free art forum founded in 1985 to encourage the development of indigenous artistic talent in America. The exhibited works are professionally judged, and scholarships for continuing education and cash prizes are awarded participating artists.

It took a few days for the legal papers to be drawn up, and on Tuesday, April 1, Andy and I signed them on the same dining room table in their home. Betsy brought out a bottle of champagne, and the three of us congratulated each other and, sipping champagne with our excitement, gave a toast on April Fool's Day to the art world and all those who have opinions, of whatever kind, about Andrew Wyeth.

ANDREW WYETH'S *HELGA SUITE*

JOHN WILMERDING

Deputy Director, National Gallery of Art, Washington

Familiar as the art of Andrew Wyeth is to many, and deeply rooted as it is in the American tradition, his pictures in the so-called Helga series possess a fresh power that is startling. On a superficial level the press and public have already found them sensational,[1] but on reflection, at first hand, these pictures do convey a cumulative visual and technical force, long present in Wyeth's art but seldom revealed with such coherence and impact. They are fascinating on a number of related levels: for their place in the longer continuities of western, American, and modern art; for their connections to the Brandywine tradition and the history of the Wyeth family in American painting; and for their illumination of Andrew Wyeth's personal style, artistic preoccupations, and working process.

Because of both their number and subject the pictures are indeed best described as a suite, in its various evocations of meaning. They are a distinct series, with overlapping subdivisions and internal sequences; they suggest a sense of closure and privacy, mostly domestic and often set within rooms; and they evolve in lyrical rhythms in the manner of music. The subject of virtually the entire group is Helga Testorf, a neighbor of the Wyeths in Chadds Ford, Pennsylvania (a few sheets are devoted to her daughter, Carmen). The collection was executed over a fifteen-year period, from 1971 to 1985; Helga was thirty-eight when Wyeth began to draw her and fifty-three when he brought the series to an end. Such close attention by a painter to one model over so long a period of time is a remarkable, if not singular, circumstance in the history of American art. As such, it affords us an opportunity to see intertwined images of biological change and artistic growth.

The collection when acquired by Leonard Andrews consisted of 240 works, mostly on paper, including 4 temperas, 9 highly finished drybrush paintings, 63 watercolors, and 164 pencil sketches and drawings. Three other paintings in the series, *Day Dream, Loden Coat,* and *Knapsack* had been sold earlier into other collections.[2] In addition, the artist's wife, Betsy Wyeth, who retained possession of three major drybrush works of Helga (*Autumn, Lovers,* and *Night Shadow*), is leaving them to the Leonard E. B. Andrews Foundation. Altogether, the works in the series reveal an artistic focus notable for its control and complexity, its capturing of surface texture and emotional depth.

While Wyeth has always worked in a process of private concentration, producing an extensive sequence of studies for a single image, this group is worthy of attention in its own right. This is the first time the artist has permitted into public view a large suite of sequential drawings related to a single work. Moreover, almost all are more than documentary working studies; they have a polish, refinement, even grandeur, a compelling strength and beauty quite their own.

Making up the whole are at least thirty different interrelated poses, ranging from only a single study in a few instances, through others involving a handful of sketches, to a few consisting of more than a dozen works. For the series of images showing Helga asleep there is the dramatic accumulation of no less than thirty-five drawings and watercolors investigating various poses. As we look at Helga depicted nude and clothed, indoors and out, asleep and awake, in different seasons and times of day, we are led to think of those venerable cycles in earlier European and American art. In nineteenth-century terms these are Wyeth's Four Seasons and Voyage of Life.

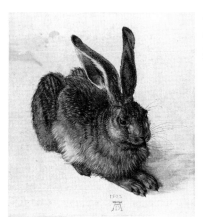

Albrecht Dürer
The Young Hare, 1502
Watercolor and gouache,
9⅞ x 8⅞ inches. Albertina Collection, Vienna

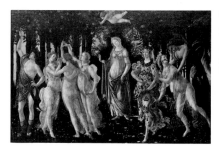

Sandro Botticelli
Primavera, c. 1478
Tempera on panel,
6 feet 8 inches x
10 feet 4 inches.
Uffizi Gallery, Florence

Indeed, such associations suggest that there are several approaches to the *Helga Suite* which might prove helpful to enriching our sense of context for these works, approaches through the European and American traditions which offer us precedents and counterpoints for both the conventions and the inventions in Wyeth's art. Though largely introduced to the disciplines of art in his father's studio and thereafter cultivating his natural talents, Andrew Wyeth has always been observant of other art as he has seen it. Similarly, he has pursued a career for the most part circumscribed by two areas of local geography, the Brandywine valley of Pennsylvania and the coastal farmland of Cushing, Maine, where he divides his year. Such travel as he has done in recent decades has been more for pleasure than art. Nonetheless, his recorded conversations and interviews make clear he is a painter informed about past art where it is of interest and relevance to him, whether among the old masters or his American artistic predecessors.

By the same token, he knows which artists are stylistically distant from him, Renoir or Velázquez for example, because their color and painterliness seem to Wyeth distinctively European in sensibility.[3] In fact, the spirit and technique of his art are consciously grounded in the classical masters of the early Renaissance in Italy and in the north. Especially appealing to Wyeth is their sense of clarity and design, of attention to texture and above all to line. Noting particularly compositional contrasts and reflections, he has said, "I was so much taken by . . . the works of the Renaissance master Piero della Francesca," which he first saw as a youth in reproductions.[4] But even more Wyeth was to find inspiration in the combined delicacy and strength of line he saw exemplified in the drybrush watercolors of Dürer on the one hand and in the meticulous paintings of Botticelli on the other.

"Above all, I admired the graphic work of the northern Renaissance genius Albrecht Dürer."[5] N. C. Wyeth had given his son a set of facsimiles of Dürer engravings, and both their subject and execution struck the younger Wyeth profoundly. One feels his strong sense of self-identification with the early German draftsman, who for Wyeth is the first master and exemplar of drybrush painting. Specific images have remained sharp in Wyeth's consciousness: Dürer's famous drawing of the *Young Hare* and *The Large Piece of Turf* ("To me, it is his greatest work"[6]), both in the Albertina Collection, Vienna, the latter directly inspiring Wyeth's own drybrush drawing of *Grasses*, 1941. Wyeth's admiration extends equally to Dürer's rendering of textures and to humble creatures themselves, emotionally as well as quite literally down-to-earth. We should note how much Helga is an earthy creature, often set closely into the surrounding terrain. Elsewhere, Wyeth remarked on Dürer's imaginative process in the engraving of the *Knight, Death, and the Devil*, whereby "the mundane, observed, became the romantic,"[7] a process as much at work in Helga observed and transformed.

Some of the finest works in the Helga series are the drybrush watercolors. In contrast to the traditional handling of watercolor, which is fluid, spontaneous, and suggestive, the drybrush technique requires squeezing much of the moisture out of the bristles to achieve more body and richness of detail. "Drybrush is layer upon

layer. It is what I would call a definite weaving process. You weave the layers of drybrush over and within the broad washes of watercolor."[8] The allusion to weaving is of course equally appropriate to the animal hairs of a painter's brush, the fibers of grasses and weeds, and the growing strands of human hair. Helga's hair is not surprisingly the principal focus of attention in many of these paintings, most notably *Cape Coat, Drawn Shade, On Her Knees, Overflow, Pageboy, Crown of Flowers, The Prussian,* and *Refuge.* These painstakingly wrought passages suggest her sensuous animal nature, organic and tender as Dürer's *Hare.* We can imagine Wyeth's emotional intensity no less than he imagined Dürer's to be: "Oh, how I can feel his wonderful fingers wringing out the moisture of that brush, drying it out, wringing it out to get that half-dry, half-lingering dampness to build up, to weave the surface of that little creature's coat."[9] No wonder he could also claim, "I work in drybrush when my emotion gets deep enough into a subject."[10]

If one early touchstone for Wyeth was Dürer, the other was Botticelli, who could also offer thematic and stylistic precedents. As a modern practitioner in the medium of tempera, Wyeth is unsurpassed. In taking up this old-master technique, he would naturally cast an eye to the examples of the Renaissance. Botticelli's art commanded attention for its particular technical character. Wyeth noted, "When you study the early men, like Botticelli's *The Birth of Venus,* you will note that although it is done on canvas, it is very beautifully woven together. I've tried painting tempera on canvas, but I didn't like it. . . . I didn't like the give of the canvas. It bothered me."[11] What he has sought in his paintings is a sense of permanence, captured both by the distillation of imagery and by the hardness of medium. Composed of a mixture of dry pigment with distilled water and egg yolk, tempera quickly hardens and, when applied to wood panel, perfectly suits the artist's wish to achieve an image as solid in feeling as in form. "There's something incredibly lasting about the material, like an Egyptian mummy," Wyeth feels. "Tempera is, in a sense, like building, really building in great layers the way the earth itself was built."[12]

For Wyeth tempera has multiple associations with the earth, and as in most of his work the Helga series is as much a portrait of a landscape as of a figure. Besides the notion of endurance, the colors of tempera and of his countryside are the same for Wyeth, and both generate a sense of meditative isolation. As he recounted, "I think the real reason tempera fascinated me was that I loved the quality of the colors: the earth colors, the terra verde, the ochers, the reds. . . . I really like tempera because it has a cocoon-like feeling of gray lostness – almost a lonely feeling."[13] Warm red-browns dominate many of his temperas, and the evocation of earthiness is especially strong in such Helga paintings as *Braids, Letting Her Hair Down, Sheepskin,* and *Farm Road.*

The early Renaissance and Botticelli provided not just a stylistic starting point for Wyeth, but an imagery of figures with elevated attributes and meanings. When we look at the eloquent and tender *Crown of Flowers,* do we not think of its painter dreaming back through the memory of art to the *Birth of Venus,* c. 1482, and even more to the *Primavera,* c. 1478 (both Uffizi Gallery, Florence)? While no doubt neither consciously referring to Botticelli's nudes nor bearing their mythological or philosophical carriage, Helga has the suggestive aura of a personification, if not a goddess, of nature. She is also an embodiment of love, and while other depictions in the series remain closer to the immediate observations of portraiture, here with her floral crown she recalls the myths of spring and Flora, of Venus and the graces, even Eve out of Dürer's garden. There is an allegorical power, if not program, present; in Wyeth's terms it is making the mundane into the romantic.

The various poses and features that Wyeth depicts in his views of Helga are a way of exploring different moods and aspects of personality. But recording the details of physiognomy for Wyeth is just a part of observing the ordinary, and in the accumulated number of renderings we sense more than portraiture at work here. While the repeated aspects of Helga's face and torso make clear an accuracy of likeness, there is apparent in works like *Crown of Flowers* the embodiment of deeper moods and associations. In fact, through his career-long scrutiny of individuals Wyeth has rarely undertaken a traditional posed portrait: "I don't think I'm really a portrait painter, because I only use a head to express something more. . . . If it's an outdoor person, I feel that his countenance reflects the skies he walks under: the clouds have reflected on his face for his whole life and I try to get that

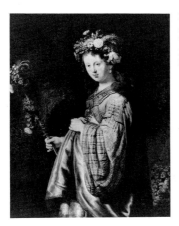

Rembrandt van Rijn
Saskia as Flora, 1634
Oil on canvas, 49¼ x
39¾ inches. The Her-
mitage, Leningrad

Edouard Manet
Olympia, 1863
Oil on canvas, 51¼ x
74¾ inches. Musée
d'Orsay, Paris

quality into the portrait. . . . It's like painting the sky. To me, a sky and a landscape are together. One reflects the other. They both merge."[14]

Crown of Flowers is perhaps the most suggestive work in the series of a personification approaching allegory. There is a rich tradition for this in the history of art, with other obvious examples being Rembrandt's paintings of his wife and later his mistress posing as emblems of nature, first *Saskia as Flora* (1634, Hermitage, Leningrad; and 1635, National Gallery, London), then *Hendrickje as Flora* (c. 1654, The Metropolitan Museum of Art, New York). Even within the type Rembrandt probes a broad range of emotional expression, for example, the beauty of human and natural fecundity, intimate personal affection, almost lustful physical sensuality, and delicate spiritual lyricism. Each woman's floral wreath links her to nature's capacity for growth and rebirth. In this vernal guise Helga is an especially touching figure of regeneration in Wyeth's often otherwise autumnal landscapes.

The nude as a repeated subject for painters is of course an enduring one in western art. Whether posed by an anonymous model, mistress, or wife, the figure could serve variously as a study of form, a celebration of love, or an emblem of the artist's studio and thus by extension a meditation on the nature of art. For example, one thinks of the imagery of Helga alternatively nude and clothed and the variants of her reclining poses as descending from the Goya majas and, in the sequence of *Black Velvet*, Manet's *Olympia*, 1863 (Musée d'Orsay, Paris). We know that the purposes and motivations in each circumstance were different, that Manet, for instance, was concerned on one level at least with the sociology of the prostitute in nineteenth-century Paris and on another with the processes of seeing brightly lit forms flattened out in strong frontal lighting. Yet we cannot help but read the black velvet ribbons around Olympia's and Helga's necks as emphasizing their nakedness. As the only article of clothing both wear, it calls attention to their available or vulnerable sexuality, as the case may be. By such means the nude becomes a vehicle for considering ideas of real versus ideal form, physical versus pure love. No doubt in many sheets Helga's torso, seen frontally and from behind, is a sustained study of anatomy. But certainly in the summary watercolors and temperas, as the precedents of art help explain, she expresses "something more."

Whatever the degree of Wyeth's conscious response to this larger tradition, he also remains an avowedly native artist of his own time. As a painter in the American tradition he has embraced its central currents of realism as a style and landscape as a subject; as an expression of the twentieth century, his art bears its own witness to our age's sense of anxiety, introspection, and isolation. Certainly, his impulses toward self-reliance and native inspiration place Wyeth in line with earlier American artists like Charles Willson Peale and William Sidney Mount, who preferred to return or stay near home to practice their craft. The close scrutiny of nature, self, and America puts him as well in the company of Henry David Thoreau, Emily Dickinson, and Robert Frost. Like the leaves of Walden, the white rooms at Amherst, and the stone fences of New Hampshire, the grasses on Kuerner's

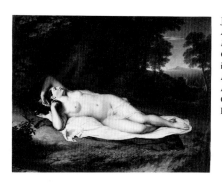

John Vanderlyn
*Ariadne Asleep on the
Island of Naxos*, 1814
Oil on canvas, 68½ x 87
inches. Pennsylvania
Academy of the Fine
Arts, Philadelphia.
Gift of Mrs. Joseph
Harrison, Jr.

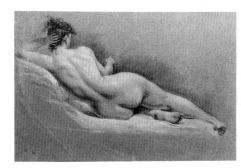

John Trumbull
*Reclining Nude:
Back View*, 1784
Black and white chalk
on blue paper, 14 x 22½
inches. Yale University
Art Gallery, New Haven.
Gift of the Associates in
Fine Arts

hill and the spare walls of his own granary offer Wyeth ample lines and surfaces for endless revery and stimulation. With the sloping contours of the one and the plain right angles of the other he literally builds his compositions in the way, he says metaphorically, "the earth itself was built."

Besides this shared contemplation of the commonplace and the close-at-hand, Wyeth's vision also aims for the concentration of poetry and the journal entry. Although his paintings occasionally include figures in motion or engaged in some activity, these are not narrative or dramatic works. His landscapes tend to be confined places of calm, and the individuals he paints within them rest alone and stilled in meditation. Consider Helga's poses, for instance, in *Barracoon, Black Velvet, Campfire, Night Shadow, Overflow, Sun Shield, Asleep, Walking in Her Cape Coat,* and *Farm Road.* These range from pure sleep to daydreaming to introspection, and through this imagery of thought Wyeth leads us to consider more than the temporal: "I do have this feeling that time passes – a yearning to hold something – which might strike people as sad. . . . I think the right word is not 'melancholy,' but 'thoughtful.' I do an awful lot of thinking and dreaming about things in the past and the future – the timelessness of the rocks and the hills – all the people who have existed there."[15]

In a similar way Emily Dickinson extends her observation of the immediate to the universal: "The grass so little has to do, – / A sphere of simple green. . . ." It holds "the sunshine in its lap,"

And even when it dies, to pass
In odors so divine,
As lowly spices gone to sleep
Or amulets of pine.

And then to dwell in sovereign barns,
And dream the days away, – [16]

For both Dickinson and Wyeth the individual is not just placed in a landscape but fused with it. The artist achieves such a union by an abstraction of design whereby the local terrain is generalized and by a comparable abstraction of thought embodied in the human stance and gaze. This fusion is characteristic of Wyeth's style and explains why the Helga pictures are so elusive to categorize and define.

As a whole, the *Helga Suite* is a rich amalgam of several primary types of subject long treated in the development of American art – the portrait, nude model, landscape, and genre. Generally speaking, portraiture was the first American art, and it served fundamental national needs in two critical ways: it was practical and it was democratic. During the first centuries of discovery and settlement of the New World, the painting of portraits fulfilled the useful purpose of recording likenesses for posterity, in primacy over pure aesthetic expres-

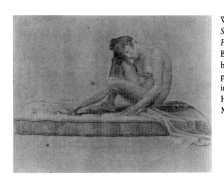

Washington Allston
*Study of a Seated
Female Nude*, 1804
Black chalk and white
highlights on blue-
purple paper, 14 x 15⅞
inches. Courtesy
Harvard University
Museums, Cambridge

John La Farge
The Golden Age, 1878
Oil on canvas, 34⅝ x
16½ inches. National
Museum of American
Art, Smithsonian Institu-
tion, Washington, D.C.
Gift of John Gellatly

sion. For a culture historically interested in the pragmatic and down-to-earth, the palpable and here and now, the technical and technological, portraiture (like our early architecture and furniture) could be at once pleasing and serviceable. But painting the human face and figure also celebrated the individual within a democracy, and by extension singular deeds or achievements. The portrait could record equally the humble and the anonymous with the mighty, the wealthy, and the heroic. Indeed, there is an argument that America's early history as a colony, nation, and republic is a history of individual aspirations, declarations, and acts. Certainly, our first great history painting might be described as portraiture in action and emerged out of a portrait tradition largely founded by Benjamin West and John Singleton Copley.

It is not surprising, then, to realize that thereafter the depiction of the human face and figure has been a continuing calling and achievement of so many major American artists, from Gilbert Stuart and Thomas Sully in the early nineteenth century, through Thomas Eakins, James McNeill Whistler, and John Singer Sargent in the second half of the century, to George Bellows, Walker Evans, and Andy Warhol in our own. It is a distinctively native note that American portraitists have made their subjects comfortable, relaxed, informal, and casual. We admire the combination of technical accuracy and individual attention. *Helga* belongs in this tradition, on one level as pure physiognomic and anatomical portraiture.

But Helga unclothed also belongs, as we have seen, in that venerable lineage of the artist's model, which in European art extends back to the antique but which has had periodic interest as well for American painters working in the academic mode. Sketching the nude from casts of ideal sculpture and from live models has of course been a standard practice in the training of artists. For American artists study of the nude refined their abilities to render volume, texture, and organic relationships accurately, while inherited precedents from Europe provided the means for imbuing the figure with elevated associations, such as occasional allegorical or mytholog-ical attributes. The first major American painting in this category is John Vanderlyn's *Ariadne Asleep on the Island of Naxos*, 1814 (Pennsylvania Academy, Philadelphia). The pose goes back to many masters, including Titian and Giorgione, and reflects Vanderlyn's early study in Paris, where he looked at the old masters in the Louvre and responded to the rising currents of neoclassical taste under the leadership of David and Ingres. Whatever the mythology and idealism in which Vanderlyn has clothed Ariadne, he has also alluded to the pristine virginity of the New World, suggested by the distant clear-lit sky and the bright, delicate flowers growing in the foreground. It is in this same garden, metaphorically updated, that Ariadne's descendant Helga reclines.

During the same period other contemporaries of Vanderlyn sketched the nude model, often in quite relaxed and natural poses. Among the most noteworthy were John Trumbull and Washington Allston, whose polished drawings were generally executed abroad in the spirit and style of their European contemporaries. As such, these nude studies possess a joining of exacting observation and execution with a capacity for noble sentiment, which again continues in the various guises of Helga. By the middle of the nineteenth century American artistic interest

Thomas Dewing
Reclining Nude Figure of a Girl, n.d.
Pastel on paper, 7 x 10½ inches. National Museum of American Art, Smithsonian Institution, Washington, D.C. Gift of John Gellatly

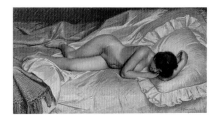

Frank Duveneck
Siesta, n.d.
Pastel on primed canvas, 34 x 64½ inches. Cincinnati Art Museum. Gift of Theodore M. Foucar

in the nude centered around the production of idealized marble sculptures depicting mythological figures and personifications. Painters at this time primarily turned instead to interpretations of the national landscape, although their attention returned in the latter part of the century to studio subjects and to current styles they found practiced abroad. Many of those who went to Europe for training or travel rediscovered the traditional salon concern with the study of the nude model.

For some, like George Fuller, Albert Ryder, and John La Farge, the nude tended to be an imaginary creation, often carrying literary associations. For others, like William Merritt Chase and Childe Hassam, the figure like the landscape was a shimmering surface reflecting nuances of texture, color, and light. Yet others used the depiction of a figure, whether clothed or unclothed, as a meditation on purity of form (Thomas Dewing) or as an exercise in realism (Frank Duveneck), that is, in rendering solidly modeled volumes and unidealized likenesses. This latter current carried directly into the twentieth century, most notably in the work of George Bellows and Edward Hopper.[17] Their straightforward observation and unembellished recording of the physical world seemed well suited to the energies of a new age. Hopper, in particular, isolated his models under a glare of light and within strong, plain designs which emphasize at once their palpability and their aloneness in the real world. However different their painting techniques, it is not surprising that Wyeth should have declared: "I admire Edward Hopper more than any painter living today."[18]

Wyeth's art may also be seen in the broad context of American landscape and genre painting, especially where they blend and the figure is placed as a counterpoint within the setting. For discussion here we may consider landscape as both an outdoor and indoor space, each as used by Wyeth offering different lines and surfaces to structure a composition. His genre elements also vary from the norm in that he is rarely interested in illustrating a story; his subjects do not pictorialize narrative or literary content, and consequently his figures are seldom engaged in obvious or intense physical activity. At the same time Wyeth does paint individuals to examine their larger humanity and their mortality. In these concerns, in the geographical terrains he does depict, and in his choices of media he embraces the worlds of his two towering predecessors in American art, Winslow Homer and Thomas Eakins.

With the former Wyeth shares Maine, with the latter Pennsylvania. With both he shares a mastery of drawing, watercolor, and painting, and further with Homer he shares an art grounded in, but eventually growing beyond, illustration. He has expressed his admiration for both artists, though with occasional reservations, more so regarding Eakins: "A lot of people say I've brought realism back – they try to tie me up with Eakins and Winslow Homer. To my mind, they are mistaken. I honestly consider myself an abstractionist."[19] By this last he means us to see his concerns with essential design and form and with meaning and feeling beyond surface reality. Although Eakins painted and spent most of his life in the meadows of the Delaware valley not far from Wyeth's Brandywine fields, Wyeth is equivocal about any artistic inheritance. "I appreciate Eakins, but he wasn't an

George Wesley Bellows
Nude with Hexagonal Quilt, 1924
Oil on canvas, 51 x 63 inches. National Gallery of Art, Washington. Collection Mr. and Mrs. Paul Mellon

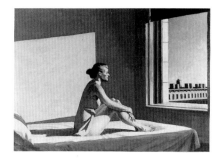

Edward Hopper
Morning Sun, 1954
Oil on canvas, 28⅛ x 40⅛ inches. Columbus Museum of Art. Howald Fund Purchase

influence. . . . Eakins trained in the studio of the French academic painter Gérôme"[20] – a stylistic distancing in Wyeth's point of view. Nonetheless he acknowledges the great power of Eakins's realism in transcending the mere accuracy of facile recording. In an interview Wyeth recounted, "You've got to watch that the technique isn't all you see. Once Mrs. Eakins came into her husband's studio and said, 'Oh, Tom, that hand is beautifully painted. I've never seen you do one better.' Eakins took a palette knife and scraped it right off the canvas. 'That's not what I wanted,' he said, 'I wanted you to *feel* the hand.'"[21]

Wyeth's sympathy for Homer is perhaps more instinctive, a response to both the feeling and technique of Homer's art. "I loved the works of Winslow Homer, his watercolors, which I studied intently so I could assimilate his various watercolor techniques. . . . Watercolor perfectly expresses the free side of my nature."[22] "Winslow Homer in his watercolors is America's most sensitive painter – such warmth of feeling for his country."[23] Watercolor permits not just great breadth of expression, but a directness and intimacy that can convey unexpected power and emotion. But Wyeth's appreciation for Homer derives from more than observation of execution and method. Comparison of major themes in the work of each suggests other shared similarities of approach.

Homer, of course, was trained as a magazine illustrator; Wyeth inherited the same tradition from his father, N. C. Wyeth, and his father's teacher, Howard Pyle. Homer and Andrew Wyeth perfected their draftsmanship to a level of ability that enabled them to execute a full range of drawings, from preparatory sketches to finely finished works in their own right. For both the watercolor might serve as a plein-air variant of a more controlled painting on canvas or panel. In addition, there are numerous thematic and compositional parallels, whether consciously drawn by the artist or not, that are worth noting. Especially in Homer's pictures of the 1870s there are the repeated images of figures seated in meadows or crossing pastures, quietly gazing at the horizon or preoccupied with some detail at hand. They are caught up in the reveries of youth and later in the more wistful, adult reflections of self-awareness. Still a young man himself, in his mid-thirties, Homer painted such familiar scenes as *The Nooning*, c. 1872 (Wadsworth Atheneum, Hartford), and *Boys in a Pasture*, 1874 (Museum of Fine Arts, Boston); is it no surprise that Wyeth at age thirty-five should recapitulate the scene in *Faraway*, 1952 (private collection)? There are also the abstracted later landscapes by each artist to contrast: Homer's *Northeaster*, 1895 (The Metropolitan Museum of Art, New York), and Wyeth's *Snow Flurries*, 1953 (National Gallery of Art, Washington). Finally, there are the similar compositional devices of juxtaposing forms in the foreground and in extreme depth, as the full moon looms nearby in Homer's *Kissing the Moon*, 1904 (Addison Gallery, Andover, Massachusetts), and in Wyeth's *Moon Madness*, 1984 (private collection), both bold designs from the artists' mature imaginations.

More specifically relevant to the Helga series are Homer's sequences of the later 1870s depicting young women indoors and out. *Blackboard*, 1877 (Ganz Collection, Los Angeles), is one of several devoted to

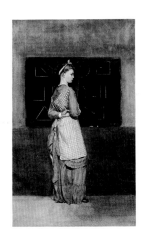

Winslow Homer
Blackboard, 1877
Watercolor, 19½ x 12¼
inches. Collection Jo
Ann and Julian Ganz, Jr.

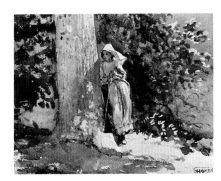

Winslow Homer
Weary, 1878
Watercolor and pencil
on paper, 8⅝ x 11¼
inches. The Terra
Museum of American
Art, Chicago

schoolroom interiors where the abstract geometry of the walls and space frame the central figure; this form provides visual structure for the painting and comments perfectly on the very idea of education as intellectual order, control, and clarity. Wyeth, too, repeatedly sets his figures against the geometric lines and planes of a wall, doorway, window, or porch. The obvious examples here are *Barracoon, Drawn Shade, Day Dream, Easter Sunday, Letting Her Hair Down, Overflow, In the Doorway, Peasant Dress,* and *White Dress.* For the most part these are images about thought, and the dark closures of rooms appropriately suggest a sense of privacy and the mind inward-turning.

Homer pursued, as has Wyeth, a parallel group of works showing women resting or pausing in fields and woodlands, *Weary,* 1878 (Terra Museum, Chicago), being a characteristic example. While some of these include small groups of girls, usually in peasant dress, by the end of the seventies Homer was concentrating on the single figure, reading a book, picking a flower, or simply absorbed in the suspended moment. With their pastoral mood, bright coloring, and freshness of handling these watercolors intimate youthful promise and growth, as much in nature as in the figure. That union of individual and surrounding landscape is likewise to be found in such views of Helga as *Campfire, Cape Coat, Knapsack, In the Orchard, Seated by a Tree, Walking in Her Cape Coat, Farm Road,* and *Refuge.*

If Homer provides a central reference for Wyeth's rendering of Helga clothed, it is Eakins to whom we must look for a counterpoint to the more sexual side of Helga nude, the human form literally stripped to its revealed, unprotected, undisguised, truthful essentials. Unlike Homer and Wyeth, Eakins received formal academic training as a young man, first at the Pennsylvania Academy of the Fine Arts in Philadelphia and then in the later 1860s under Gérôme and others in Paris. From these early years date a number of strong charcoal drawings by Eakins of nudes posing in the studio. The subjects are anonymous and ordinary, and his renderings are direct and unblemished. There is little interest in beautification, refinement, or idealization, only the concern for depicting the actual realities of weight and mass and shape, the facts of flesh and bone. That honesty of observation and execution is but one element extending into the later realism of Andrew Wyeth.

Eakins also devoted much of his subsequent career to the production of portraiture. Although he undertook a large number of commissions, his greatest works were usually measured by the degree to which he transcended the initial bounds of recording mere physiognomy. In these he managed to reveal the substantial realities of the human character, the burdens of endurance, the toll on flesh and spirit of what was possible and what was not. This admiration for sturdiness of character is another aspect which passes down into Wyeth's best subjects. Eakins, too, often posed his figures against the simple walls of his house and studio; he completed portraits of his wife, Susan, periodically in his career; and he painted several related pictures of the nude model in the studio. While these precedents again are relevant to the Helga series, the number, continuity, and duration of Wyeth's group are significantly different.

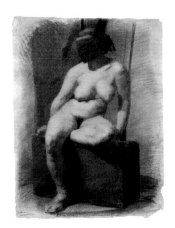

Thomas Eakins
*Nude Woman Seated
Wearing a Mask,*
1874–76
Charcoal on paper, 24¼
x 18⅝ inches. Phila-
delphia Museum of Art.
Given by Mrs. Thomas
Eakins and Miss Mary
Adeline Williams

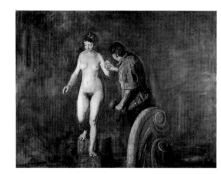

Thomas Eakins
*William Rush and His
Model,* 1908
Oil on canvas, 35¼ x
47¼ inches. Honolulu
Academy of Arts. Gift of
Friends of the Academy

Eakins's paintings of the nude are in part comments on the artistic process of seeing and recording truthfully, regardless of the critical consequences. His own direct sketching after a live model was in some cases consciously transposed into surrogate historical images of his Philadelphia predecessor, the sculptor William Rush. Eakins did three major canvases devoted to the subject of *William Rush Carving His Allegorical Figure of the Schuylkill River* or *William Rush and His Model* (1877, Philadelphia Museum; 1908, Brooklyn Museum; and 1908, Honolulu Academy of Arts), as well as a number of preparatory studies and variants. Unlike Wyeth he turned his attention to the theme at two key, widely separated moments in his life, in his early maturity and at his career's end. While the subject generally was an expression of Eakins's tribute to artistic integrity and accomplishment, and particularly to the creative traditions in his own city, it is also evident that he identified with the sculptor he was depicting, as in more than one work Rush seems to bear the features and carriage of Eakins himself. Eakins was sensitive to the vagaries of critical reaction and shifting reputation, and his paintings about the intimate concentration and the aesthetic chemistry of the studio were not least deeply felt meditations about his own life and aspirations as an artist.[24] Interestingly, his self-projection into the Rush image is notably stronger in the late works and, even more pertinent to the Helga pictures, the later model is older, like the artist himself.

By comparison, Wyeth does not physically place himself within the depicted space of his model, though we surely feel the intensity of his looking and thinking. What is palpable is the implied bond between the artist and his subject as it becomes art. Wyeth follows Eakins in the unsentimentality and directness of sexuality and in the seeing of an individual as an embodiment of larger truths. Wyeth's studio is not consciously described: it is more generally the rooms of his house and the surrounding landscape in which the figure stands and with which he or she becomes identified. Above all, it is the goal of making technique serve not just what one sees, but feels.

Within this broadly drawn American tradition Wyeth's art needs to be seen as part of the more circumscribed continuum of an artistic family, directly traceable back through Andrew's father, Newell Converse Wyeth, to his teacher, the illustrator Howard Pyle, and to the nineteenth-century artist George de Forest Brush, much admired by Pyle, N. C., and Andrew. Brush was very much an academic painter, having trained at the National Academy of Design in New York in the early 1870s, then studied with Gérôme in Paris, and later himself teaching at the Art Students League. From his long admiration for the old masters of the Italian Renaissance he painted the numerous mother and child compositions for which he is most widely known. But it is his more imaginative earlier work with its striking qualities of mood and finish that we might well understand as appealing to the Wyeths. In addition, during his early years as a professional artist Brush sought to enhance his income by doing illustrations for magazines, an artistic tradition actively continued by the Wyeth family.

With the Helga material in the mind's eye, especially the pearly surfaces and sinuous lines, we can find curious but applicable parallels in Brush's magical series of Indian pictures from his early maturity. These paintings suggest echoes in the Helga works because of Brush's highly polished textures and crisp, expressive

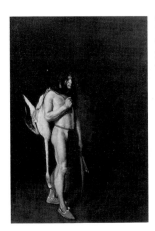

George de Forest Brush
The Indian Hunter, 1890
Oil on wood panel, 13 x
9 3/8 inches. Collection Jo
Ann and Julian Ganz, Jr.

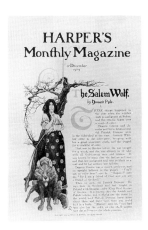

Howard Pyle
*Decorative Title Page
and Initial T, Harper's
Monthly Magazine*
cover, December 1909
Page measures 9 1/2 x 6 1/2
inches. Photo courtesy
Harper's Magazine

contours as well as the usually reflective stance of his figures.[25] Brush first traveled to the American West with his brother in 1881 and over the next decade painted a sequence of Indian pictures showing the native in various hunting postures. The several in which the Indian is closely juxtaposed with a large bird (a swan, heron, or flamingo) are unusually intriguing for their subliminal sexuality.

Brush's Indian is always well-proportioned, his skin gleaming and musculature tense. All the more compelling, then, is the bird at his side, strikingly large – almost human in size – and colorful – either brilliant white or shocking pink. The first conveys a sense of purity, the second passion. Of course, the distinctively long neck of both the swan and flamingo carries phallic associations and, who knows whether intentionally or subconsciously, Brush paints this form extended in various positions. In two works, *The Indian Hunter,* 1890 (Ganz Collection, Los Angeles), and *The Indian and the Lily,* 1887 (private collection), the bird hangs over the Indian's back, its neck falling limply almost to the ground. By contrast, in two others, *Out of the Silence,* c. 1886 (Gilcrease Institute, Tulsa, Oklahoma), and *The Silence Broken,* 1886 (private collection), the bird's neck is outstretched rigid in flight. In a final one, *The Headdress Maker,* 1890 (Peters Collection, Santa Fe, New Mexico), the Indian is seated with the dead pink flamingo stretched out from his crotch across his legs, the long neck reaching out across the floor in front of him. Although these are male nudes in comparison to Wyeth's female, one cannot help but feel the passage of both technical and sensual elements from one artist to the other.

Howard Pyle's connection to the Wyeth artistic lineage is more direct, as he spent much of his career in the Delaware-Pennsylvania area. From a mixture of self-trained motivation and some formal study Pyle became an accomplished and popular illustrator of history and fiction. Pyle taught art classes on and off around the Philadelphia area, and N. C. Wyeth emerged as his acknowledged best pupil. N. C. in turn initiated his son's early training, setting up still-life arrangements for him to draw and teaching him the basic disciplines of draftsmanship, composition, and above all close observation. From these exemplars Andrew Wyeth also gained a fascination with history and a sense of things existing in place and time. "You see, a lot of my pictures . . . come from dreaming of my past experience."[26] Close scrutiny of something thus led to capturing its essential features but also its relationship to a setting: "I was seeking the realness, the real feeling of the subject, all the texture around it, everything involved with it, even the atmosphere of the very day in which the object happened to exist."[27]

The work of Pyle and the senior Wyeth, with which Andrew grew up, demonstrated the imaginative and mythic capacities of art. While they were foremost concerned with narrative illustration, their strongly graphic style offered the example of powerful expressive form, through silhouetting and contrast, and the command of line as an agent of suggestive texture and modeling. Because their subjects generally accompanied stories of action or fictional heroes of the past, their imagery of necessity was filled with lively motion of form and design. They selected critical moments to highlight, key conversations between central characters or dramatic activities

N. C. Wyeth
Winter, illustration for
"The Moods" by
George T. Marsh,
Scribner's Magazine,
December 1909
Oil on canvas, 33 x 30
inches. Private collection.
Photograph courtesy
The Brandywine River
Museum

of flight, pursuit, and confrontation. Such storytelling and animation of moving figures rarely appear in Andrew Wyeth's earliest work under his father's influence, an exception being his tempera of *Winter,* 1946 (North Carolina Museum of Art, Raleigh). It showed a young boy running down a hill, the one beyond which Wyeth's father had been killed in an automobile accident the year before. Not only did the painting inherit his father's stylistic character, it was the son's first major work to crystallize the process of identifying a figure with its place. "It was me, at a loss – that hand drifting in the air was my free soul, groping. . . . The hill finally became a portrait of him."[28] The loneliness and emptiness of this hillside thus came to express the artist-son's deepest feelings of isolation combined with the recognition that this looming mass of landscape was the embodiment of his father's permanent memory.

We need only turn to key illustrations by Pyle, such as his *Decorative Title Page and Initial T,* a *Harper's Magazine* cover illustration of December 1909 for a story called "The Salem Wolf," or his running figures of a wolf and victim in a painting entitled *Once It Chased Dr. Wilkinson into the Very Town Itself,* an incident in the same story, to see his essential style. These figures are antecedents of Helga, more stilled in poses of rest or slightest motion, standing by a tree or crossing the grass. By similar means of graphic contrast and shapely silhouetting N. C. Wyeth often set single figures against a background, sometimes tilting up his angle of view or lowering a horizon to enhance the visual drama. His oil of *Winter,* 1909 (private collection), was appropriately painted for a story in *Scribner's Magazine* called "The Moods."[29] Here were the aesthetic basics which passed into Andrew Wyeth's own art; after a full career and decades later these same essentials govern both the outlines and the spirit of the Helga compositions. Now her sturdy features and sober demeanor, reflective of her northern European background, match the somber browns and enduring contours of this Pennsylvania terrain. Alternatively, the moments of caressing light and bright color, the strong grass greens and single garland of flowers, speak to those infinite cycles of growth and regeneration, whether by seed in the earth or in human flesh.

Lastly, appreciation of the *Helga Suite* requires consideration of Andrew Wyeth's own personal style, for coming in the late maturity of his life, it bears an internal vision of his own making. Helga may in fact be related to the context of his work in the immediately preceding years and, however contained a cycle in its own right, to the context of other figures – animal and human, male and female – painted almost in counterpoint contemporaneously. First of all, the subject of the nude was not a new one for Wyeth with the Helga series, nor was Helga the only nude model he painted in this period. In the late 1960s with *The Virgin* Wyeth began a sequence of half a dozen temperas of Siri Erickson, the daughter of a Maine neighbor of Finnish descent. Characteristically, having just completed a final painting of Anna Christina Olson, the focus of many powerful pictures in preceding decades, Wyeth was in search of something new when he made a visit to the Erickson farm.[30] Meeting Siri, he found in her those striking northern features which had appealed to him in several other sitters, most notably

Karl and Anna Kuerner and George Erickson. Siri, then fifteen, also had a sexual innocence and unself-consciousness which allowed her to pose, and the artist to paint, with a certain detachment.

Where Siri metaphorically provided an artistic rejuvenation after Christina Olson's death, so Helga Testorf provided a parallel continuity and return to human potency after the final illness of Karl Kuerner. The former pair belonged to Wyeth's Maine experience; the latter were part of his life in Pennsylvania. Kuerner and his wife and their surrounding farmland were the inspiration for nearly four hundred drawings, watercolors, and temperas, with the last painting being *Spring, 1978*, showing the ghostly figure of Kuerner reclining in a field.[31] Thus, the methodological pattern was set for the Helga series to follow, in which the artist would intensely examine all aspects of a subject, finding each shift in viewpoint or proximity to yield another association or idea. Also a German immigrant, Helga had come to help nurse the ailing Kuerner, and it was in that house with all its secluded and accumulated sentiments that, "building in great layers," Wyeth now saw new life and began his studies of her. The work would continue in the house and in the fields near Kuerner's farmland. The Testorf family lived on another neighboring farm, and so the emotional continuities of landscape and personality were assured.

Many of the formal aspects of the Helga pictures clearly relate to familiar devices of design and viewpoint employed in previous Wyeth works. The figure seated on a porch, next to a window or in a doorway, standing against a sloping hillside, or walking through the grass exists in the Wyeth repertory in such memorable pictures as *Anna Kuerner, 1971*, *Christina Olson, 1947*, *Garret Room, 1962*, *Chambered Nautilus, 1956*, *Adam, 1963*, *Roasted Chestnuts, 1956*, and *Up in the Studio, 1965*. The head-and-shoulders close-ups of Helga seen frontally, in profile, and in three-quarter views have similar connections to *Nogeeshik, 1972*, *Grape Wine, 1966*, and *Lynch, 1970*. But Wyeth extends his moving stance full circle with *Farm Road*, where Helga is seen from behind, private and silent. The paradox many historians have cited between realism and abstraction remains strong in the Helga images, as Wyeth stresses focus, major contours, pure textures, expressive brushwork, and a distilled sense of design. Wyeth's interest is not in photographic but intensified reality. The underlying abstraction of his compositions is partially the exertion of aesthetic power over routine observation, but it is also an aspect of seeking an original concentration of thought: "My struggle is to preserve that abstract flash – like something you caught out of the corner of your eye. . . . I've got to get that momentary off-balance quality in the very base of the thing."[32]

Among the most characteristic aspects of Wyeth's strongest compositions are his devices of contrasting near and distant forms, the cropping of key framing elements, and the manipulation of his angle of view. Other observers have astutely called attention to the formal parallels of close-up and aerial viewpoints in his work and that of several twentieth-century contemporaries, such as Edward Hopper, Charles Burchfield, Grant Wood, Edward Weston, Charles Sheeler, and Georgia O'Keeffe.[33] The intense concentration on a single object, often close to the ground or a nearby wall, and the tilting up or down of the horizon line are frequent devices of expressive design to be found underlying realist and regionalist art of the thirties and forties. Already a familiar visual vocabulary in Wyeth's art, such compositional motifs continue in the Helga works, for example, the extreme close-up in *Sun Shield*, the high, angled horizon in *Farm Road*, or the abstracted landscape pattern in *Walking in Her Cape Coat*. With its broad quilt of dark leaves this last recalls the dense and mysterious tempera *Thin Ice* of 1969.

Deriving both from his personal style of realism and from the demanding nature of his media, Wyeth's textures have been particularly compelling, even sensuous, in effect. His frequent wish to fuse figure and landscape is often achieved by a similarity of stroke and surface applied alternatively to field grasses, animal fur, and human skin and hair. This distantly traces back to his early admiration for Dürer, but one also feels a certain subliminal association of vibrant human life with an earthy animal nature. As noted earlier, in the Helga series alone there are a striking number of images with an overriding attention to hair and fur, whether Helga is

Andrew Wyeth
The Virgin, 1969
Tempera, 46 x 39 inches.
The Brandywine River
Museum Collection

Andrew Wyeth
Beauty Mark, 1984
Tempera, 22 ¾ x 20 ½
inches. Private collection

undressed, her nakedness enhanced by the different contours of falling locks, or whether she is dressed, clothed in various animal skins.

Besides Siri Erickson and Helga Testorf, Wyeth painted a number of other nudes during this period. We already know of the artist's sentiments about the genesis of some of these. After Christina Olson's death, he has said that turning to Siri "was almost as if it symbolized a rebirth of something fresh out of death."[34] But to a larger degree this markedly new and intense subject coming late in the artist's maturity suggests an effort to reclaim that sexuality associated with earlier stages of human growth and to transpose the powerful idea of regeneration onto a higher mythic plane. Siri, for example, was "like finding a young doe in the woods. . . . Here was something bursting forth, like spring coming through the ground. In a way this was not a figure, but more a burst of life."[35] Thus began a sequence of nude studies which might be viewed as an examination of sexual self-awareness, from puberty and virginity to the mature capacity for procreativity.

Wyeth seemed to have been concerned with both the idea and the fact of coming of age, for he held on in secret to the early paintings of Siri until she was of legal adult age. In other nudes of the period he further explored the consciousness of youthful sexuality, some female, as in *Beauty Mark,* 1984, some male, as in *Undercover,* 1970, and *The Clearing,* 1979. In tandem with the Helga nudes they show not just observation of the different genders but a broader look at nuances of sexual expression. Indeed, at moments he seems to record both a specific physical presence as well as something more universalized. It is curious but significant that occasionally aspects of the males appear feminine, as in the long blond hair of Eric Standard, the young man in *The Clearing,* and the shoulder-length hair of the Indian *Nogeeshik,* while Helga in *Pageboy* and *Sheepskin* appears rather masculine. Further in the Helga series she ranges in expression from the reserved and detached to a ripe and inviting sexuality. Following Siri, she represents a later adult stage of human awareness. All told, this spectrum of near androgyny and periods of sexual growth reveals an artistic aspiration to probe the subtle range of our basic humanity.

That an artistic compulsion and ambition of such seriousness should come to a man entering late adulthood ought not to be surprising. Sociologists defining the major stages of human development can provide us with a context of general characteristics perhaps useful here. If Helga was middle-aged during the undertaking of this suite, the artist was fifty-three when he began and sixty-eight when he completed it. During this period he experienced several ailments, underwent a hip operation, and had some serious respiratory problems – all stark reminders of one's mortal tenure. As one moves into the period of late adulthood, generally perceived to begin during the early and mid-sixties, one becomes increasingly conscious of transition and change. These may be obvious biological changes or psychological and social ones only subliminally felt. This is a period in life when one faces the paradox of both deterioration and fulfillment. On the one hand we experience physical decline and impairments, and we note the quickened pace of debilitation and death among friends and relatives; on the other

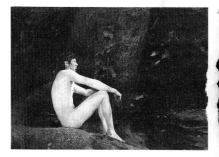

hand the pattern of our life's work is estab... to lay claim for some mark of immortality.[36] W... level of seriousness and richness of meaning.

Looking toward old age summons concerns of vulnerabili... remind us, we look dually to sustain youthfulness in some form and to think in terms of seasonal passage.[37] Without reading the artist's mind precisely, we cannot be surprised by Wyeth's turn to an imagery of healthful potency and to the sequential moments of day and year in his painting of Helga. By extension from Wyeth's recollections of his previous series devoted to Christina Olson and Siri Erickson, we can see that Helga further embodied for him the forces of regeneration and continuity. "In the various portraits of Christina there were remarkable changes. In some cases you might never know it was the same person. But behind everything, there was always that strange relationship we had, one of perfect naturalness, excellent communication without too many words."[38] While the flesh may not be a stay against time, Wyeth's subjects allow him the release of vibrant and sustaining creative energies.

Many historians have noted the great intellectual and artistic productivity of men in late adulthood, for example, Picasso, Yeats, Verdi, Frank Lloyd Wright, Freud, Jung, Michelangelo, and Tolstoy.[39] To this we might obviously add Titian, Rembrandt, and in American art Winslow Homer. In a characteristically thoughtful essay Kenneth Clark cites his short list of Michelangelo, Titian, Rembrandt, Donatello, Turner, and Cézanne as artists who "have produced their most impressive work in the last ten or fifteen years of fairly long lives."[40] What Clark goes on to argue provocatively is that this creativity of later age is an apparent pattern possible in artists but not so much in writers. The key is that "the painter is dealing with something outside himself, and is positively drawing strength from what he sees. The act of painting is a physical act, and retains some element of physical satisfaction. . . . A visual experience is vitalising. Although it may almost immediately become a spiritual experience (with all the pain which that involves), it provides a kind of nourishment."[41] In this perspective, Helga seen as a life force emerges as a natural subject for Wyeth's later (if by no means last) work.

Some artists in late career turn toward abstraction and a detachment from realism, as did Turner, Cézanne, and Monet; some to the serene brilliance of color, as with Renoir and Matisse; others to patently sexual imagery, as with Picasso; and yet others to a sense of tragedy or brooding darkness, as did Titian, Rembrandt, and Goya. "The increased vitality of an aged hand is hard to explain. Does it mean that a long assimilation of life has so filled the painter with a sense of natural energy that it communicates itself involuntarily through his touch?" asks Clark. He goes on to quote the aging Japanese painter Hokusai, who wrote: "Everything I do, be it a dot or a line, will be alive."[42] Summarizing the elements he finds in the late work of great artists, Clark cites a sense of isolation and rage against human folly, a feeling of pessimism and resignation, a mistrust of reason echoed by a trust in instinct, and finally an impatience with artistic conventions. None of these tendencies necessarily applies

Andrew Wyeth
Maidenhair, 1974
Tempera, 29⅛ x 23
inches. Private collection

...olation, reliance on instinct, and naturalism ... However time will assess the Helga work in the development ... the undertaking does suggest a shift of artistic gears or, in the artist's terms, a liberation and new spontaneity.[43]

What did prompt Wyeth to take up the nude as a subject so unexpectedly and intensively around 1969? As we have seen, it was not just the sustained attention to Helga Testorf, but just previously to the young Siri Erickson and thereafter to other models in Maine and Pennsylvania. Johnny Lynch was in his teens when he sat for *Undercover,* 1970; the seventeen-year-old Eric Standard posed for a watercolor and the tempera *The Clearing* in 1979; and Ann Call was about forty when Wyeth painted *Beauty Mark* in 1984. The span of these and others parallels exactly the Helga series, which clearly gave a new direction and momentum to his career in this period. (These were not the first nude subjects he had ever painted: Wyeth drew Betsy shortly after they were married and at least one other figure relatively early in his career.) But for the artist, at the height of a long career, there was a danger of submitting to pictorial cliché, now so widely imitated by others. On a superficial level he wanted to break out of the image of "wagon wheels" and more importantly the rigidity he was feeling with repeated landscape temperas.

Like Christina as a model before her, Helga was relaxed and patient. Her poses changed in a natural evolution, moving indoors and out according to conditions of weather and light. She never complained about the snow, wind, or cold, even when the painter felt the chill and damp himself. (He remembered as a youth when his father set up a model in a fixed pose for him to draw, he found it confining and frequently discovered something fresher when the figure was relaxing or moving in an off-moment.) Now the human form gave Wyeth new pictorial flexibility and stirred currents of spontaneity and imagination. Although Helga's respective poses mostly evolved in an organic sequence, they were as often related to the larger fabric of Wyeth's work. For example, poses of Siri reclining and standing in a doorway were prototypes for corresponding treatments of Helga; one watercolor of Eric and another of Siri, *Black Water,* showing each reclining on a beach, anticipated a similar pose assumed in *Asleep* (no. 114); and Helga's presence in *Crown of Flowers* led to a drawing from memory Wyeth did after he had left for Maine that year and then to a tempera, *Maidenhair,* of another girl adorned with a floral wreath set in a country church interior. Perhaps most startling of all was the evolution of the drawing series entitled *Barracoon,* which led to a drybrush watercolor and later to a variant in tempera called *Day Dream,* but also to an entirely imaginary tempera (private collection) now showing a black woman posed in place of Helga.

Wyeth says that three different people posed for *Barracoon* by the time the series was complete; while it initially and largely showed Helga, it ultimately metamorphosed into quite separate imaginative resolutions. The title did not come until the end, when the artist showed his wife the tempera and, a lover of language herself,

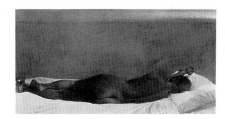

Andrew Wyeth
Barracoon, 1976
Tempera, 17¼ x 33¾
inches. Private collection

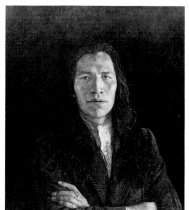

Andrew Wyeth
Nogeeshik, 1972
Tempera, 25 x 22½
inches. The Arthur
Magill Collection,
Greenville County
Museum of Art, S.C.

Betsy immediately came up with the term. A mid-nineteenth-century word, it referred to a barracks enclosure or room for confining slaves and convicts. The idea matched the composition, and thus the play of mind took off from the play of hand. Frequently, indeed, Wyeth has titled his own pictures if a strong phrase strikes him at an image's completion. But the spontaneity of circumstances may equally lead to a title arrived at collaboratively. Another instance is *Lovers,* where the mysterious shadow at the left of the finished drybrush suggested to Betsy Wyeth an unseen but imminent presence.

Throughout the Helga works one encounters minor grace notes of a similar character, where the freshness of thought or touch has produced a novel effect. In one drawing (no. 70) of Helga standing nude she appears partly drawn over an adjacent wigged military figure. This turns out to have been a brief revery on Lord Nelson standing on the deck of his vessel and contemplating an unseen love. Another very free watercolor (no. 71) of Helga asleep on the grass bears bold strokes of dark wash crisscrossing her upper torso, as well as broad abstract pools of paint around her, these again in an impulsive effort to break free from the confines of techniques long familiar to the artist. Then there are the single leaves in the final image of *Lovers,* seemingly quirky touches in the stilled interior. Yet while she was posing a leaf did flutter in through the window; Helga turned momentarily and caught it in midair, adding to the whole a welcome accent of fancy. For that matter, a single leaf or flower might occasion an entire conception, as in the beautiful watercolor *Walking in Her Cape Coat.* One day Helga walked in the Kuerner house with a single leaf caught in her hair. This prompted a brief pencil study on the spot, but soon evolved into the striking free-form tapestry of autumn foliage, with Helga's head almost lost in the corner of the watercolor. Likewise, *Crown of Flowers,* one of the most eloquent and grand creations of the Helga series, arose from the unexpected moment. On a spring day she simply walked indoors wearing the floral bouquet, explaining this was traditionally worn by German brides. Wyeth intentionally darkened the background and subdued the lustrous facial and hair tones to accentuate the bright blossoms, made by leaving the white of the paper untouched.

Finally, there remains consideration of the basic internal chronology, the organic growth, of the Helga pictures, with their hesitations and recapitulations, their rhythms and marker moments. As the writer begins with words and turns them into sentences, the artist begins with a mark he turns into a line and then into form. Wyeth's first depiction of Helga was a modest profile drawing in 1971 (no. 1). Other drawings of her full face and torso followed, leading to the first major tempera, *Letting Her Hair Down,* in 1972. (Interestingly, this composition is virtually a mirror image of the Indian *Nogeeshik,* painted the same year.) Closely related were seated studies of her, *Peasant Dress,* with Helga now turning in a three-quarter view. Early on in this first year or so of work Wyeth also undertook a sequence of multiple studies of Helga standing and walking outside, *In the Orchard.* Now seen full-length, she stood beside a large tree or in an open meadow, or walked away across the grass, an old apple tree to the side. Presumably executed over the changing seasons, this combination of drawings

Andrew Wyeth
Easter Sunday, 1975
Drybrush, 25¼ x 37¼
inches. Private collection

and watercolors shows her dressed in an overcoat (and winter hat in one), trees bare in some, autumnally brown or lush green with leaves in others. The hillside and tree limbs serve as organic equivalents of architectural framing devices. Two drawings in particular (nos. 33 and 23) give subconscious hints of sexual associations: one is a study of Helga's hand holding an apple from the nearby tree, both a simple fact of the location and a suggestion of Eve; the other shows her leaning on the spreading tree limb, with its rising trunk looking startlingly like legs spreading from a torso and its crotch marked by notably stronger lines. These juxtapositions of the standing and seated figure in a landscape, sometimes seen from behind, would reappear in other groupings (*Seated by a Tree, Knapsack, Campfire, Cape Coat,* and *Autumn*) painted over the fifteen-year period.

Also in the early seventies Wyeth asked Helga's daughter, Carmen, to pose in the same meadow. She sat for several watercolors, but proved to be a restless model, and Wyeth must have soon felt her a diversionary subject, for he did not continue. He did, however, fill a sketchbook with focused studies of Helga's face and eyes seen from different angles. By 1972 he had begun the first careful sketches of her reclining asleep nude. Interested at first in the way her hair sinuously fell around her neck, Wyeth turned to the Manet-like device of a black ribbon to accentuate the contours of flesh. Trying various turns of the head, angles of the torso, and placement of the arms, he resolved them all in the stark yet utterly restful pose of *Black Velvet*. A major counterpoint came the next year with the large vertical tempera *Sheepskin*, with Helga now clothed and her face framed by freely falling hair and the bulky fur collar of her coat. Completing this early phase of the series were a few further watercolors of Helga outdoors, *Seated by a Tree*.

One of the major works dating from 1973 is *The Prussian*, a large and powerful drybrush painting, which of course crystallizes an idea Wyeth returned to six years later in the centerpiece tempera of *Braids*. Here he alludes to her family's German history and stolid northern character. The face is framed in rich darkness, with the play of highlighted lines, her hair partly braided, partly loose, and the big polished buttons extending down her front. The second button is turned to catch a riveting metallic reflection, an echo of the edelweiss pendant around her neck in *Letting Her Hair Down*. There followed the next year an equally important drybrush, *Crown of Flowers*, also primarily a head study, now serene and fanciful. On a slight cursory drawing (page 195) Wyeth hastily sketched the notion of a German bride Helga had suggested. The hint of a bridal veil covers her head, while to the side, the sheet turned upside down, are the outlines of a small building with the artist's notation, "Bavarian church." The finished watercolor thus evolved into a tender balance between the earthly and the spiritual.

Over the next couple of years, in sketchpads and watercolors, Wyeth continued to make miscellaneous studies of Helga's head and torso, though among them were the germs of sitting and sleeping formats he brought to fruition in 1975 and 1976 with *Easter Sunday, Asleep,* and *Barracoon*. The first of these returns to Helga seen three-quarters from behind (a pose in which he also painted Anna Kuerner), seated in her earth-green cape coat.

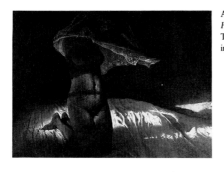

Andrew Wyeth
Heat Lightning, 1977
Tempera, 21⅞ x 30
inches. Private collection

Andrew Wyeth
Surf, 1978
Watercolor, 49 x 30
inches. Private collection

The architecture of a porch replaces the earlier apple tree as a contrasting element, but the spacious rectangle framing the landscape beyond also relates to the window motif Wyeth took up at the same time in the many images of Helga sleeping. In fact, there is an intensive series of several dozen pencil drawings of her reclining, eyes closed or partly open in phases of rest or revery, on her back and stomach, facing and turning away from the viewer. These culminate in the delicate paintings named *Barracoon,* made mysterious by her facing away from us, confined physically by the enclosure of the room yet freed by the travel of private dreams.

Maintaining an apparent rhythm of pictorial advance and return, during 1977 Wyeth took up a new pose with *On Her Knees* and modified an earlier one with *Drawn Shade.* In one drawing (no. 139) he sketches her as if framed by the familiar window, her head intersecting the horizon, but then turns in the rest of the sequence to exploring the contrasts of her firm flesh with the softness of sheets and mattress and of the surfaces of cream white with surrounding dark. (So fascinated was Wyeth with this pose that he painted at least three other pictures, depicting a different female figure – *Heat Lightning, Winfields,* and *Surf* – in 1977 and 1978.) By contrast, *Drawn Shade* gives us the figure again turned to the window. The early drawings include references both to the dark ribbon of *Black Velvet* and the edelweiss pendant of *Letting Her Hair Down,* though the final drybrush eliminates these details and darkens the closure by the pulled windowshade.

Wyeth's artistic vocabulary for the series was now fully established, allowing him suppleness and expansiveness. He could thus turn to what would be two key works of the *Helga Suite, Overflow* and *Farm Road,* one involving a series of preliminary conceptualizations, the other virtually a singular statement. With the studies for *Overflow* it is as if we are watching Helga silently breathe and turn in her sleep, her arms languidly shifting to positions of rest. (Wyeth pursued a fascinating variant in *Night Sleeper* of the same period.) Formally, Wyeth explores his concern for the ways her dark braids accent her neck and especially how the rectangular geometry of the window behind contrasts with or complements her flowing form below. In one drawing, no. 158, we note the ominous ceiling hooks so familiar from Wyeth's previous portraits of Karl Kuerner in the same rooms. Making notes to himself for the color he is about to add in watercolor and drybrush versions, he wrote on the sheet of one: "rich gold of hair . . . face catches more light." As the series proceeds to its culmination, the window gradually moves across the composition from left to right, becoming in the final image an imaginary view. No longer just the factual mullions and glimpse to Kuerner's hill, it evolves into an opening set above, and thereby extending, Helga's dreaming head. Echoing the flow of sheets and hair, the distant waterfall now evokes an exquisite flux of imagination, purity, and abundance.

The first tempera since the early period of the Helga series, *Farm Road* literally solidified in brown and hard pigment the window view of Kuerner's hillside. Wyeth began painting Helga's head and shoulders in a pose derived from images in *In the Orchard* and *Seated by a Tree,* then went on to add the high sloping field to create the strong abstract composition. Almost the same view of her head, asymmetrically placed at the lower right,

Andrew Wyeth
Night Sleeper, 1979
Tempera, 48 x 72 inches.
Private collection

Andrew Wyeth
Black Caps, 1981
Watercolor, 22½ x 28
inches. Private collection

anchors the design of *Walking in Her Cape Coat,* from the same time. Much as a footnote, *Loden Coat* extended the view to the full-length figure. At what was to turn out as the midpoint of the Helga series, now into its seventh year, Wyeth's creative energies were clearly at a high plateau of productivity. In 1979 he turned once again to do a work in tempera, perhaps the keystone achievement of the group, the simple yet profound distillation named *Braids.* The preliminary drawings reveal a conventional enough beginning: frontal, profile, and seated views. But with each increasing clarification and reduction, every contour, color, texture, and highlight gained in quiet strength to achieve an Eakins-like image of full human awareness. Neither melancholy nor triumphant, this three-quarter face displays both a technical mastery of form and a penetrating inner sense of acceptance and honesty.

Not surprisingly, there followed the continuing rhythms of experiment, recollection, and resolution in sequences that varied in their degrees of successful completion. *Night Shadow,* for example, returned to the figure of Helga stretched out asleep and, in the preliminary studies, gave evidence of certain awkwardnesses and uncertainties. But in the decisive gesture of moving in close to the face, so successful elsewhere, Wyeth achieved a dramatic image of mottled light and shadow in the final drybrush. It was to be a counterpoint to a similar image of broken sunlight on Helga's face three years later in *Sun Shield. With Nell,* by contrast, finds her awake and musing as she relaxes with the Wyeths' dog by her side. It is a sequence with a certain sly whimsy, as the artist plays with the two pairs of observant eyes.

A decade after he had begun, in 1980, Wyeth did another striking head-and-shoulders portrait of Helga, *Pageboy,* which emerged after a few relatively unresolved and conventional studies. It took its title from the shape of her hair tucked inside her dark coat collar, giving her yet another shift in image and character. Over the next five years, the last third of the Helga period, Wyeth's pace of attention and production began to slacken as other subjects came to compete for time and interest. During the early eighties some works did not satisfy him, though he still achieved touches of great felicity. The groups known as *From the Back* and *In the Doorway* attempted respectively to treat Helga from behind, in a pose now nude where she had formerly stood clothed, and to view her facing in and out in a white frame doorway. Wyeth had long been interested in depicting models standing or seated in doorways, Christina Olson being a memorable example, and like a window this opening engaged his fascination with the play between interior and exterior space. These Helga watercolors, like so many throughout the series, specifically concentrated on the angles and planes of falling light. But somehow, the proportions and relationships of formal elements "went nowhere," as the artist said, curiously as they had not worked either in a similar portrait of Siri.[44]

From the same period, *Knapsack* saw Helga seated again in the woods in watercolors less original in their composition but intense in their washes of blue, brown, and green. Likewise, the studies for *Day Dream* returned to drawings of Helga asleep. Two of the watercolors attempt new compositional formats, never quite solved: one

(no. 208) sees Helga foreshortened from the end of her bed, the other (no. 209) lying across the bottom of a vertical sheet of paper. Oddly compressed and cropped, it seemed to frustrate the artist's attempt to clarify space and surface design. One solution was a watercolor, *Black Caps,* of a different figure reclining out of doors among leaves and flowers. Another was a full-scale tempera using the pose of *Barracoon* now turned outward to the viewer (no. 206). Delicate in its veiled fabric and flowing light, it nonetheless appears to be more of a déjà vu than a new revery at this point. Possibly sensing this, the artist did find fresh expression in two compelling images, *Lovers* and *Sun Shield.* With both he pushed just enough toward new elements of a pose or effects of light to invigorate and deepen the final effect.

Other works of the period draw inspiration from earlier precedents. *Campfire* and *Cape Coat* belong to a language of outdoor poses Wyeth had used periodically throughout the series. Other miscellaneous examples saw him pressing variant possibilities for one or more designs. In passing, one should note among the numerous incidental sketches two sheets bearing the pale drawings of a seated skeleton, named "Dr. Syn" (page 198). In accordance with the long tradition of academic study and draftsmanship Wyeth has kept a skeleton for periodic sketching, occasionally making one the subject of a major picture. The pose here, partly related to ones Helga assumes in a few instances, assists the artist in seeing the essentials of organic structure, while the title puns on the mortality of the flesh.[45] No matter when it was actually drawn, Wyeth faced his own brushes with the body's deterioration in this period. During 1983 he produced no works with Helga, partly because of an operation and its recuperation. At the same time, Helga was leading to other important subjects, some of them temperas often taking a number of months to execute. Indeed, Betsy Wyeth, who has been his wife for nearly half a century and serves as collegial registrar of his output, estimates that the Helga series varied between ten and twenty-five percent of the artist's production per year over the period in question.[46]

The final work in the *Helga Suite* was *Refuge,* painted in 1985. A large drybrush watercolor, it possesses all the technical finesse and grandeur of design of its finest predecessors. Not quite an image of tragic resignation, it is one of reserve and privacy. Just as the first profile in 1971 was open and upright, this one looks downward and inward. The broad blue washes appearing in earlier watercolors are now reduced to a concentrated touch of color under her chin. Helga is not only wrapped in her overcoat, she takes refuge behind and under a tree. She appears withdrawn in this final season of silence and cold. During the preceding year Wyeth had painted *Beauty Mark,* another female nude, whose model possesses a profile like John Singer Sargent's *Madame X.* He was also able to turn his major energies again to painting visually bold landscapes in tempera, as exemplified by the near surreal abstraction of *Moon Madness.* A dark, poignant finality emanates from *Refuge.* He had painted Helga enough. The series now amounted to a significant body of work in itself and, in the context of what preceded and accompanied it, suggested a productivity of a high order. It was over. New work was under way.

1. When the Pennsylvania collector Leonard Andrews announced his acquisition of 240 Helga works in August 1986, press coverage was intense and massive, a story in itself. The art and the artist triggered a full range of opinions. At one extreme Hilton Kramer said, "He's just an illustrator. Wyeth's paintings have nothing to do with serious artistic expression." Quoted in Cathleen McGuigan, "The Wyeth Debate: A Great Artist or Mere Illustrator?" *Newsweek* (August 18, 1986), 52. "The reason people are so ga-ga over his paintings is they offer a picture of [a] nostalgic, bucolic, sentimental past that never existed." Quoted in Gregory Katz and Julia Lawlor, "Everybody's Talking about Secret Model," USA TODAY (August 7, 1986), 2A. At the other extreme Thomas Hoving said that

Wyeth was "one of America's most distinguished painters, the great observer. . . . He is the most misunderstood painter in America in the last 30 years." Ibid. And also that "they're probably the best things [Mr. Wyeth] has ever done. They are definitely unmistakably Wyeth but not typical in that they're the best." Quoted in the *Baltimore Sun* (August 7, 1986), 6C.

2. Respectively owned by The Armand Hammer Foundation, Los Angeles; Arthur Magill, Greenville, South Carolina; and Tomas Payan, Miami.

3. Wyeth has talked of Eakins being "more Spanish . . . more Velázquez . . . than American." Quoted in *Two Worlds of Andrew Wyeth* (exhibition catalogue, The Metropolitan

Museum of Art, New York, 1976), 17. On another occasion he admitted "my things aren't high key in color or joyous or Renoiresque or Frenchy—which is what a lot of people want today—the visual cocktail." Quoted in Richard Meryman, "Andrew Wyeth: An Interview," in Wanda M. Corn, *The Art of Andrew Wyeth* (exhibition catalogue, The Fine Arts Museums of San Francisco, 1973), 60.

4. Quoted in *Two Worlds*, 17.

5. *Two Worlds*, 17.

6. *Two Worlds*, 17.

7. *Two Worlds*, 17.

8. *Two Worlds*, 33.

9. *Two Worlds*, 17.

10. *Two Worlds*, 33.

11. *Two Worlds*, 35.

12. *Two Worlds*, 34.

13. *Two Worlds*, 34.

14. *Two Worlds*, 39.

15. Quoted in *The Art of Andrew Wyeth*, 60.

16. *Poems by Emily Dickinson* (Boston, 1942), 97.

17. For a thorough survey and discussion of the history of this subject see William H. Gerdts, *The Great American Nude, A History in Art* (New York, 1974).

18. *Art of Andrew Wyeth*, 74.

19. *Art of Andrew Wyeth*, 45.

20. *Two Worlds*, 17.

21. *Art of Andrew Wyeth*, 66.

22. *Two Worlds*, 15–16, 33.

23. Letter to the author, March 22, 1986, after Wyeth had seen the exhibition *Winslow Homer Watercolors* at the National Gallery of Art.

24. The fullest and most sensitive discussion of the Rush series is to be found in Elizabeth Johns, *Thomas Eakins, The Heroism of Modern Life* (Princeton, 1983), chapter four: "William Rush Carving His Allegorical Figure of the Schuylkill River," 82–114.

25. See *George de Forest Brush, 1855–1941, Master of the American Renaissance* (exhibition catalogue, Berry-Hill Galleries, New York, 1985), introduction by Bruce W. Chambers, 9.

26. *Art of Andrew Wyeth*, 47.

27. *Two Worlds*, 10.

28. *Art of Andrew Wyeth*, 58.

29. For a representative survey of the Pyle–N. C. Wyeth legacy, see *The Brandywine Heritage* (exhibition catalogue, The Brandywine River Museum, Chadds Ford, Pennsylvania, 1971).

30. The artist discusses this chronology in *Two Worlds*, 171–76.

31. The work up to 1976 is surveyed in Betsy James Wyeth, *Wyeth at Kuerners* (Boston, 1976).

32. *Art of Andrew Wyeth*, 56.

33. See the extensive discussion and comparisons drawn by Wanda Corn in *The Art of Andrew Wyeth*, 93–162.

34. *Two Worlds*, 172.

35. *Two Worlds*, 175, 176.

36. See the formulation and elaboration of these ideas in Daniel J. Levinson, *The Seasons of a Man's Life* (New York, 1978), 18–37.

37. See Levinson, *Seasons*, 6, 35.

38. *Two Worlds*, 129.

39. Levinson, *Seasons*, 37.

40. Kenneth Clark, "The Artist Grows Old," in *Moments of Vision & Other Essays* (New York, 1981), 163.

41. Clark, "The Artist Grows Old," 175.

42. Clark, "The Artist Grows Old," 172–73.

43. Conversation with the artist, October 14, 1986.

44. Conversation with the artist, October 14, 1986.

45. Dr. Syn was a famous English pirate, a fact that adds another overlay of meaning to the title.

46. Conversation with Andrew and Betsy Wyeth, October 14, 1986. I am indebted to them for these discussions, and as well to Helen Cooper, Robert Bowen, Dodge Thompson, Margaret Donovan, and Mary Adam Landa.

Editor's Note:

The Helga pictures are arranged here in thirty-six sections, each centering around a finished work or united by a common theme. The presentation is basically chronological, although the artist sometimes returned to a theme over the fifteen years of the series.

The quotations by the artist at the beginning of each section are drawn from previously published interviews and statements, and two books in particular deserve acknowledgment: *The Art of Andrew Wyeth* by Wanda M. Corn, with contributions by Brian O'Doherty, Richard Meryman, and E. P. Richardson (Boston, 1973), and *Two Worlds of Andrew Wyeth: Kuerners and Olsons* by Thomas Hoving (New York, 1976).

Full information for each work in the series, including medium, dimensions, and date, is given in the List of Works; an alphabetical listing of the section titles appears in the Index.

The Helga Pictures

LETTING HER HAIR DOWN

Art, to me, is seeing. I think you have got to use your eyes as well as your emotion, and one without the other just doesn't work. That's my art.

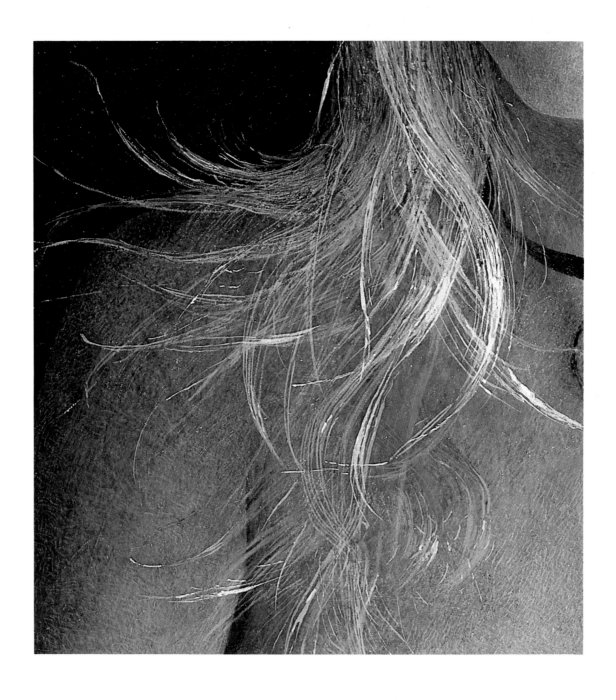

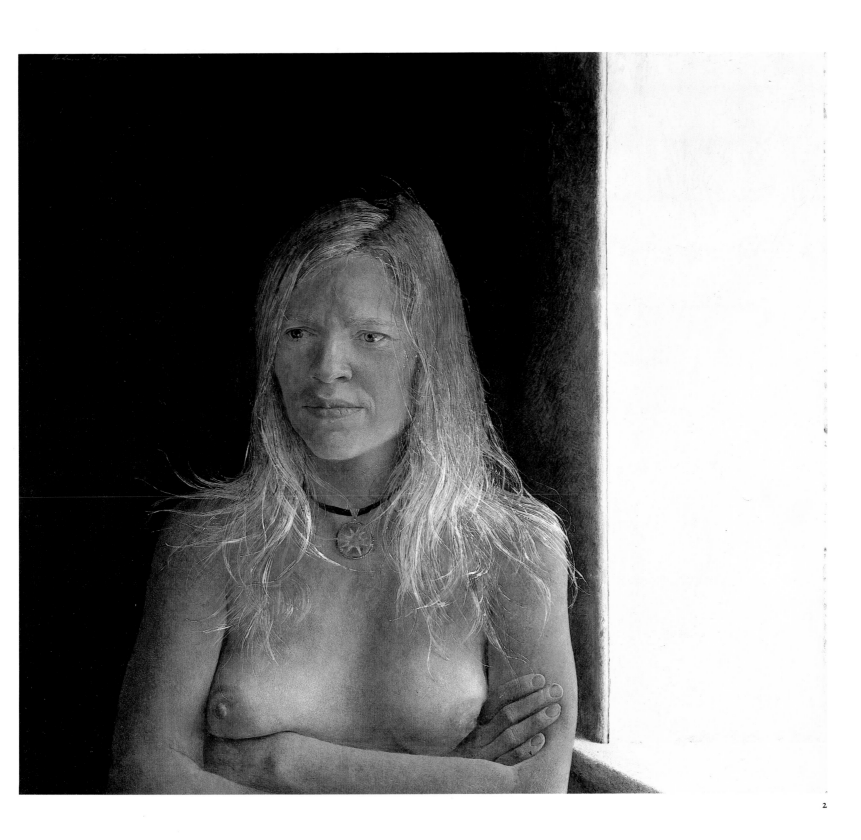

LETTING HER HAIR DOWN

35

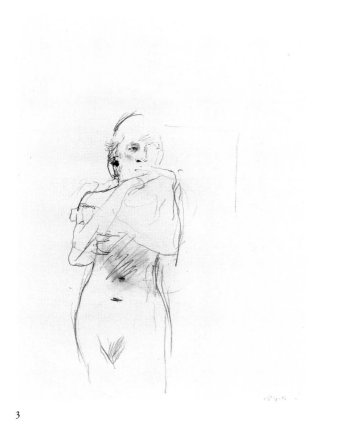

3

4

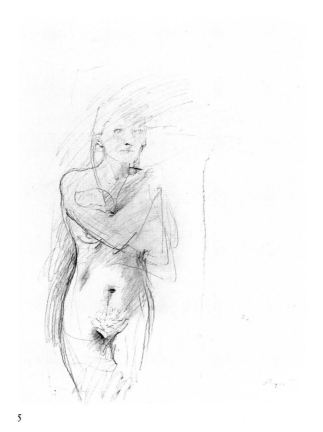

5

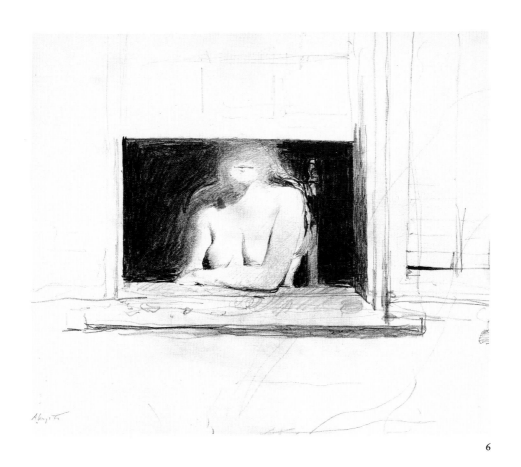

6

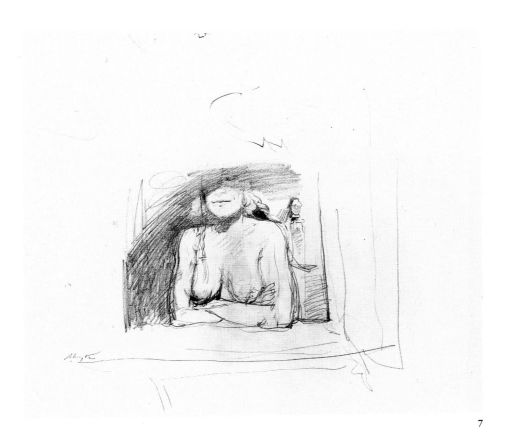

7

LETTING HER HAIR DOWN

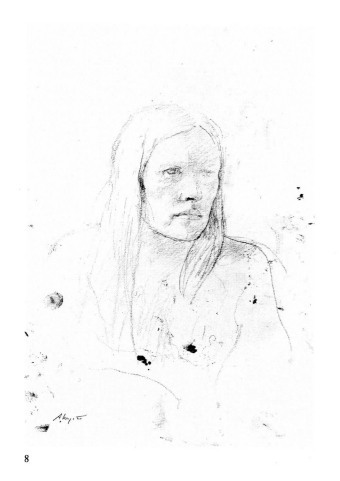

8

9

PEASANT DRESS

To me, it is simply the question of whether or not I can find the thing that expresses
the way I feel at a particular time about my own life and my own emotions.
The only thing that I want to search for is the growth and depth
of my emotion toward a given object.

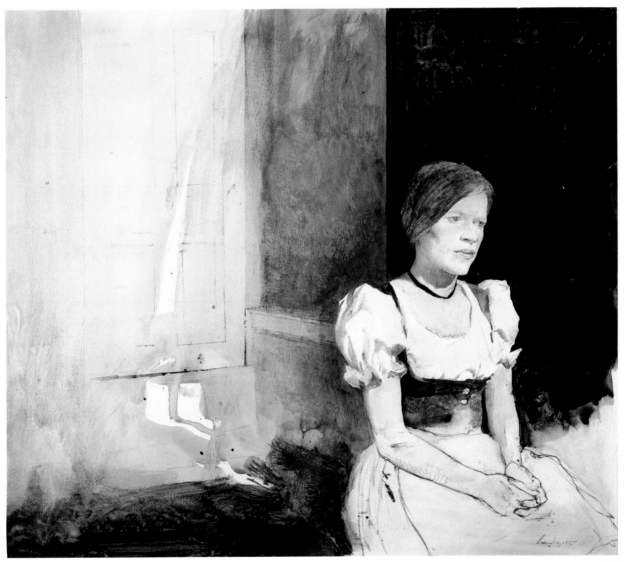

10

12

11

13

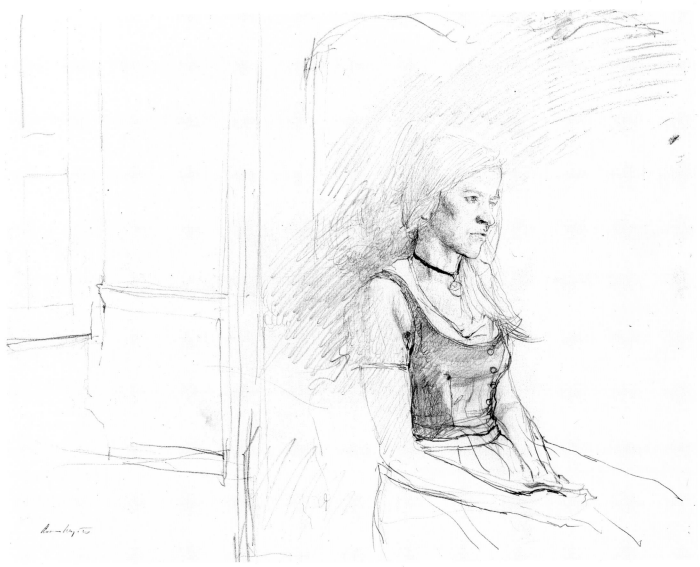

PEASANT DRESS

IN THE ORCHARD

I'll take weeks out doing drawings, watercolor studies, I may never use.
I'll throw them in a backroom, never look at them again or drop them on the floor
and walk over them. But I feel that the communion that has seeped into
the subconscious will eventually come out in the final picture.

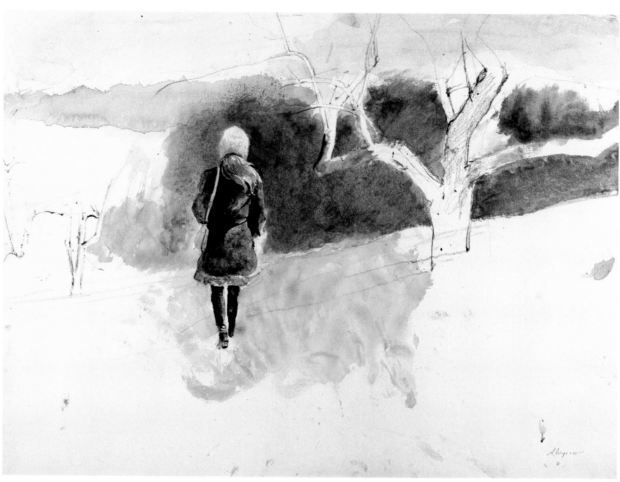

15

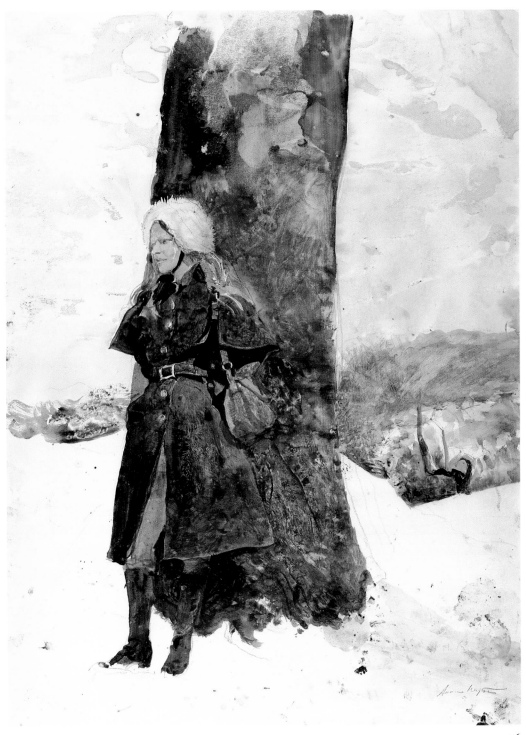

16

IN THE ORCHARD

17

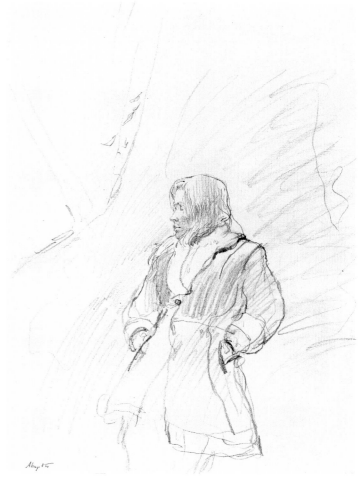

18

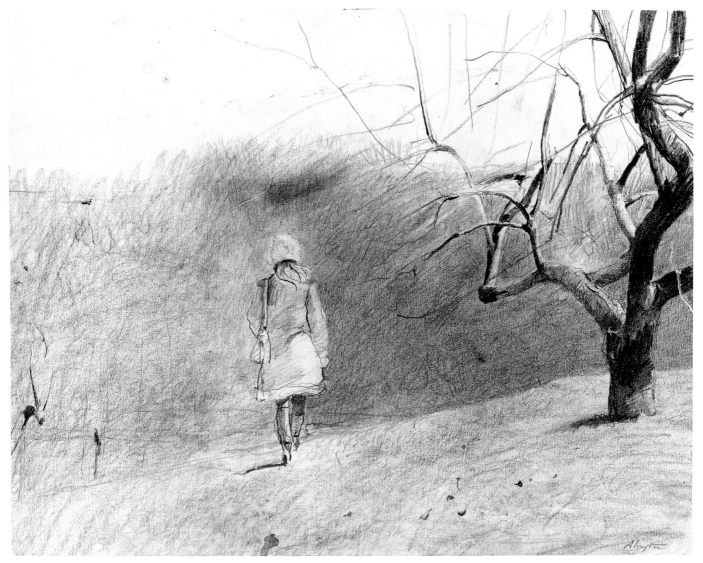

19

IN THE ORCHARD

45

20

21

IN THE ORCHARD

46

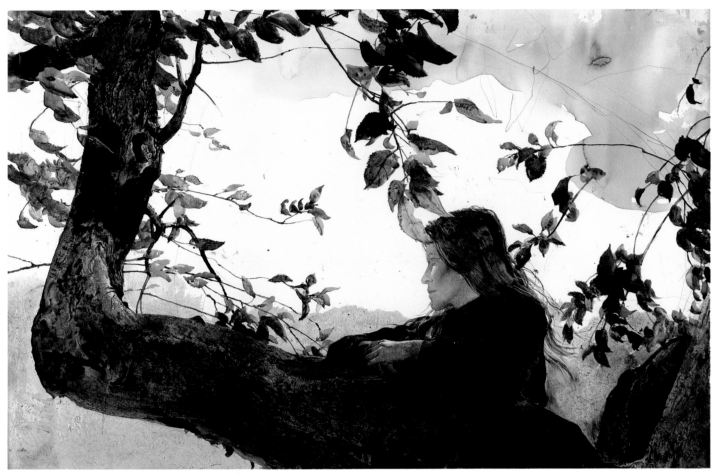

22

IN THE ORCHARD

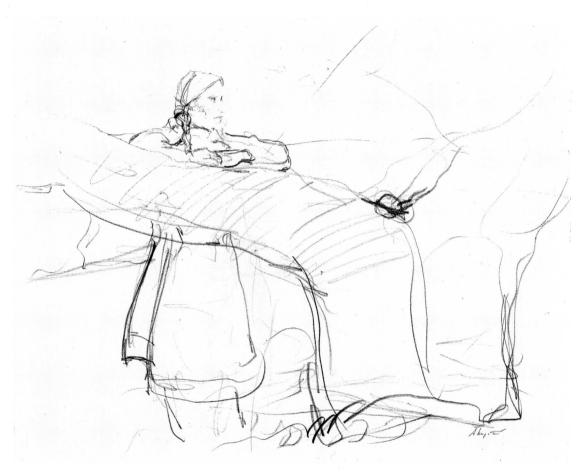

23

IN THE ORCHARD

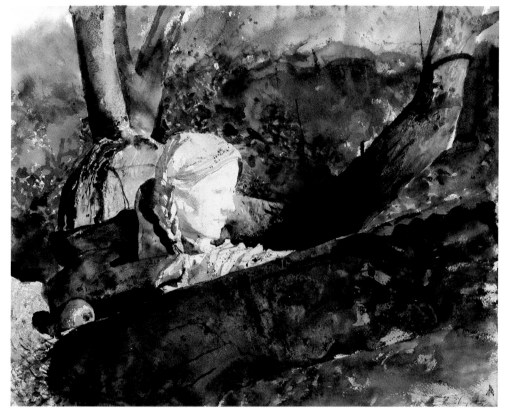

24

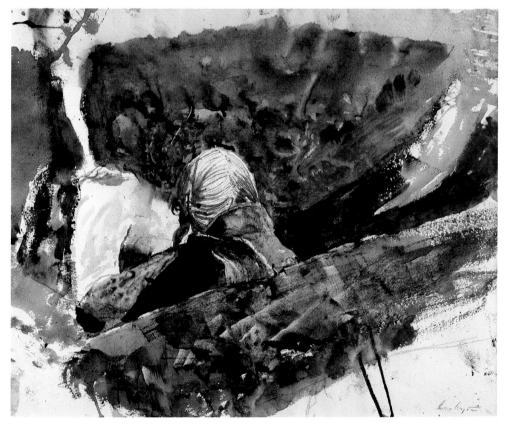

25

IN THE ORCHARD

49

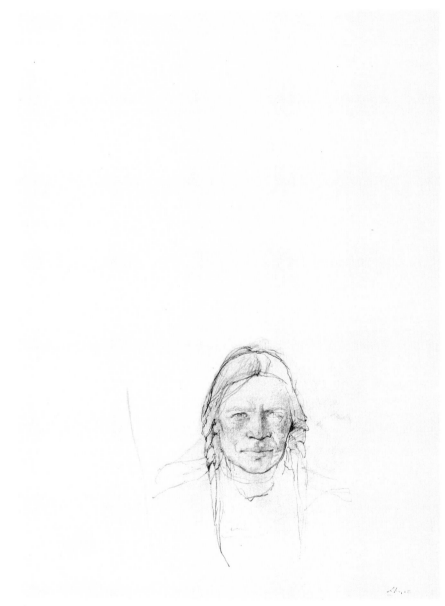

26

27

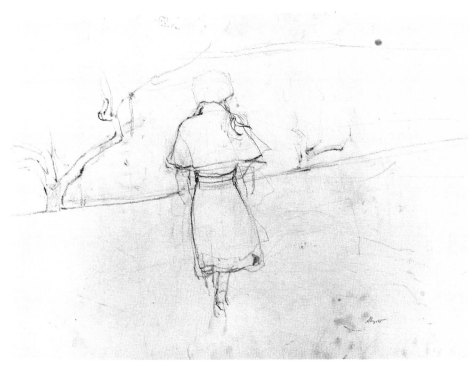

28

IN THE ORCHARD

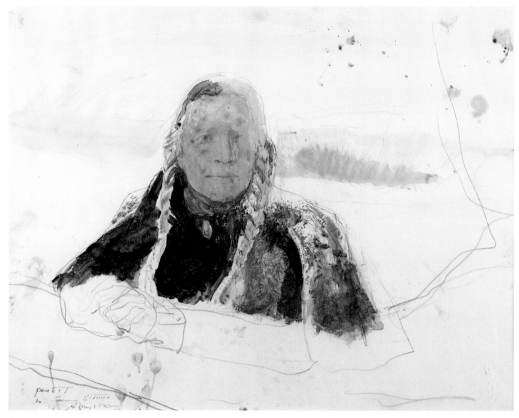

29

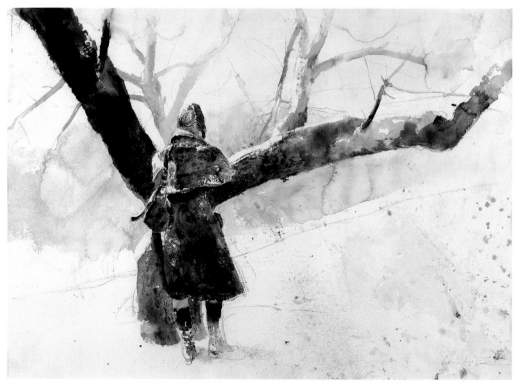

30

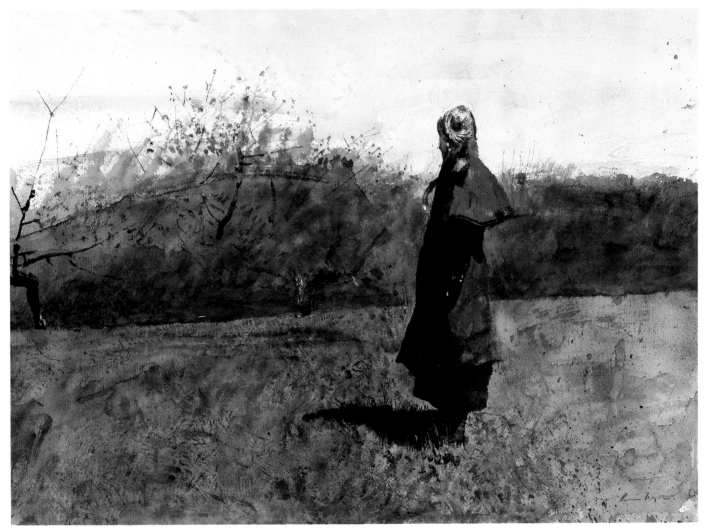

IN THE ORCHARD

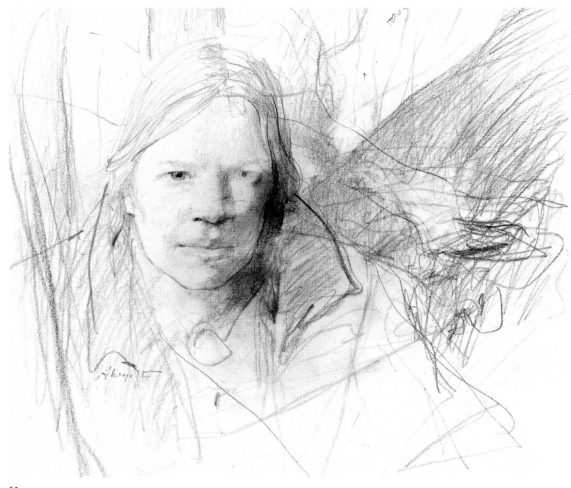

32

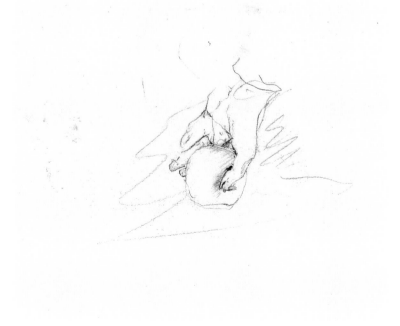

33

HER DAUGHTER

I want to keep the quality of a watercolor done in twenty minutes
but have all the solidity and texture of a painting.

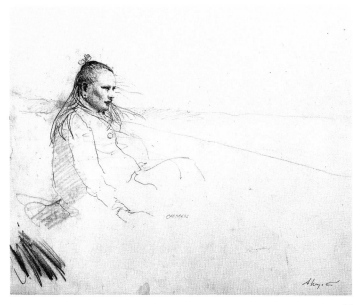

34

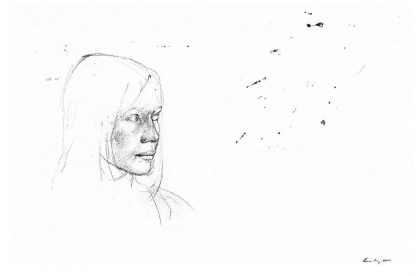

35

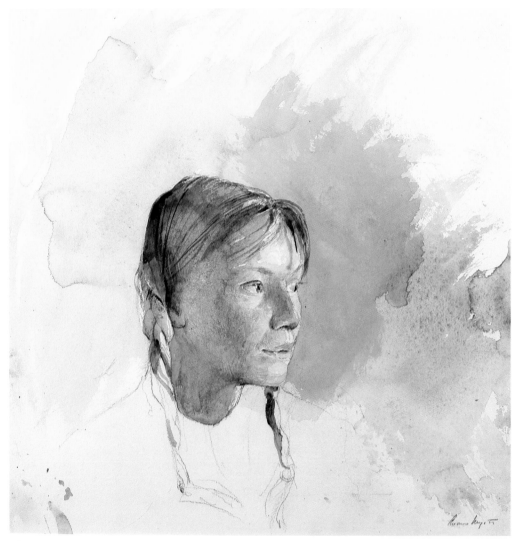

36

HER DAUGHTER

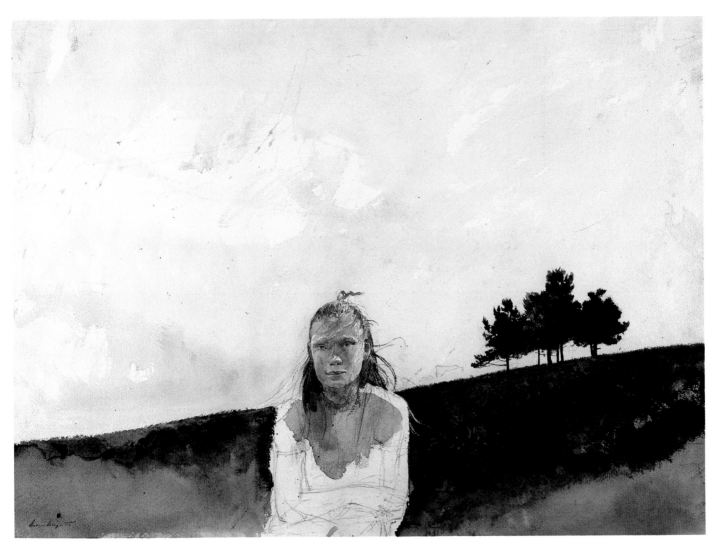

37

HER DAUGHTER

57

SKETCHPAD

I love the quality of pencil.
It helps me get to the core of a thing, and it doesn't compete with the painting.

38

39

40

41

42

43

44

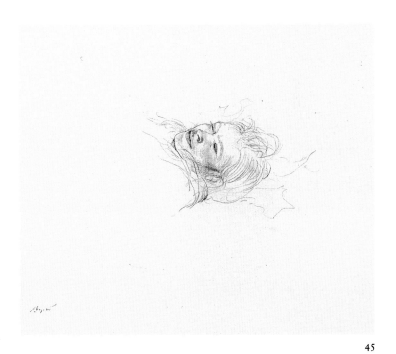

45

BLACK VELVET

My struggle is to preserve that abstract flash —
like something you caught out of the corner of your eye,
but in the picture you can look at it directly. It's a very elusive thing.

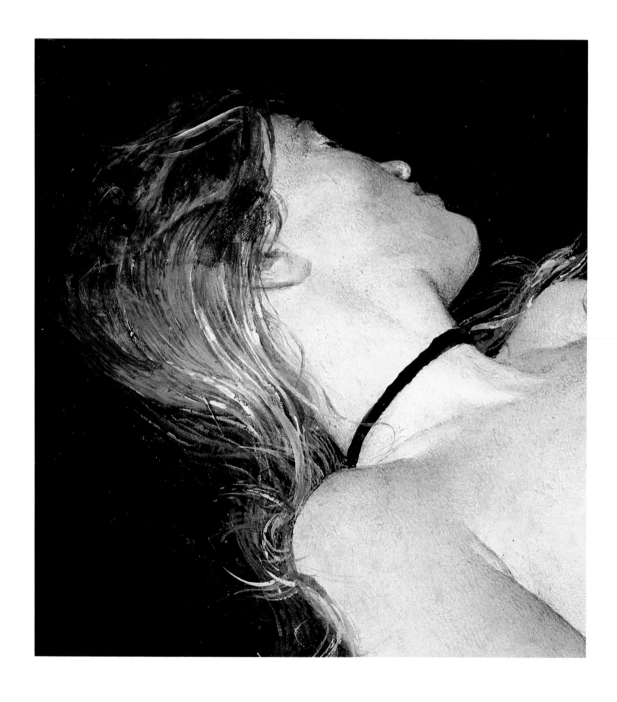

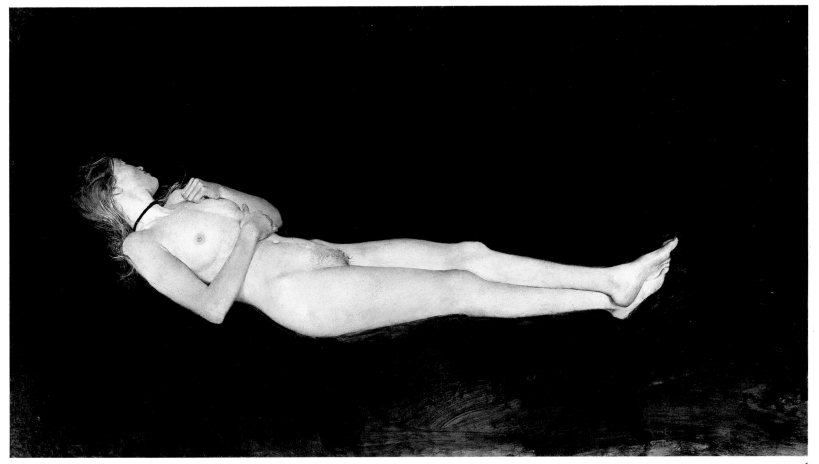

46

BLACK VELVET

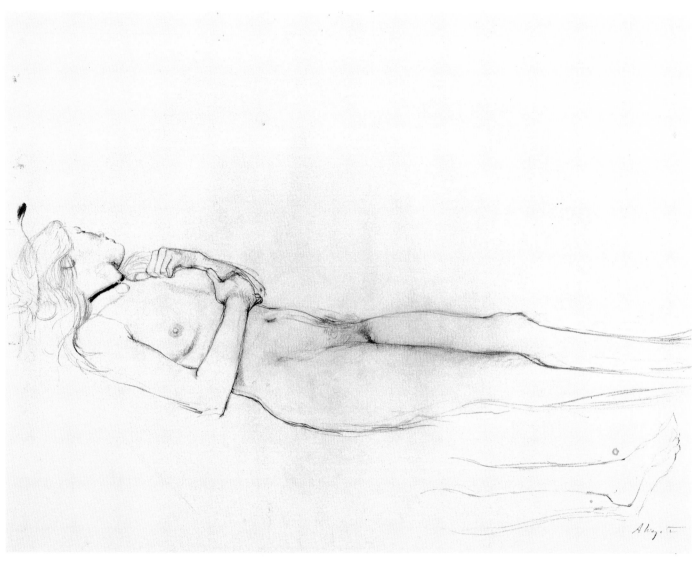

47

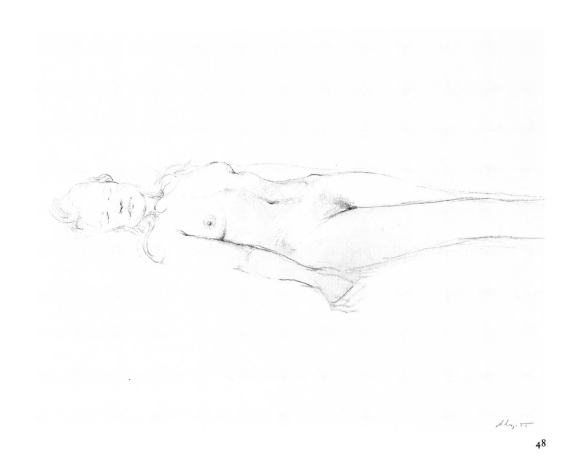

48

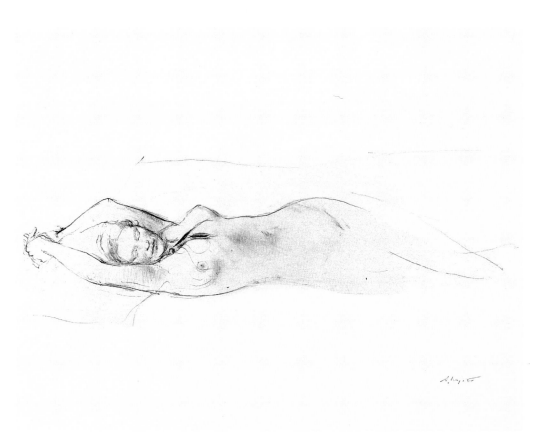

49

BLACK VELVET

63

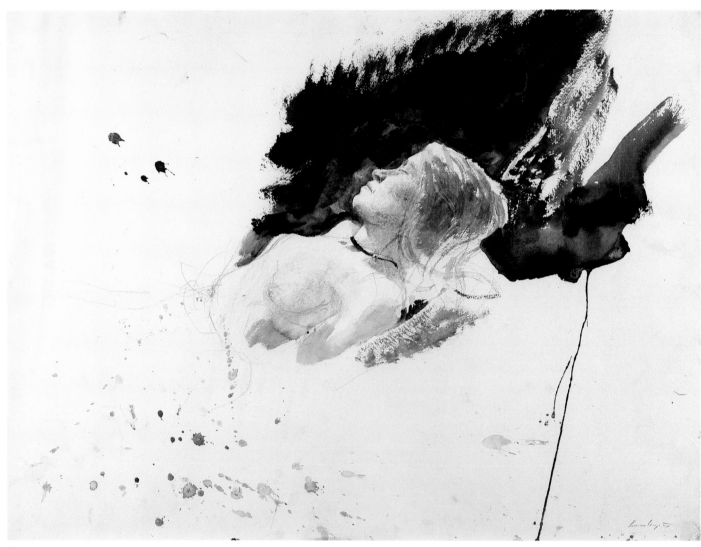

50

BLACK VELVET

64

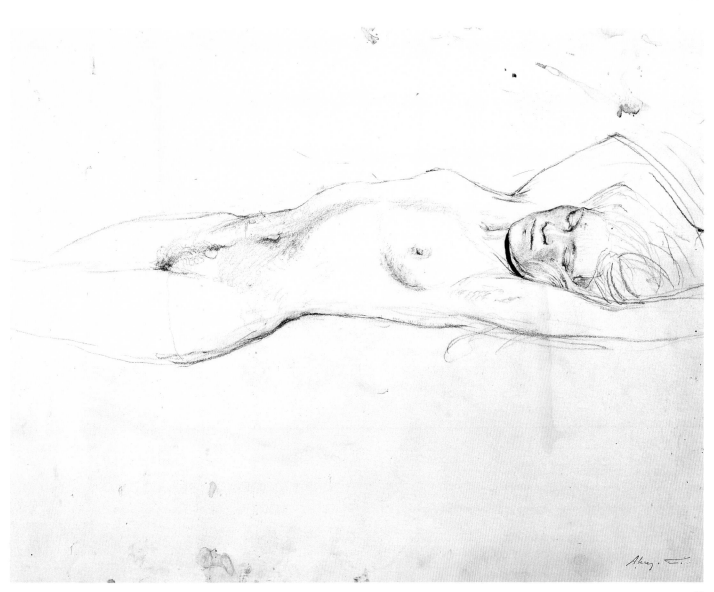

51

BLACK VELVET

SHEEPSKIN

The thing that makes me hang on to tempera is that if a picture does come off, it has a power and a solidity nothing else has; and there's a schematic quality about pure tempera that I like.

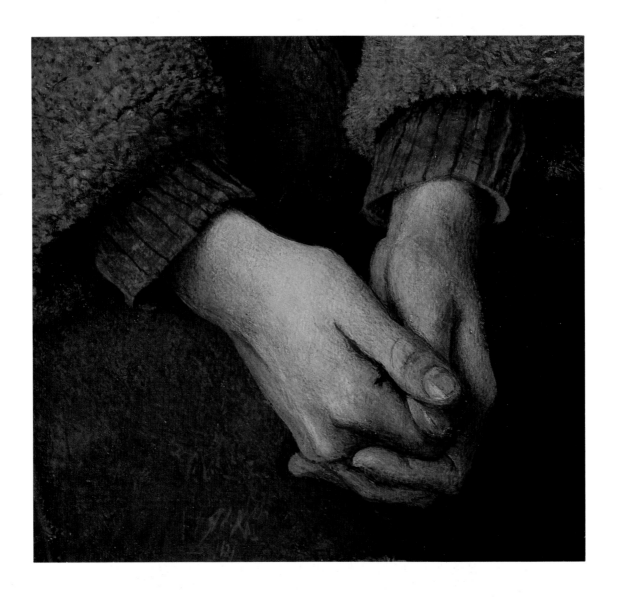

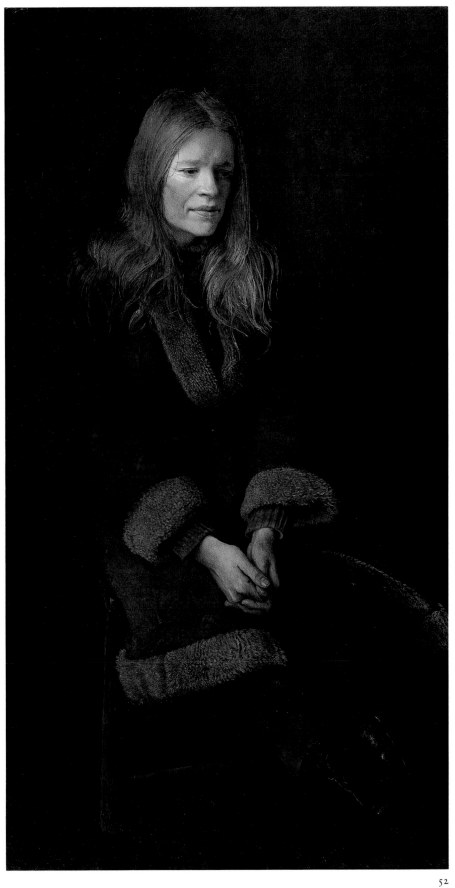

SHEEPSKIN

67

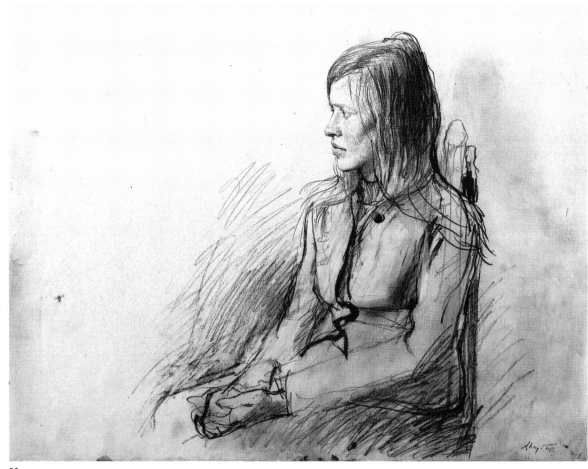

53

54

SEATED BY A TREE

I think anything like that —
which is contemplative, silent, shows a person alone —
people always feel is sad. Is it because we've lost the art of being alone?

55

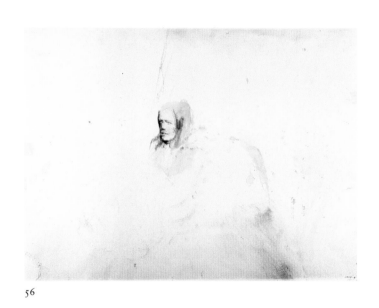

56

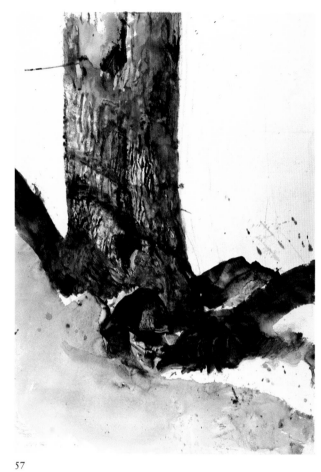

57

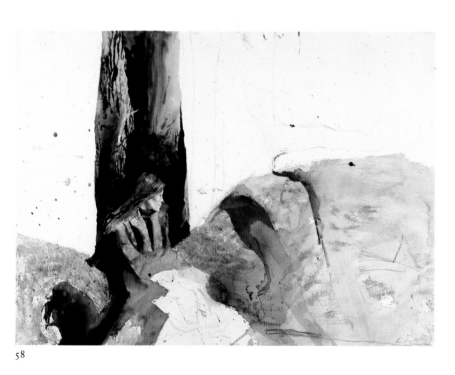

58

SEATED BY A TREE

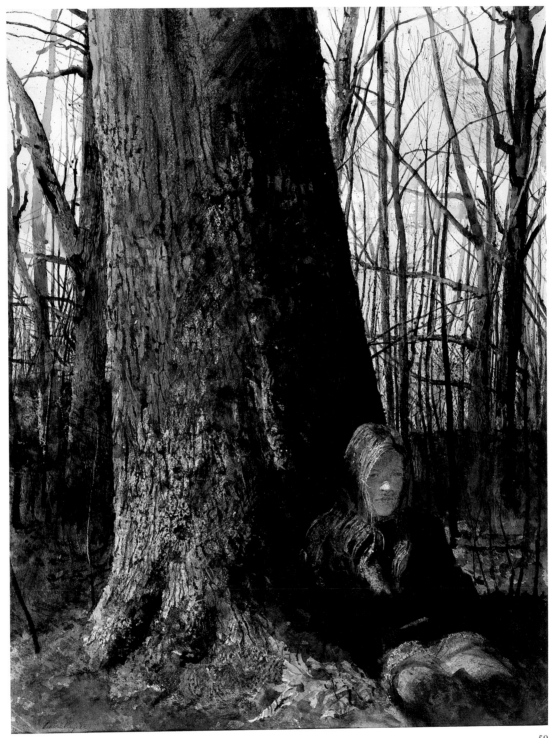

59

SEATED BY A TREE

71

THE PRUSSIAN

To my mind the master is the one who can simultaneously
give the effect of simplicity and restraint –
yet you can go right up to it and explore it endlessly with the greatest joy.

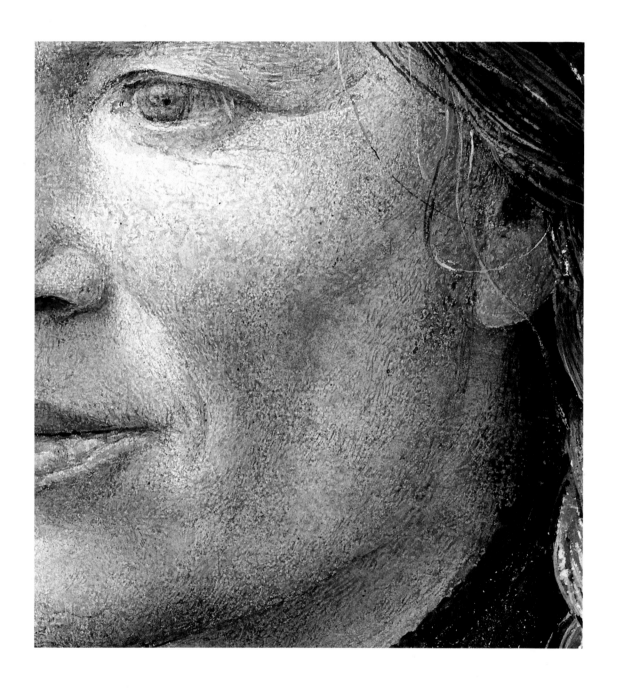

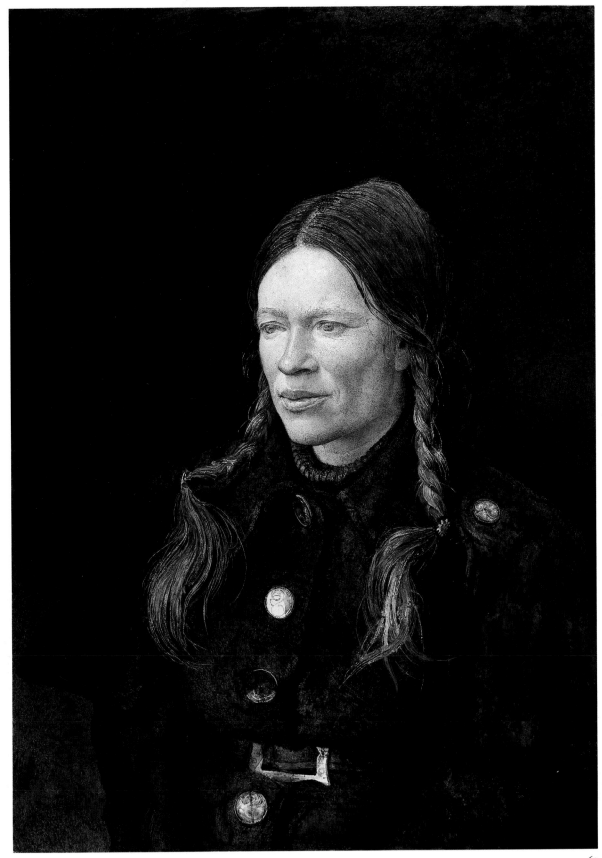

60

THE PRUSSIAN

73

CROWN OF FLOWERS

I have such a strong romantic fantasy about things – and that's what I paint, but come to it through realism. If you don't back up your dreams with truth, you have a very round-shouldered art.

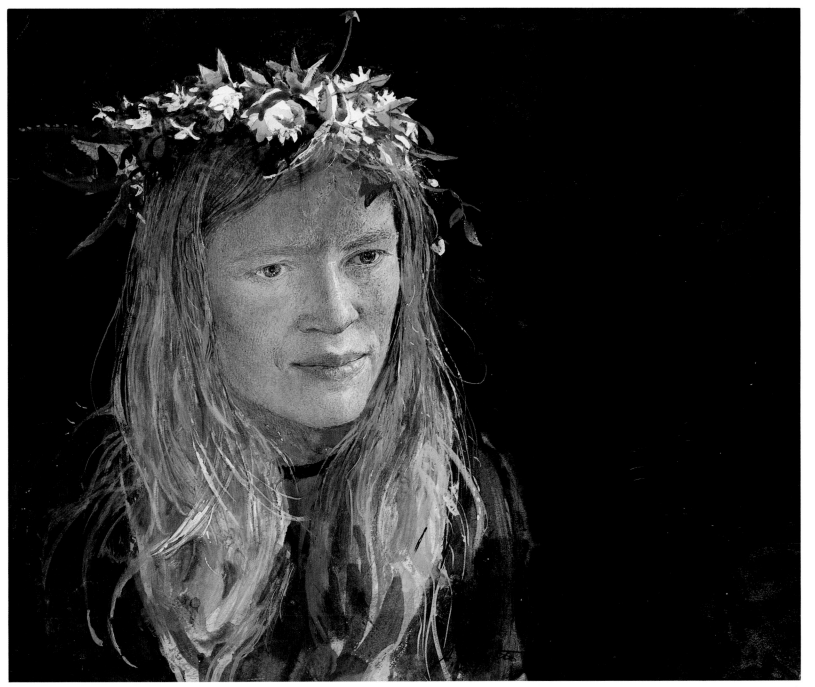

61

CROWN OF FLOWERS

75

HER HEAD

I am continuously seeking, trying out new ways. It utterly absorbs me.
I am continually producing drawings, although most of them don't ever
develop into anything because I get another idea of something that is better
than that initial, sharp, idea.

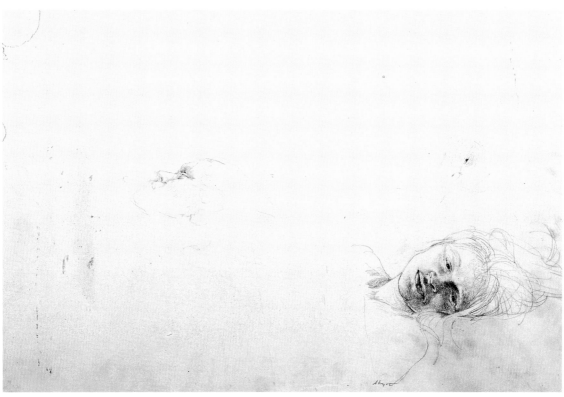

62

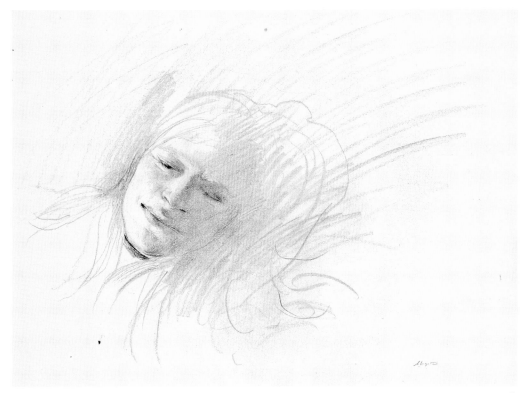

63

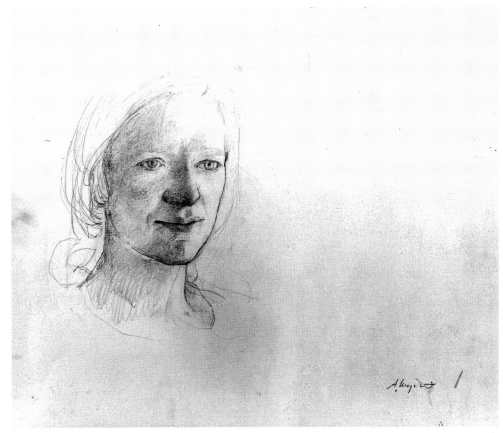

64

HER HEAD

65

66

67

68

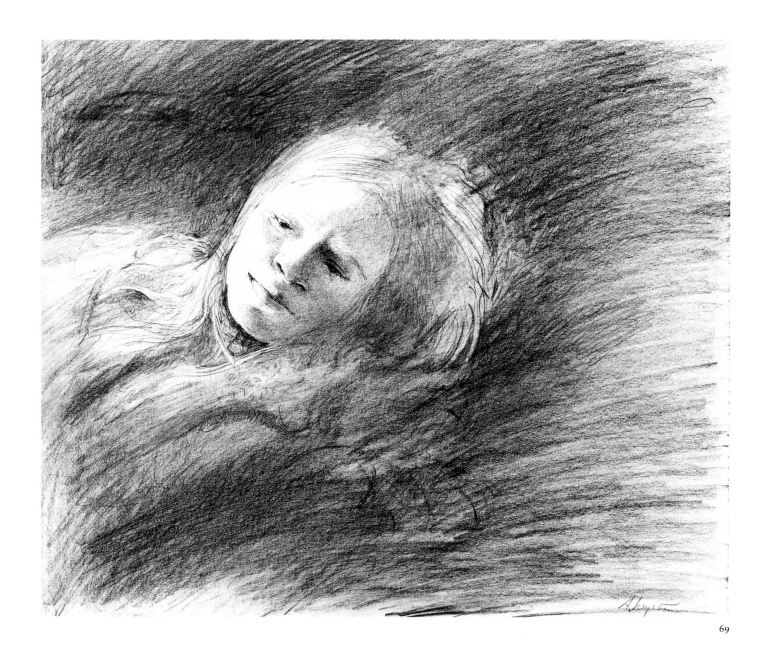

69

HER HEAD

NUDES

If somehow I can, before I leave this earth, combine my absolutely mad freedom and excitement with truth, then I will have done something.

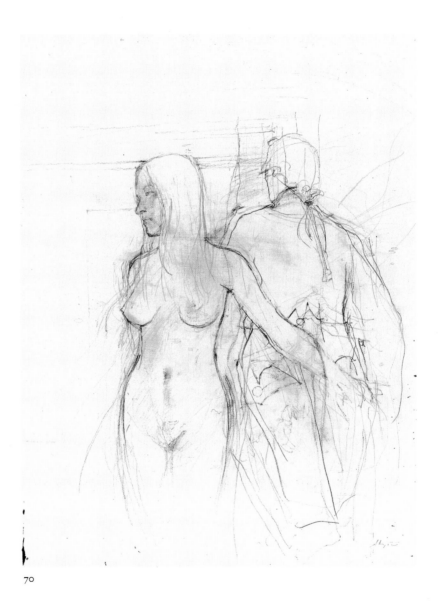

70

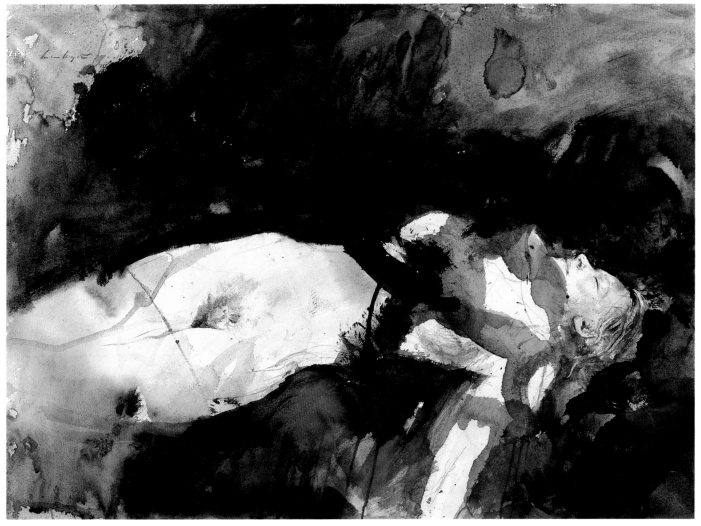

NUDES

72

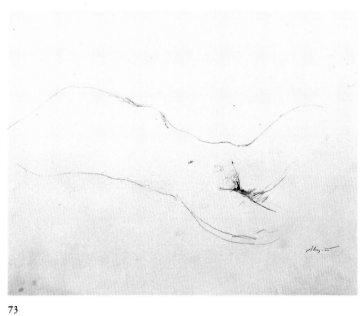

73

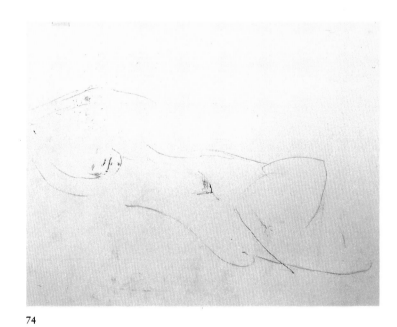

74

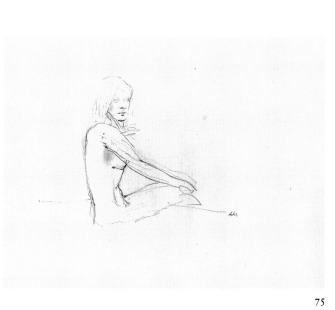

75

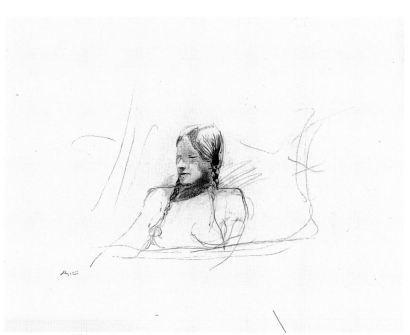

76

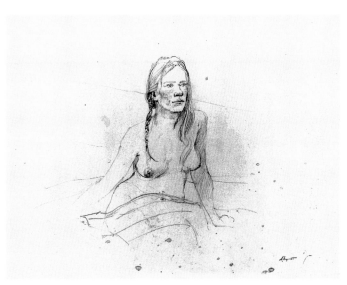

77

NUDES

83

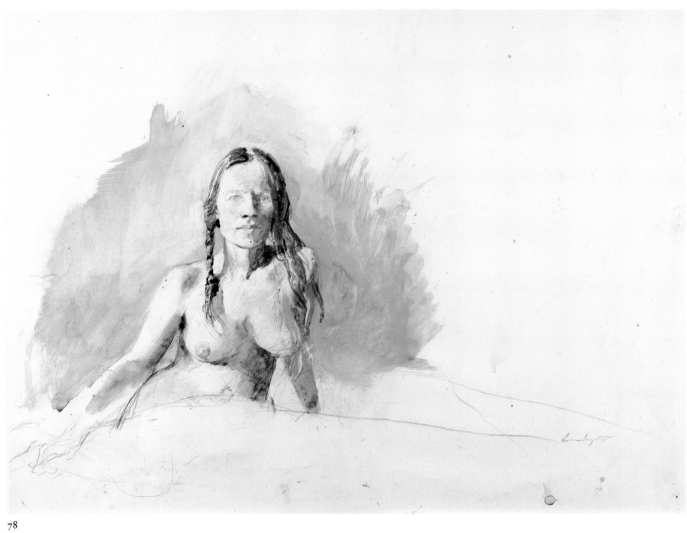

78

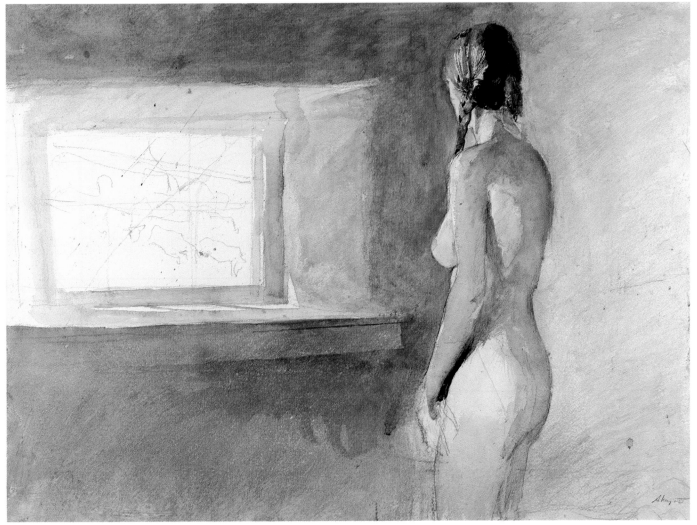

79

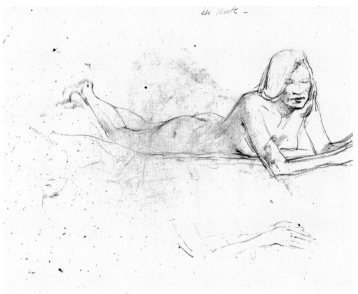

80

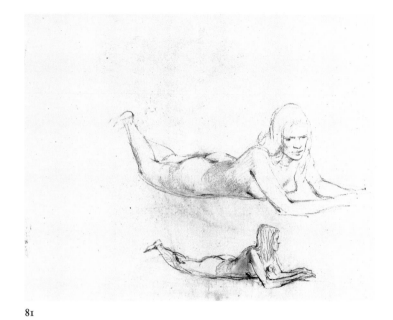

81

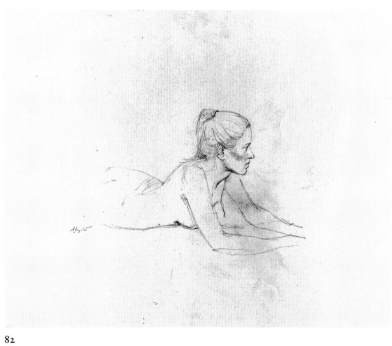

82

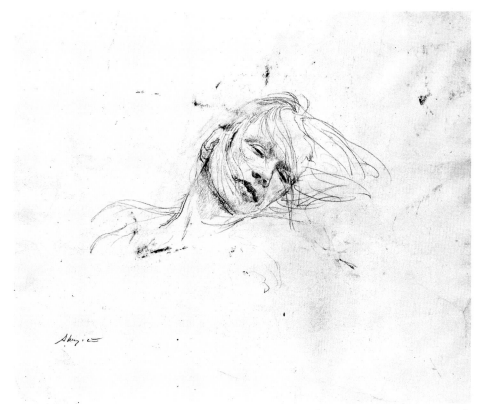

83

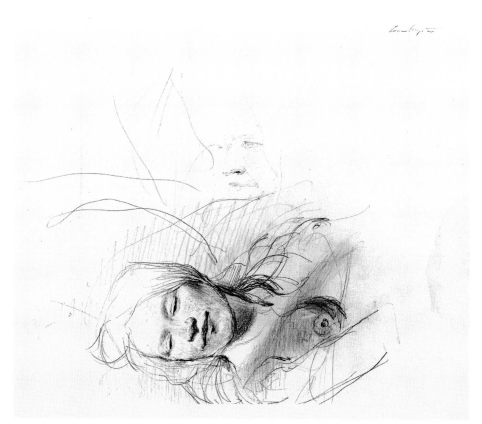

84

NUDES

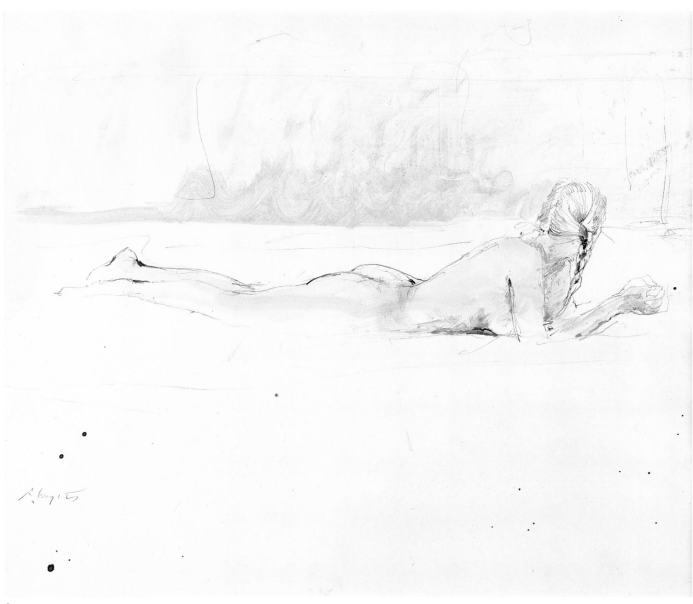

85

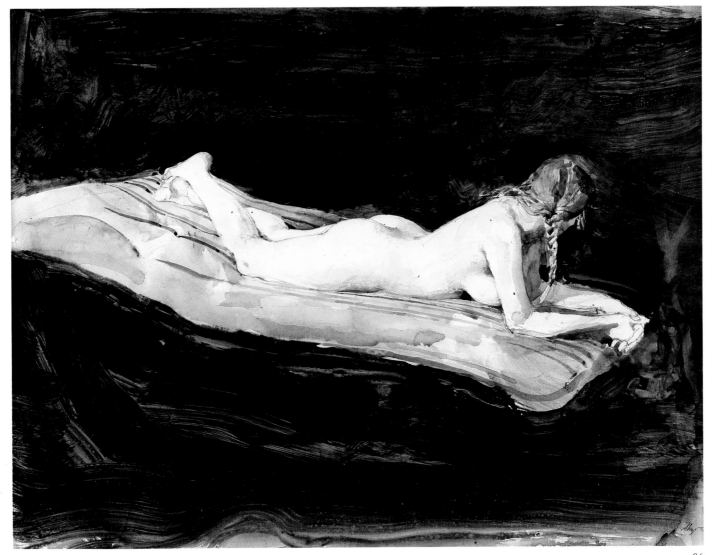

86

EASTER SUNDAY

I've had people say, why paint American landscapes?
There's no depth in it – you have got to go to Europe
before you can get any depth. To me that's inane.
If you want something profound, the American countryside is exactly the place.

87

EASTER SUNDAY

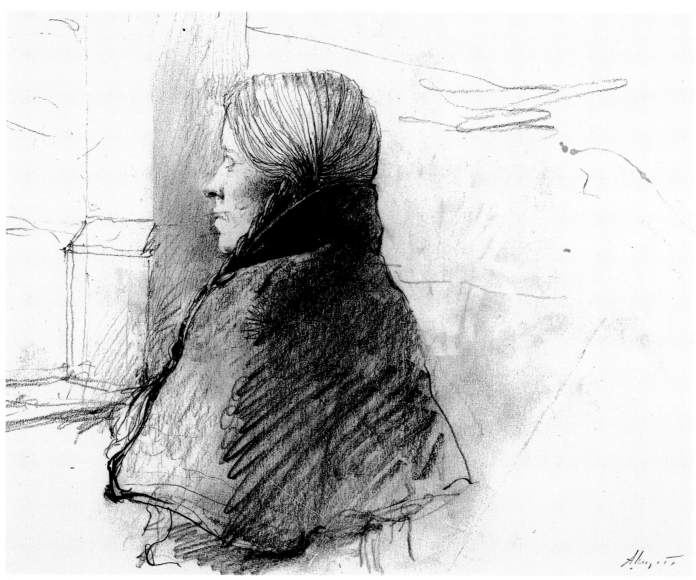

89

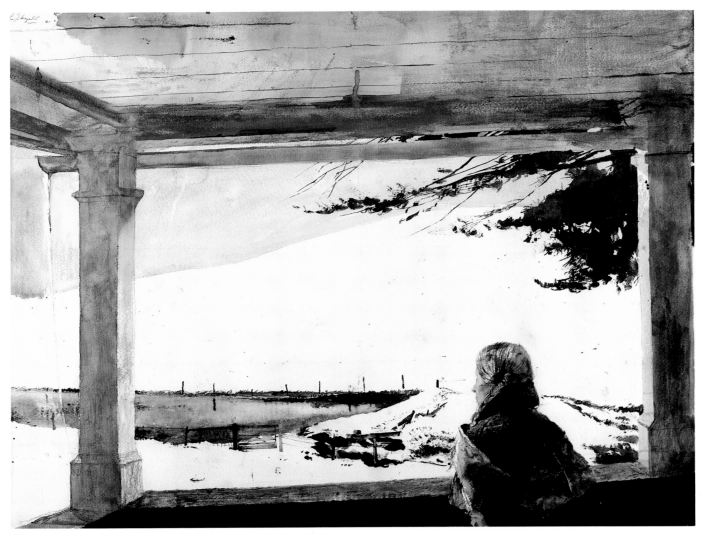

90

EASTER SUNDAY

93

ASLEEP

There are always new emotions in going back to something that I know very well.
I suppose this is very odd, because most people have to find fresh things to paint.
I'm actually bored by fresh things to paint.

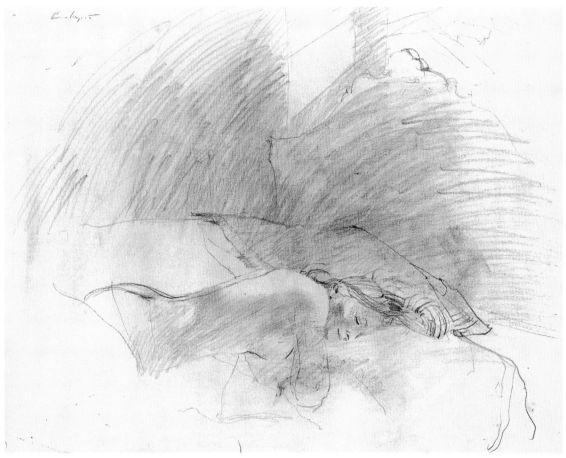

91

92

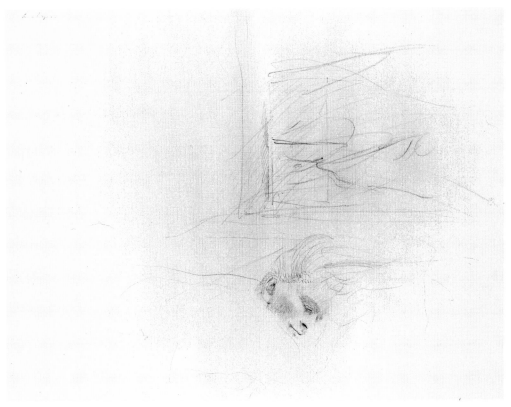

93

ASLEEP

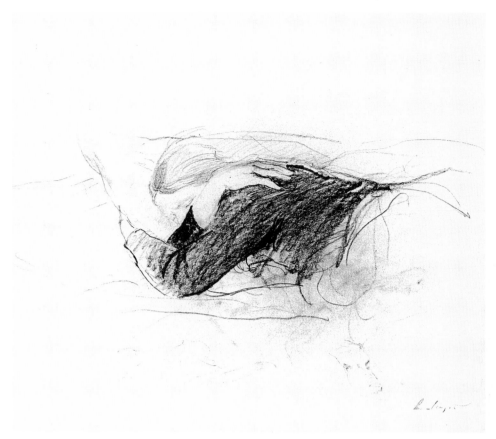

94

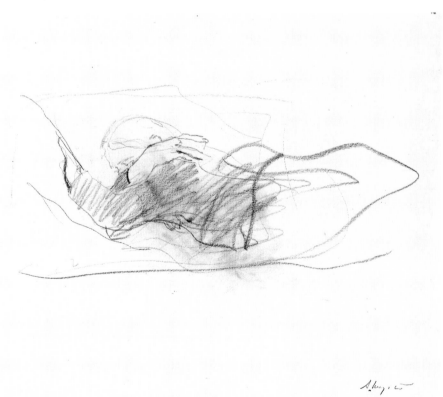

95

ASLEEP

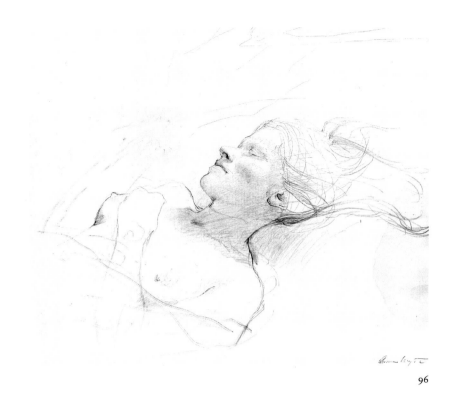

96

97

98

ASLEEP

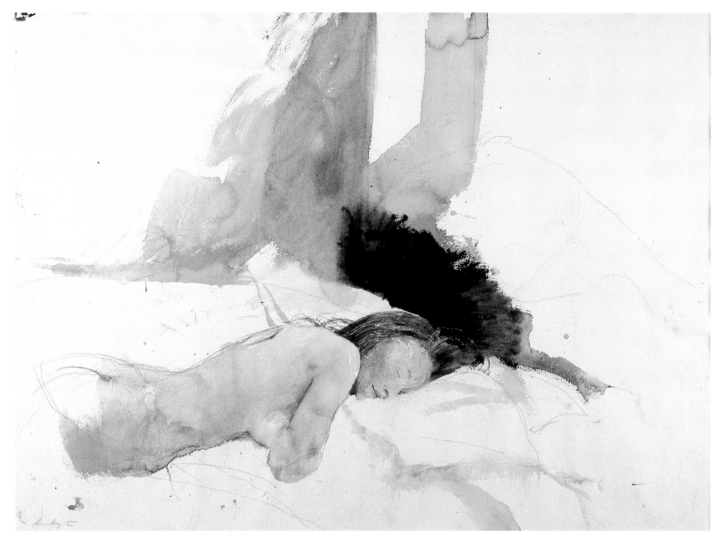

99

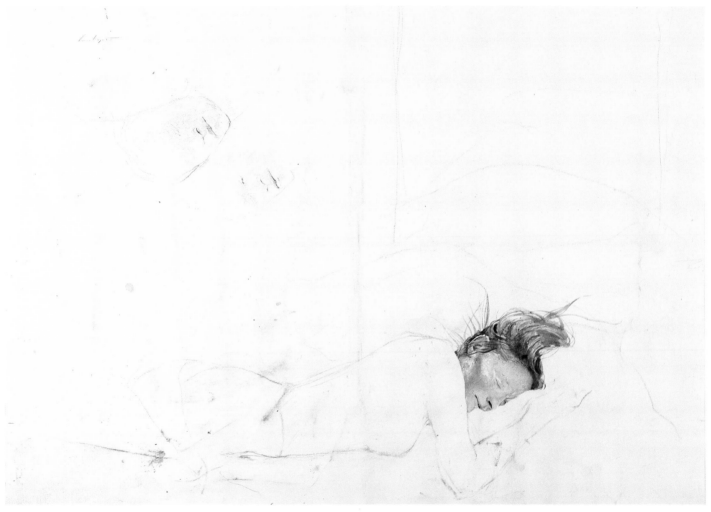

100

ASLEEP

101

102

103

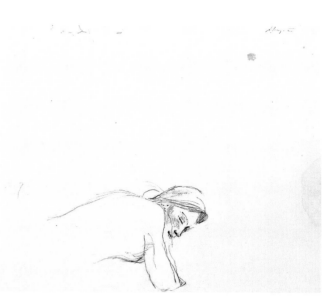

104

105

ASLEEP

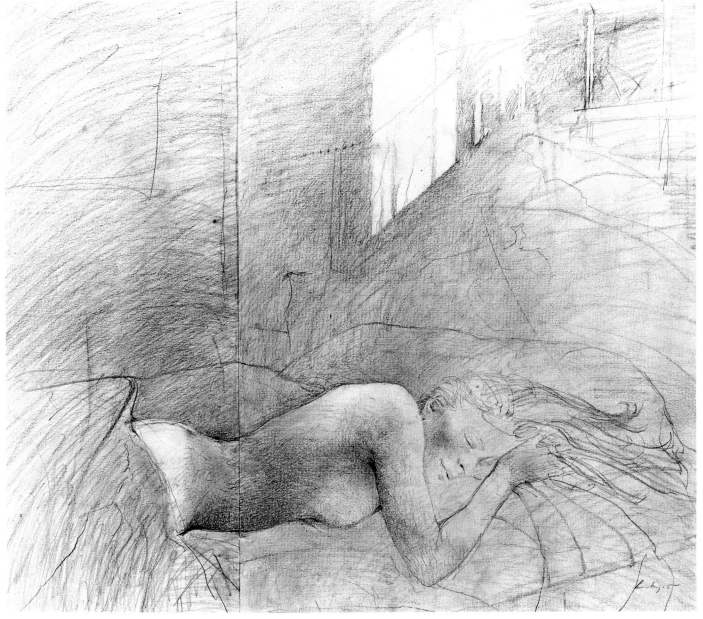

106

ASLEEP

101

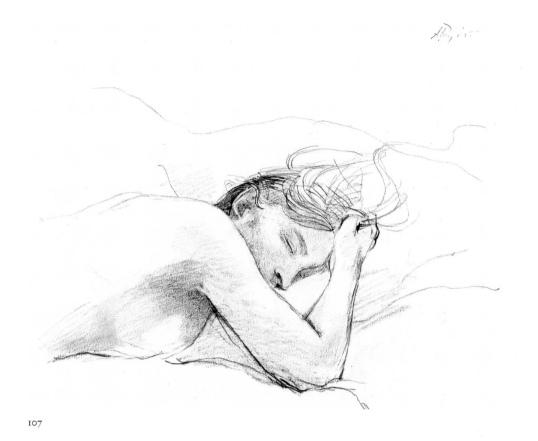

107

108

ASLEEP

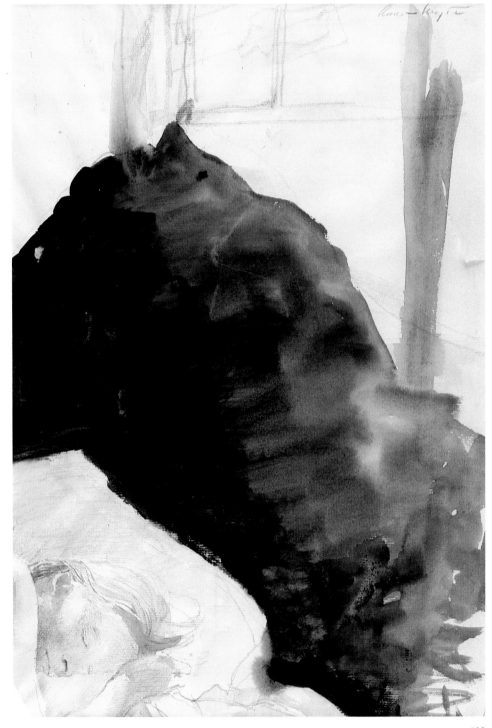

109

ASLEEP

103

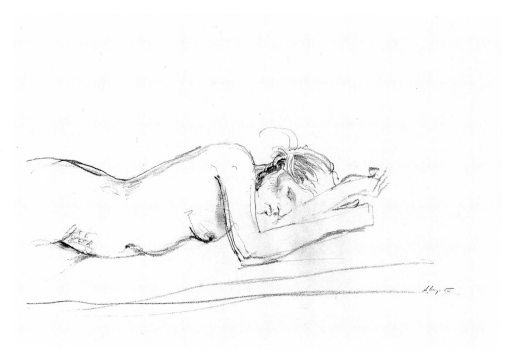

110

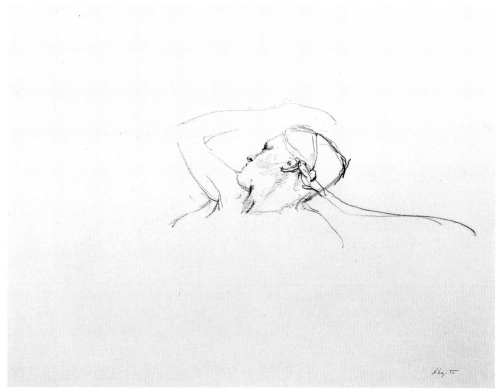

111

ASLEEP

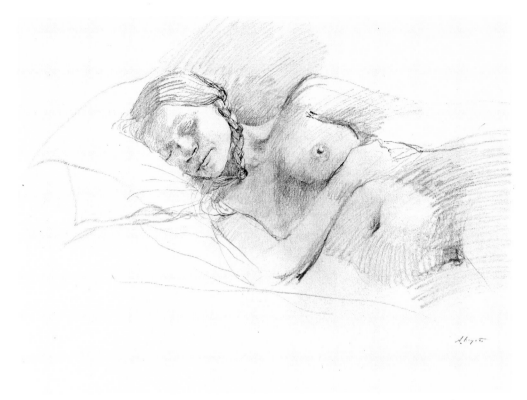

112

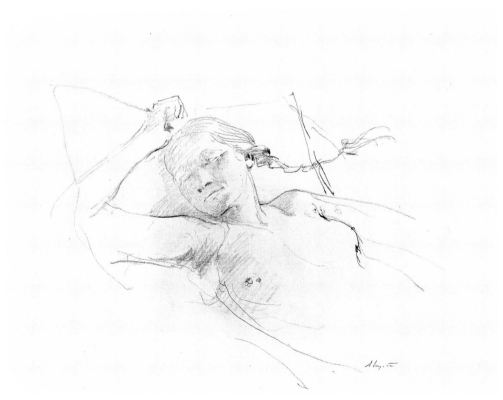

113

ASLEEP

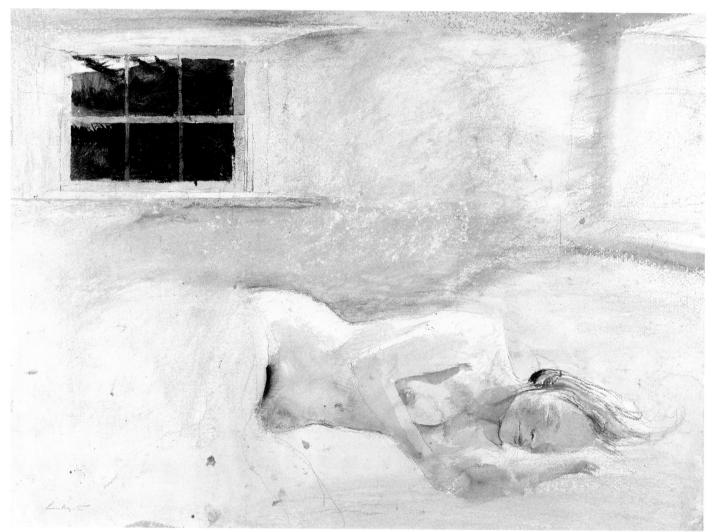

114

ASLEEP

106

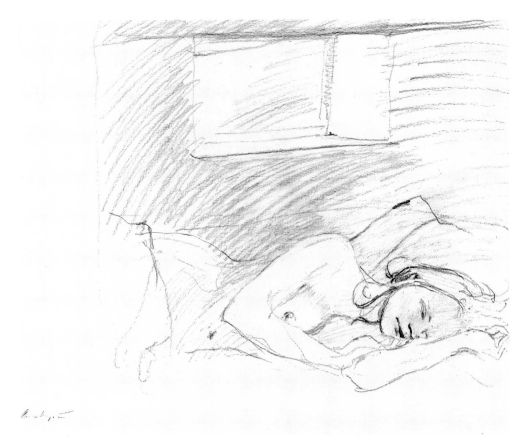

115

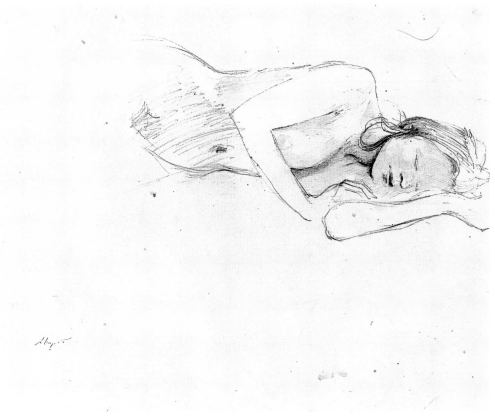

116

ASLEEP

107

117

118

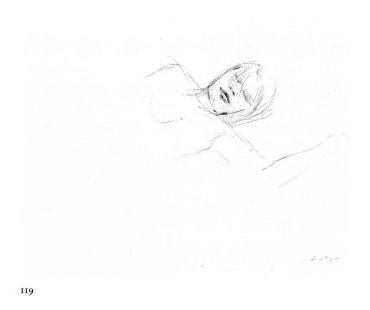

119

120

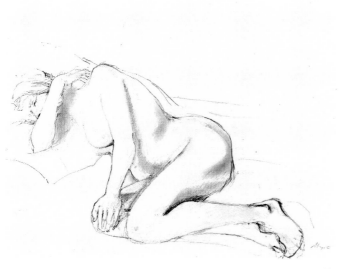

121

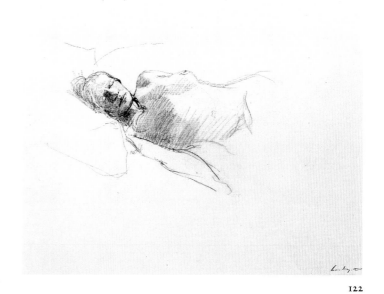

122

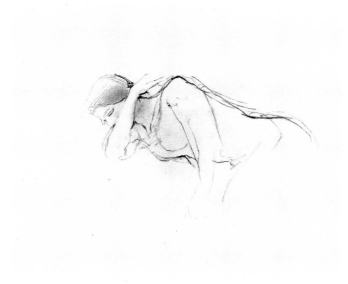

123

ASLEEP

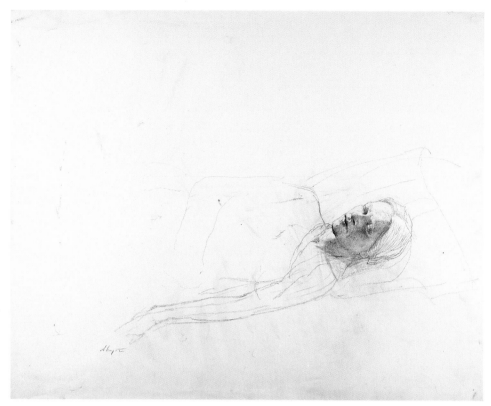

124

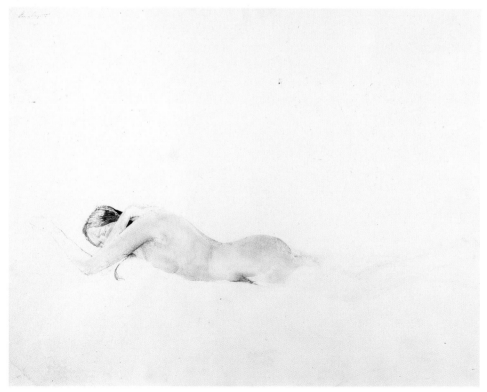

125

BARRACOON

The way I *feel* about things is so much better than the way I've been able to paint them.
The image I had in my head before I started is not quite – never quite –
completely conveyed in paint.

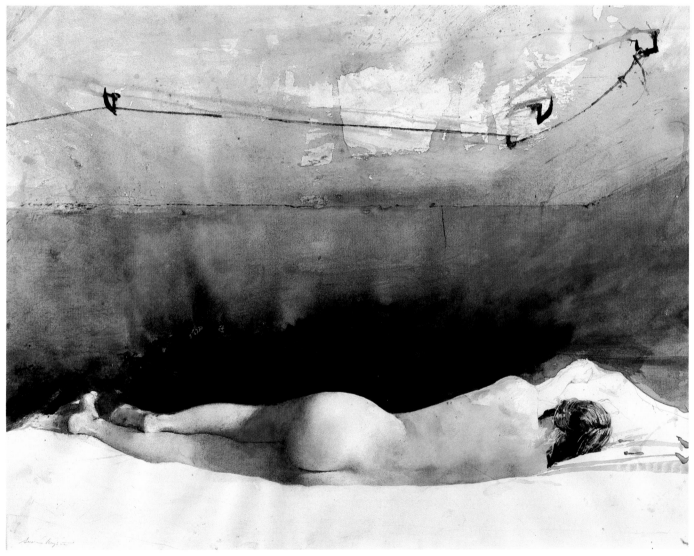

126

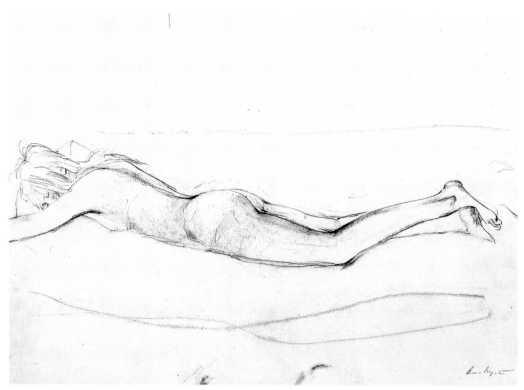

127

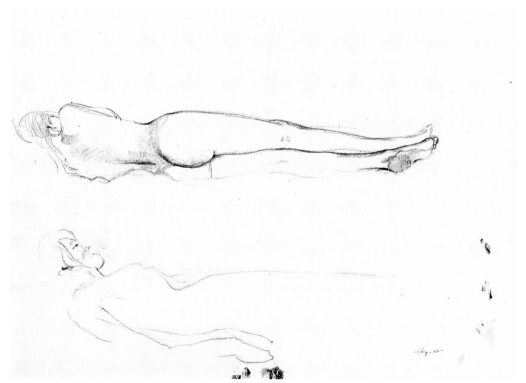

128

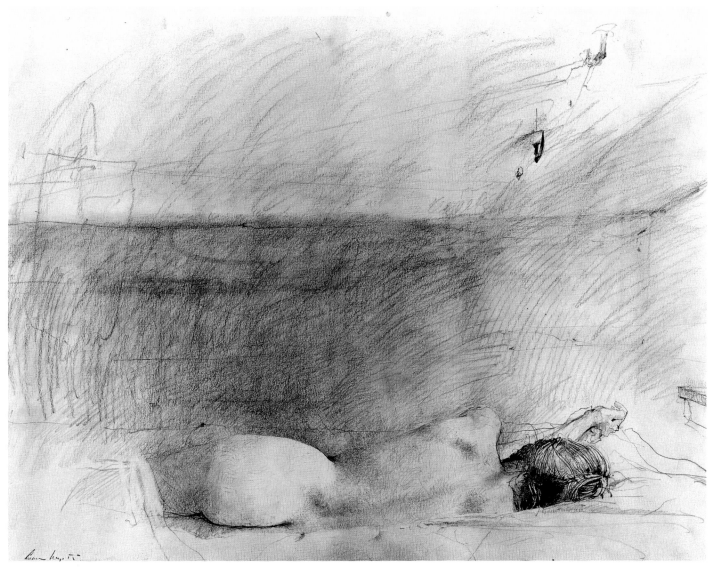

129

ON HER KNEES

In finding this one object, I find a world. I think a great painting is a painting that funnels itself in and then funnels out, spreads out. I enter in a very focused way and then I go through it and way beyond it.

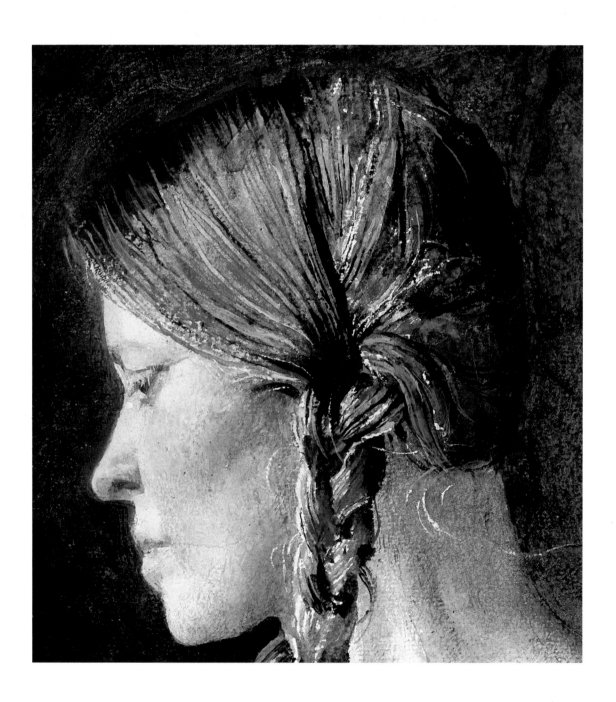

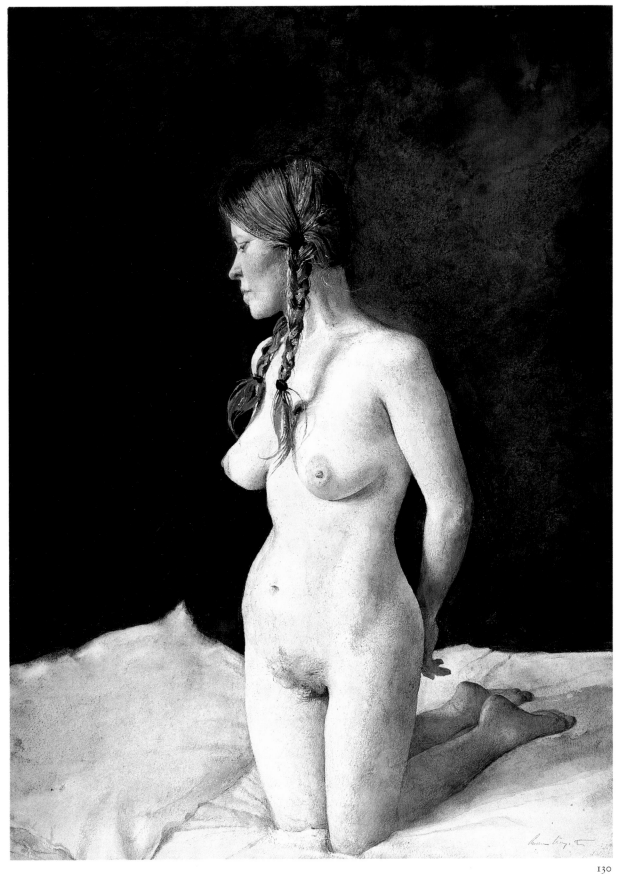

ON HER KNEES

131

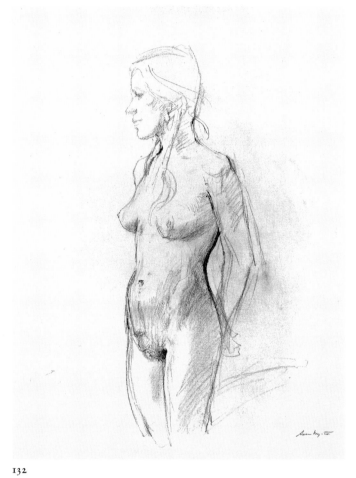

132

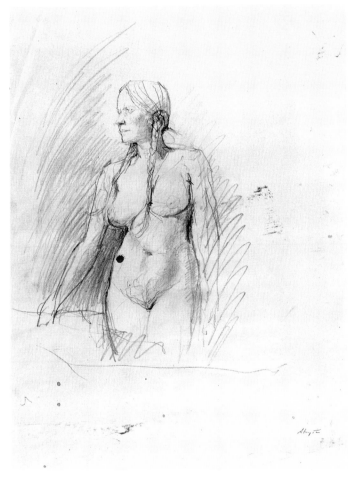

133

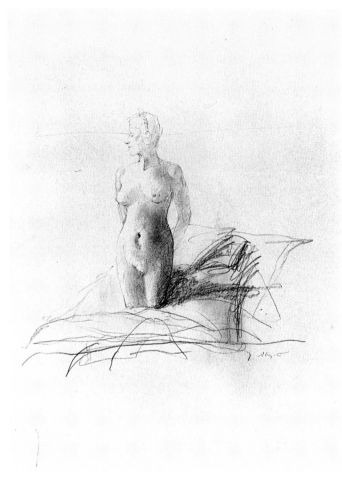

134

ON HER KNEES

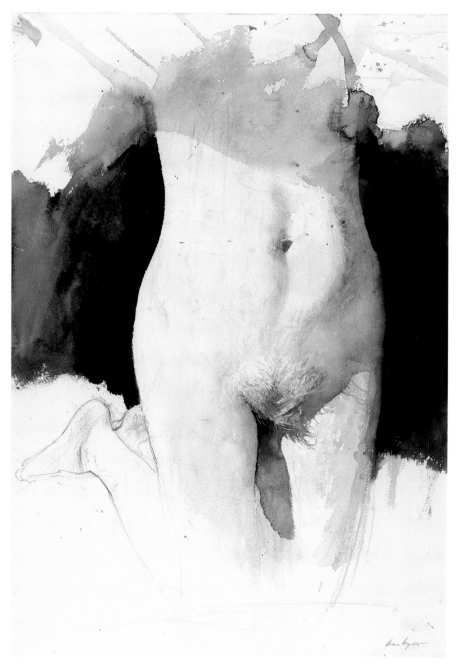

135

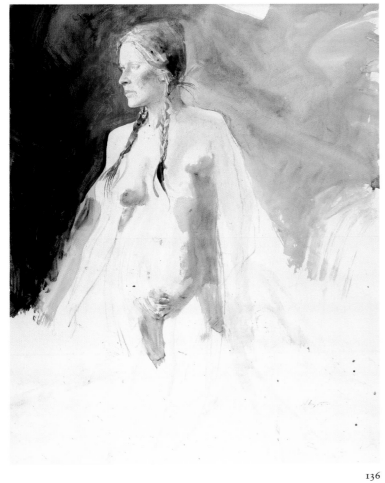

136

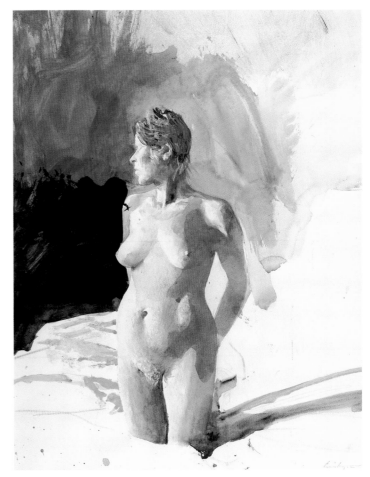

137

ON HER KNEES

119

138

ON HER KNEES

120

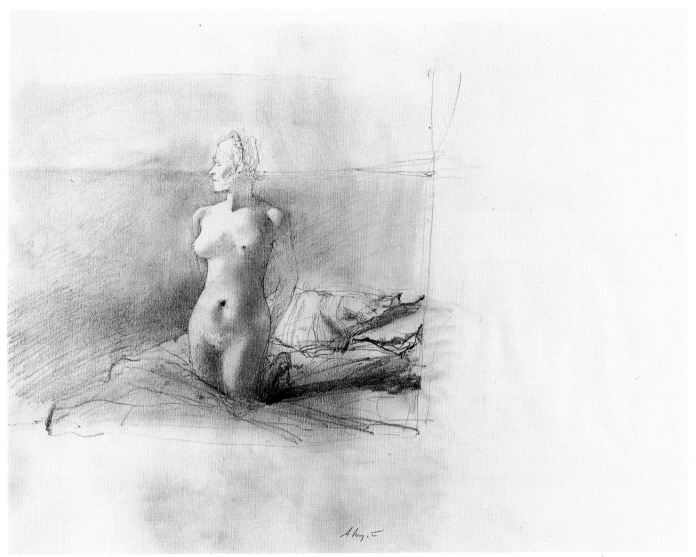

139

ON HER KNEES

DRAWN SHADE

People talk to me about the mood of melancholy in my pictures.
Now, I do have this feeling that time passes –
a yearning to hold something – which might strike people as sad.

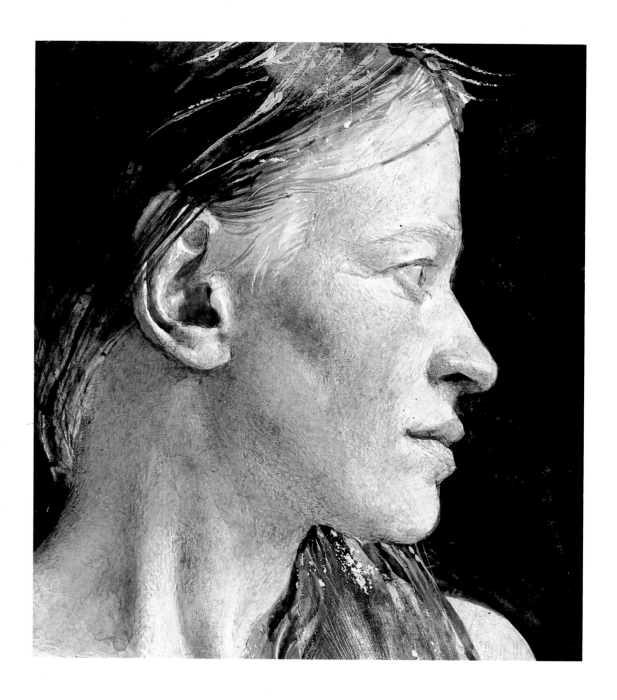

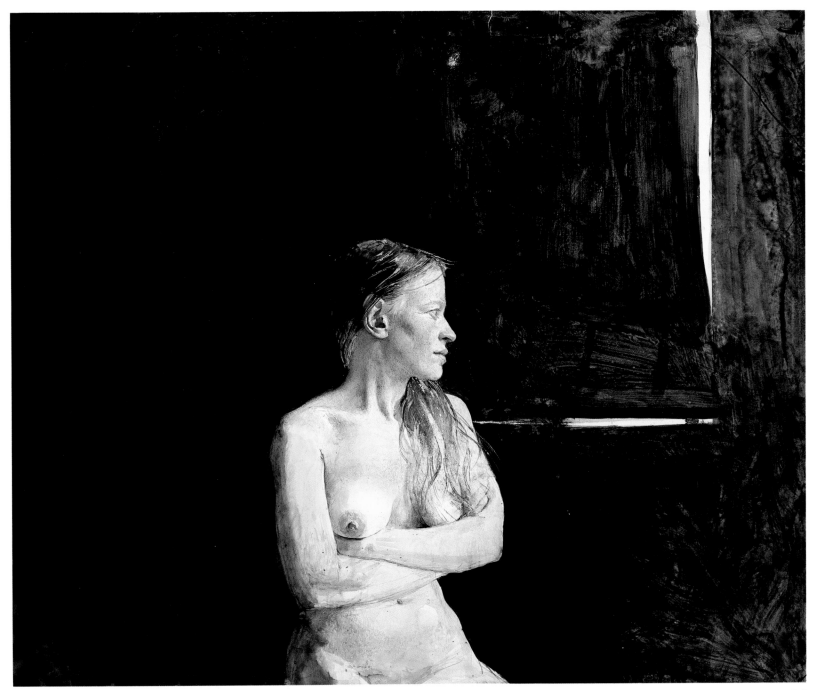

DRAWN SHADE

123

141

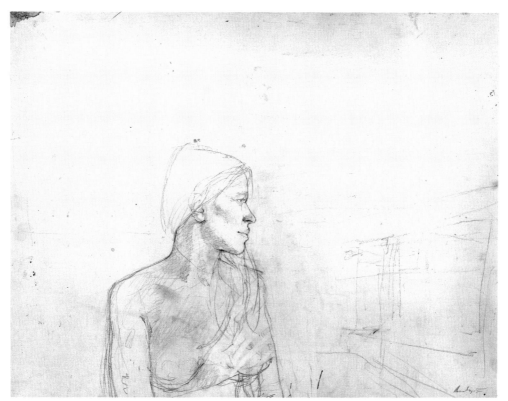

142

DRAWN SHADE

124

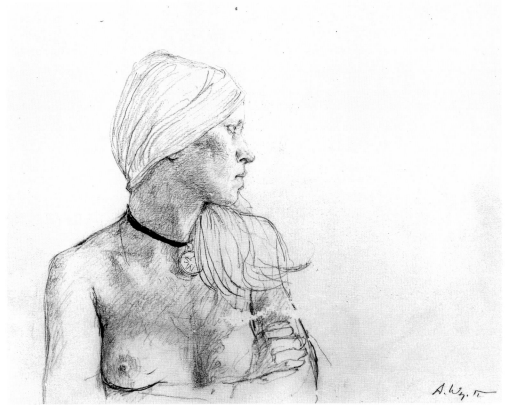

143

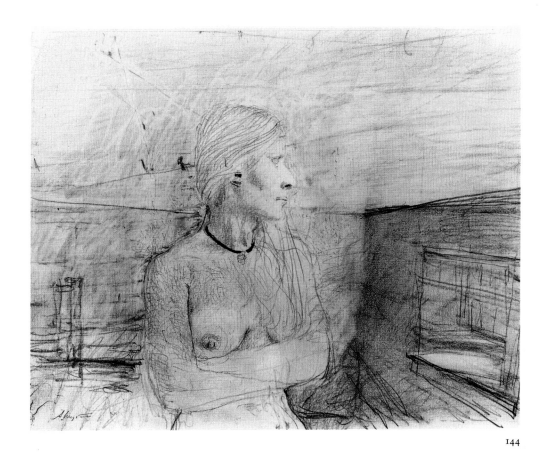

144

DRAWN SHADE

125

OVERFLOW

I think one's art goes as far and as deep as one's love goes.

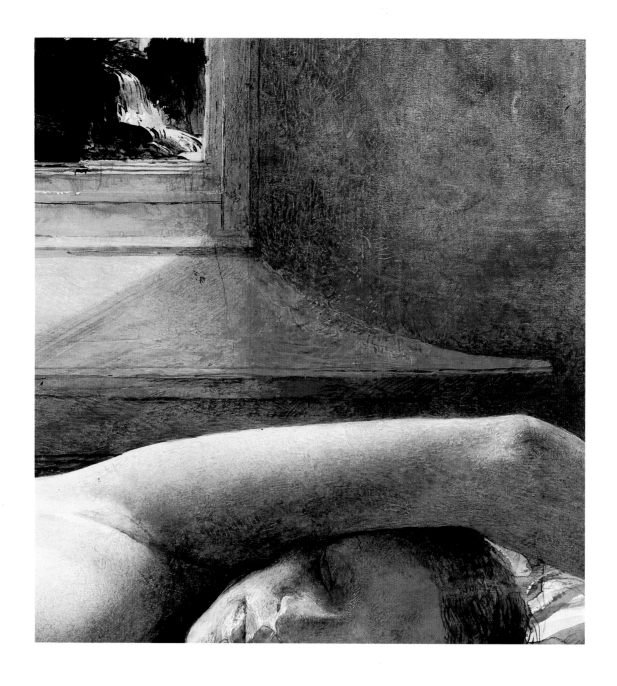

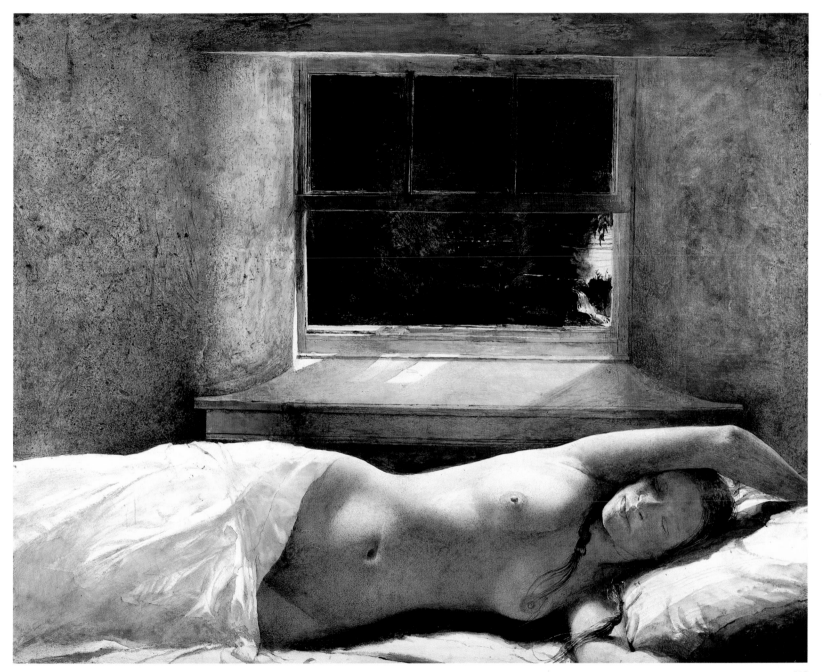

145

OVERFLOW

127

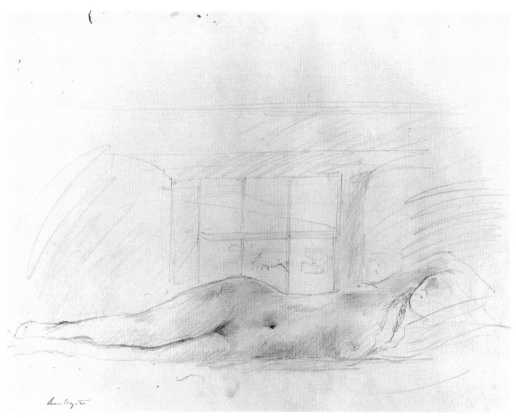

146

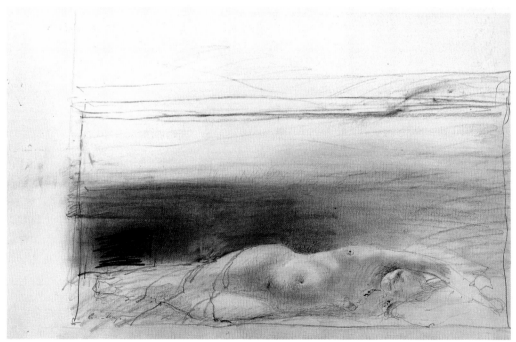

147

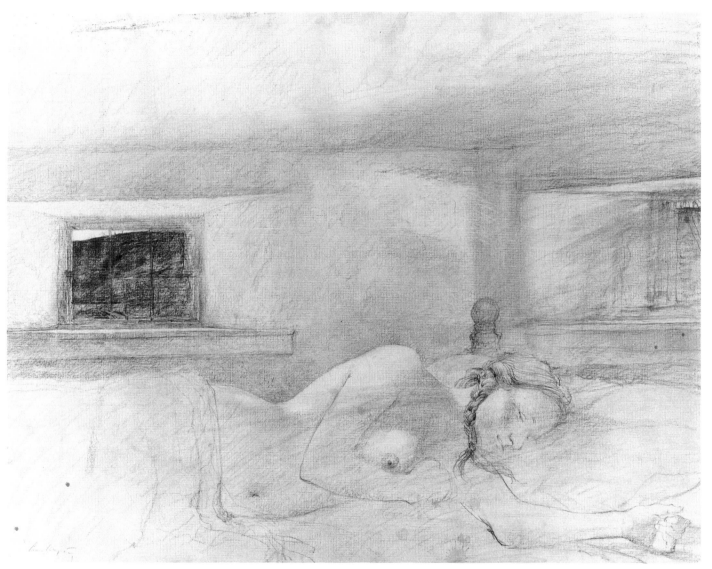

148

OVERFLOW

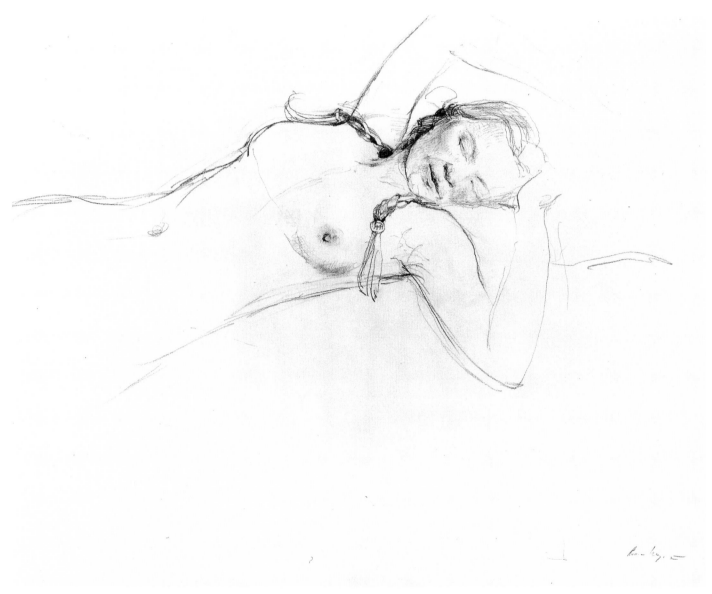

149

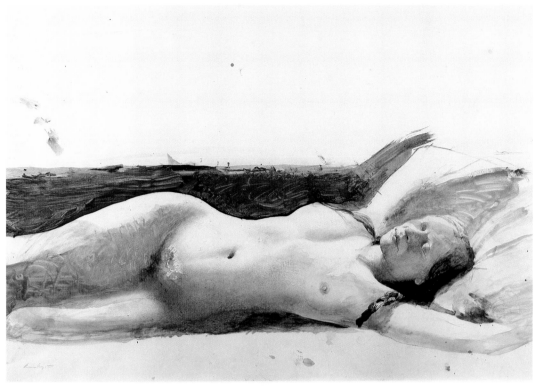

150

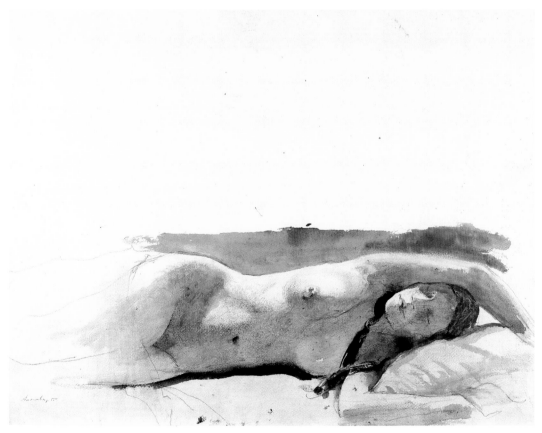

151

OVERFLOW

131

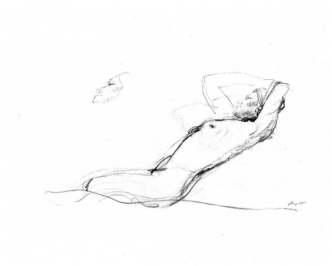

152

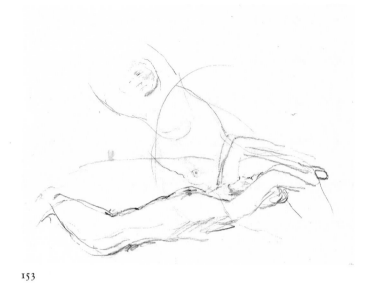

153

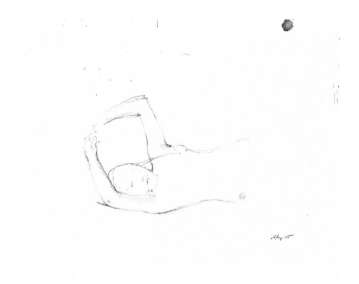

154

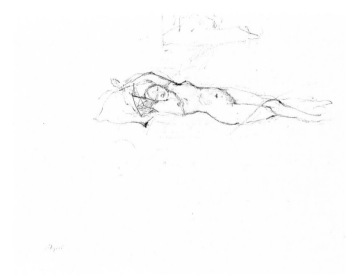

155

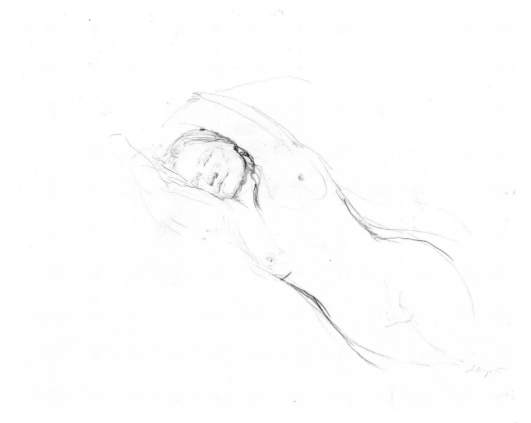

156

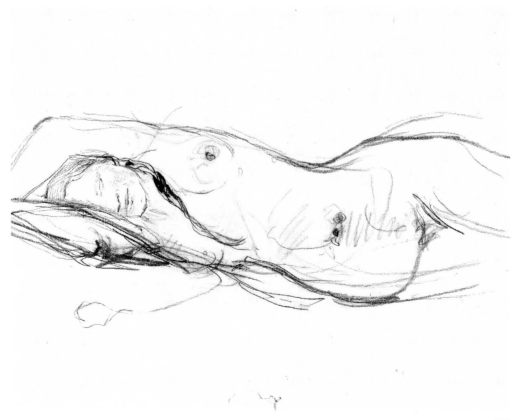

157

OVERFLOW

133

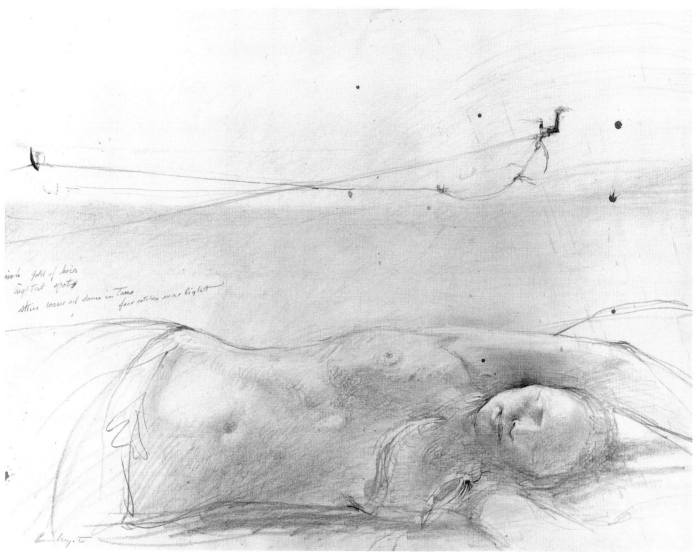

158

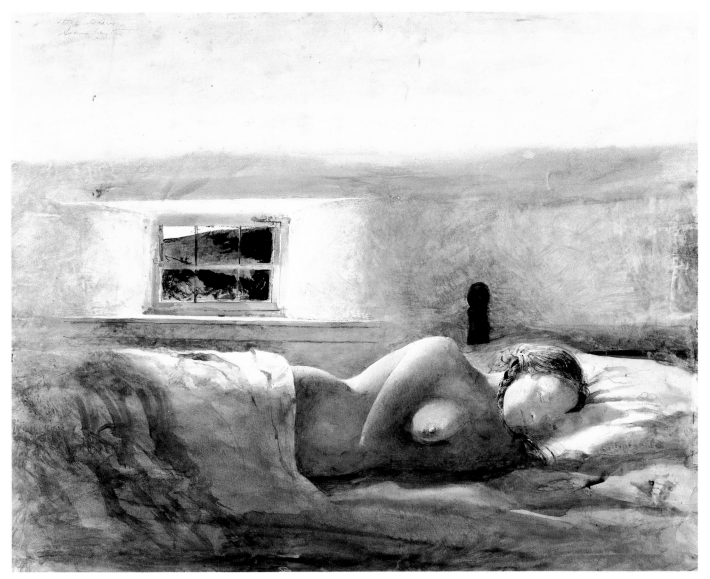

159

OVERFLOW

135

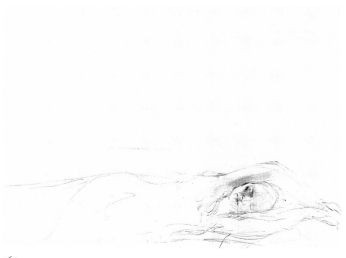

160

161

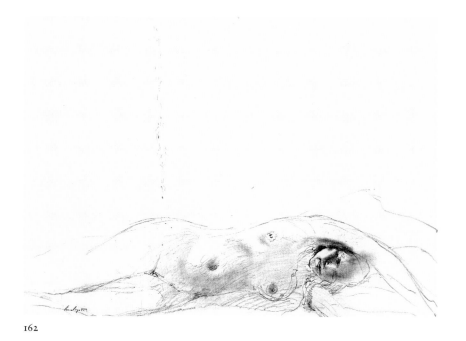

162

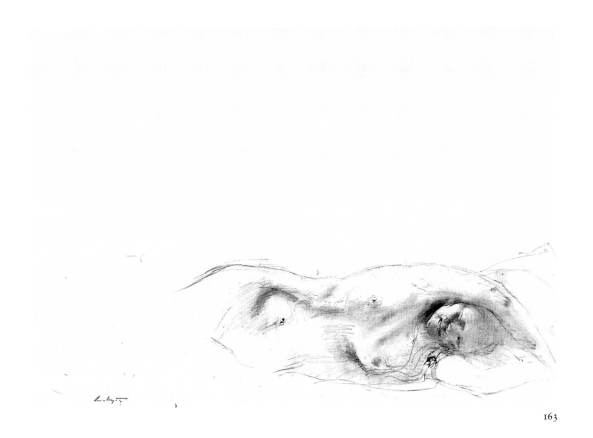

163

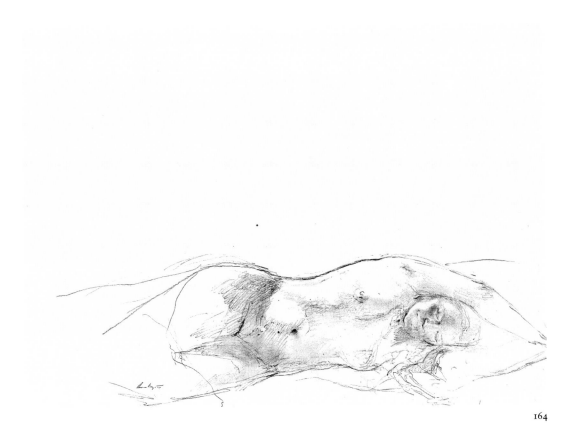

164

OVERFLOW

FARM ROAD

You look at my pictures . . . there's witchcraft and hidden meaning there.
Halloween and all that is strangely tied into them.

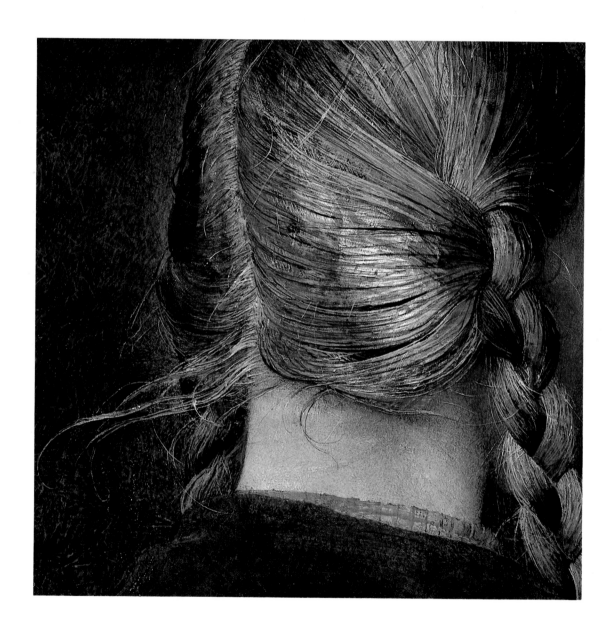

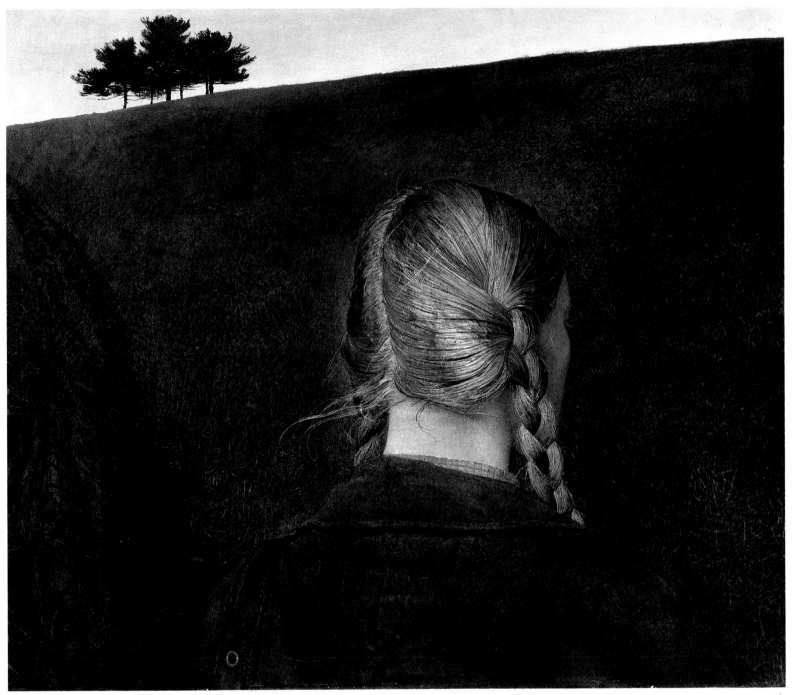

FARM ROAD

139

WALKING IN HER CAPE COAT

I love to study the many things that grow below the corn stalks and bring them back into the studio to study the color. If one could only catch that true color of nature — the very thought of it drives me mad.

166

167

168

WALKING IN HER CAPE COAT

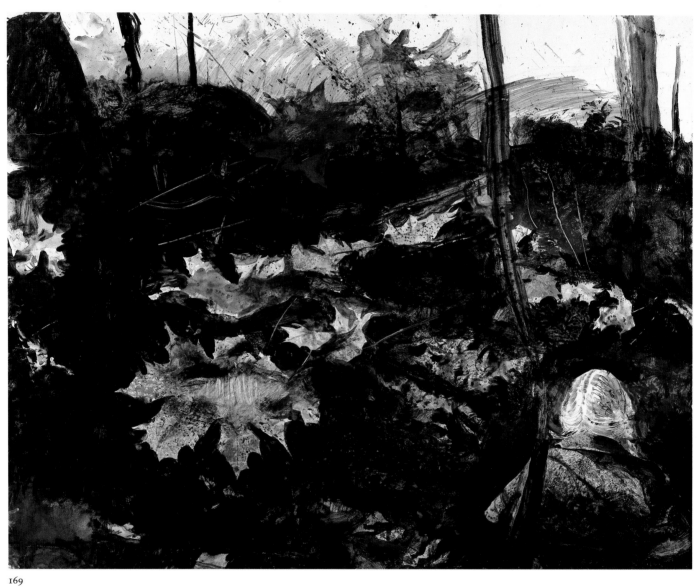

169

LODEN COAT

With watercolor, you can pick up the atmosphere, the temperature, the sound of snow sifting through the trees or over the ice of a small pond or against a windowpane. Watercolor perfectly expresses the free side of my nature.

170

171

LODEN COAT

144

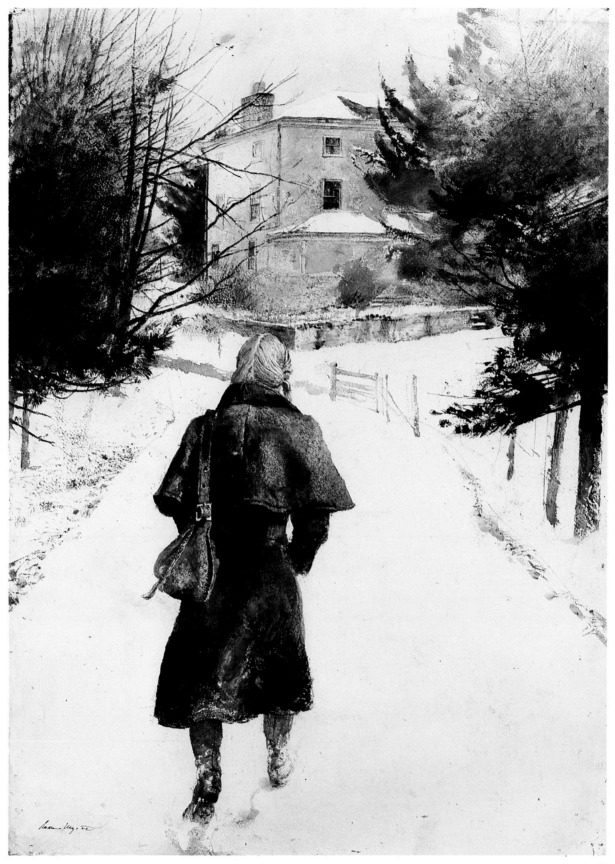

LODEN COAT

145

BRAIDS

I don't think I'm really a portrait painter, because I only use a head to express
something more. And, if a painting stays just a head, I'm not satisfied with it.
If it's an outdoor person, I feel that his countenance reflects the skies
he walks under, the clouds have reflected on his face for his whole life
and I try to get that quality into the portrait.

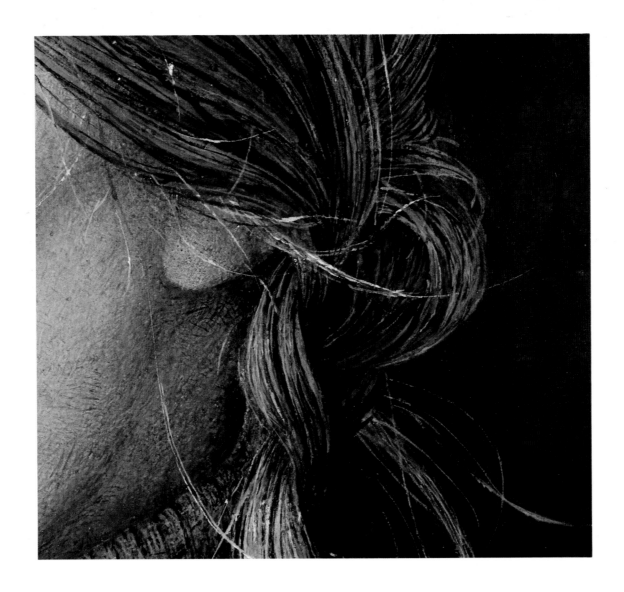

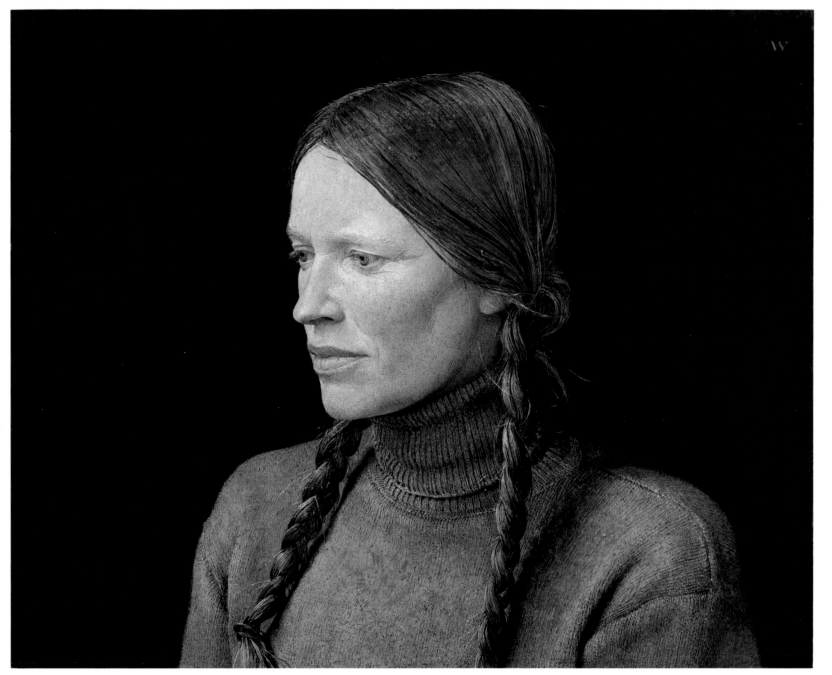

173

BRAIDS

147

174

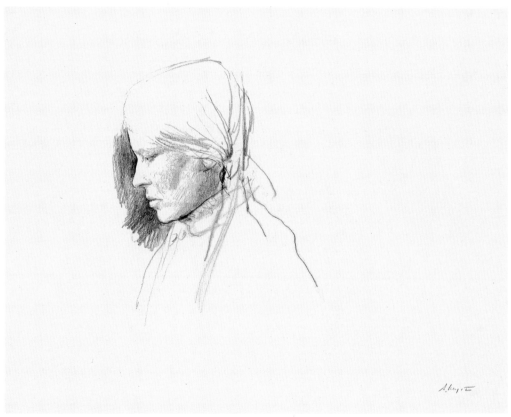

175

BRAIDS

148

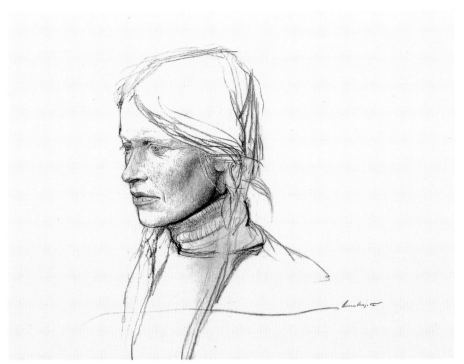

176

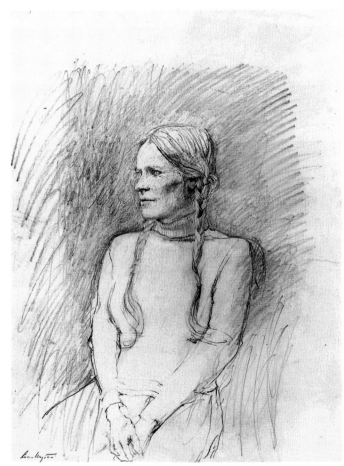

177

BRAIDS

149

NIGHT SHADOW

Night Shadow is abstract – almost primeval.
She could almost be an Indian with that band around her.
I think you feel the involvement when you look at it.

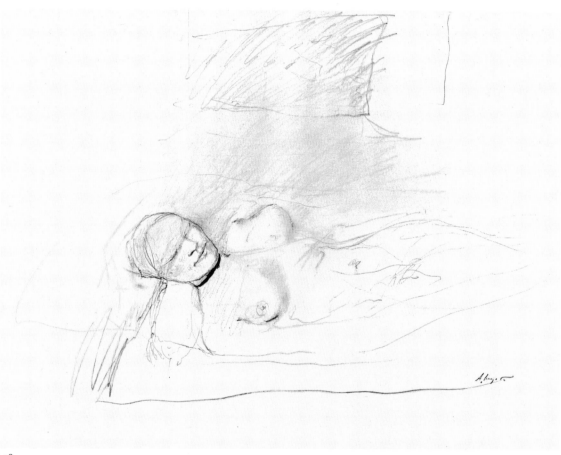

178

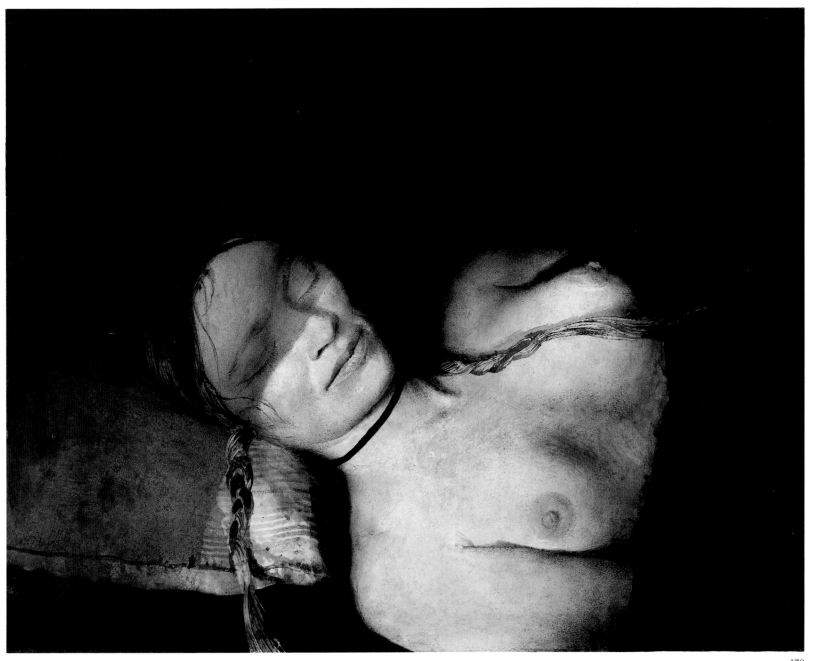

NIGHT SHADOW

151

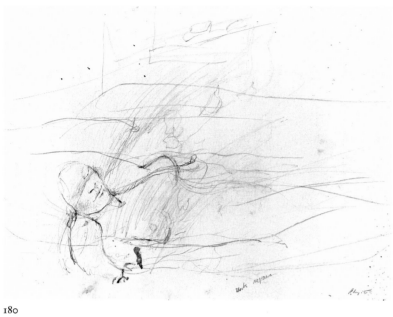

180

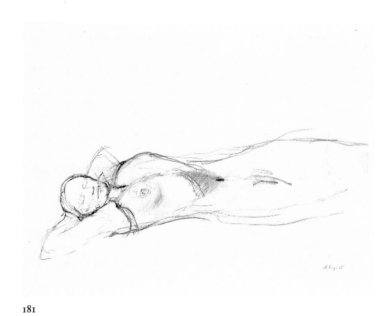

181

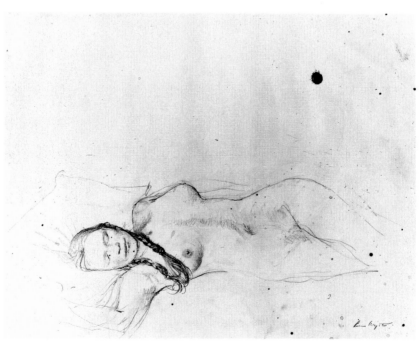

182

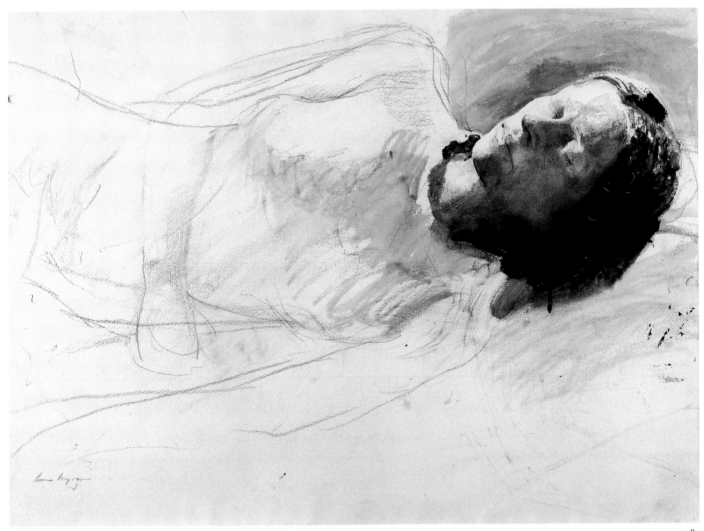

183

NIGHT SHADOW

153

WITH NELL

The commonplace is the thing, but it's hard to find.
Then if you believe in it, have a love for it, this specific thing will become a universal.

184

185

186

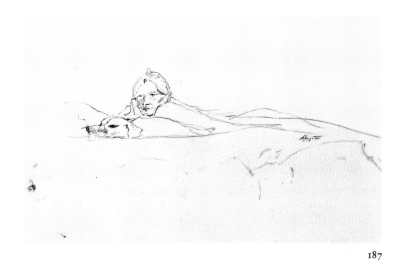

187

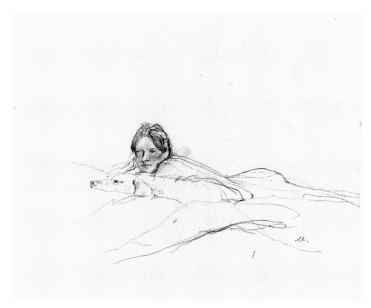

188

WITH NELL

PAGEBOY

Drybrush is layer upon layer.
It is what I would call a definite weaving process.
You weave the layers of drybrush over and within the broad washes of watercolor.

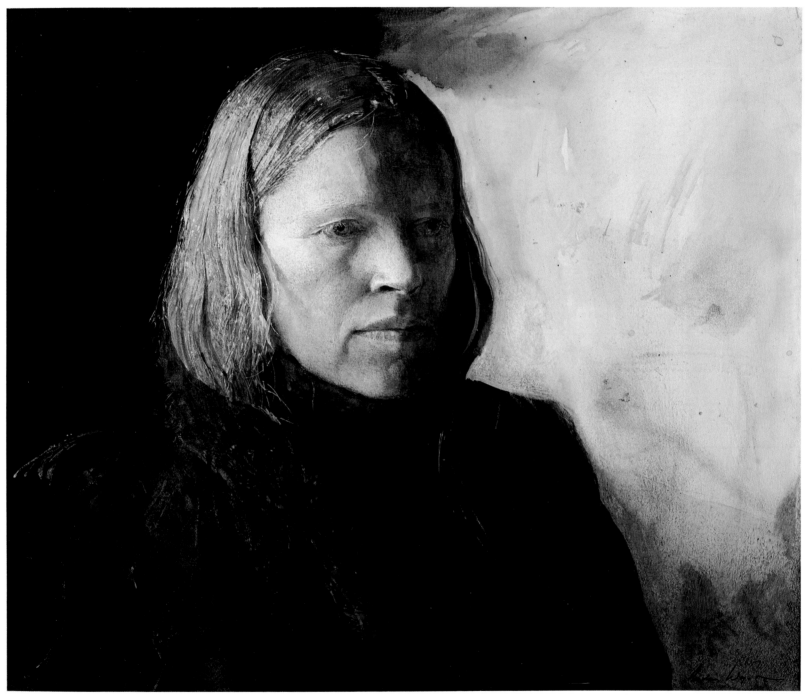

189

PAGEBOY

157

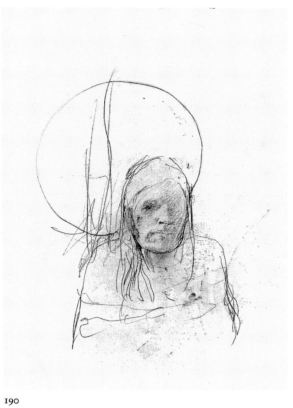

190

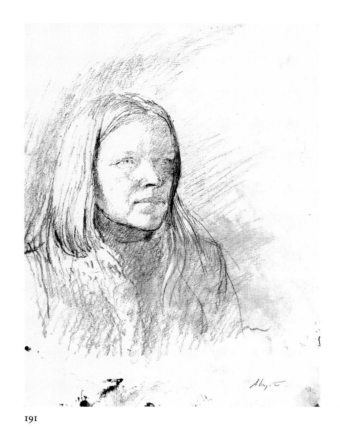

191

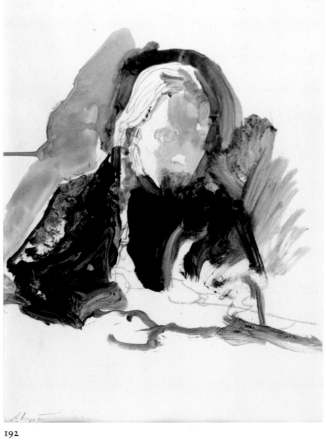

192

PAGEBOY

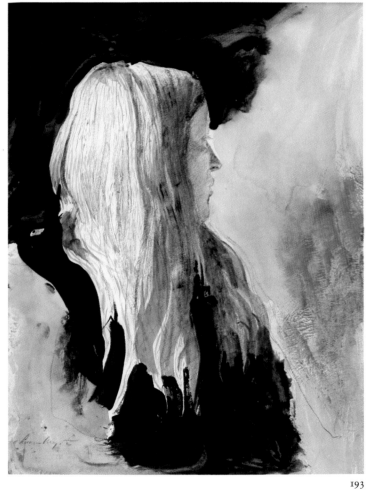

193

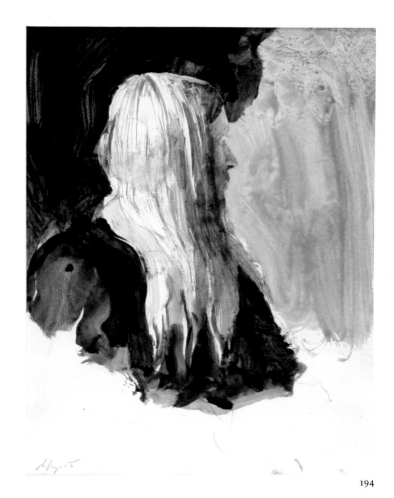

194

FROM THE BACK

I honestly consider myself an abstractionist.
Eakins' figures actually breathe in the frame.
My people, my objects, breathe in a different way; there's another core —
an excitement that's definitely abstract.

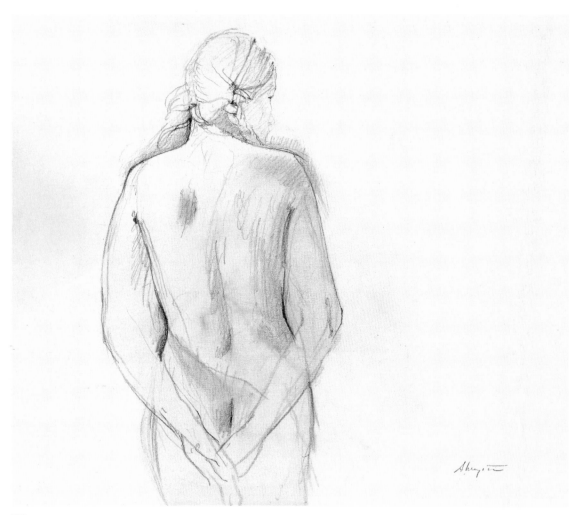

195

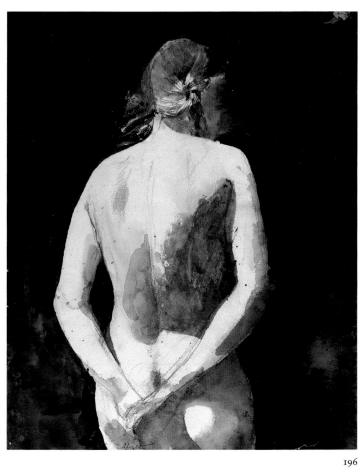

196

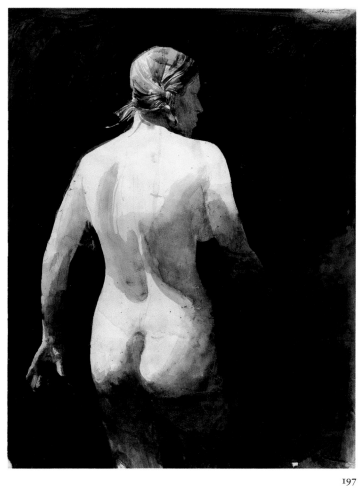

197

FROM THE BACK

161

IN THE DOORWAY

There's a quote from *Hamlet* that is my guide. . . .
He tells the players not to exaggerate but to hold a mirror up to nature.
Don't overdo it, don't underdo it. Do it just on the line.

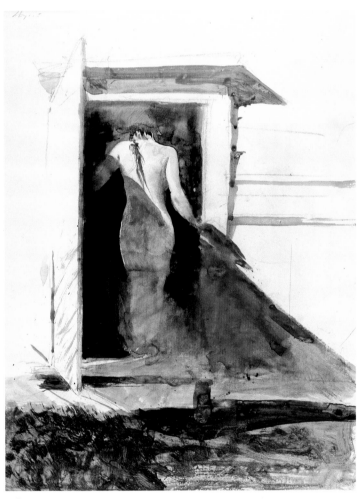

198

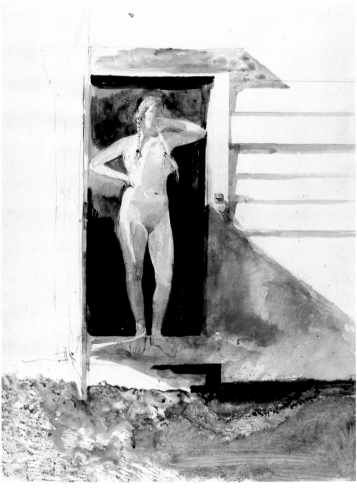

199

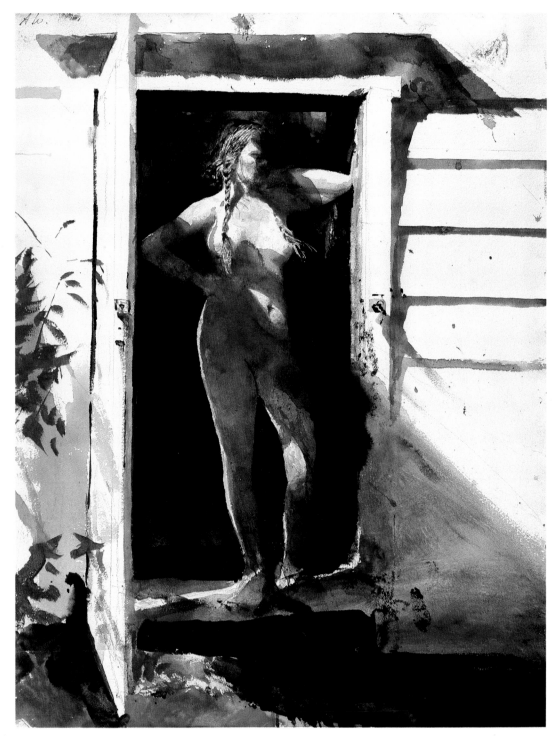

200

IN THE DOORWAY

I do an awful lot of thinking and dreaming about things in the past and the future —
the timelessness of the rocks and the hills — all the people who have existed there.

201

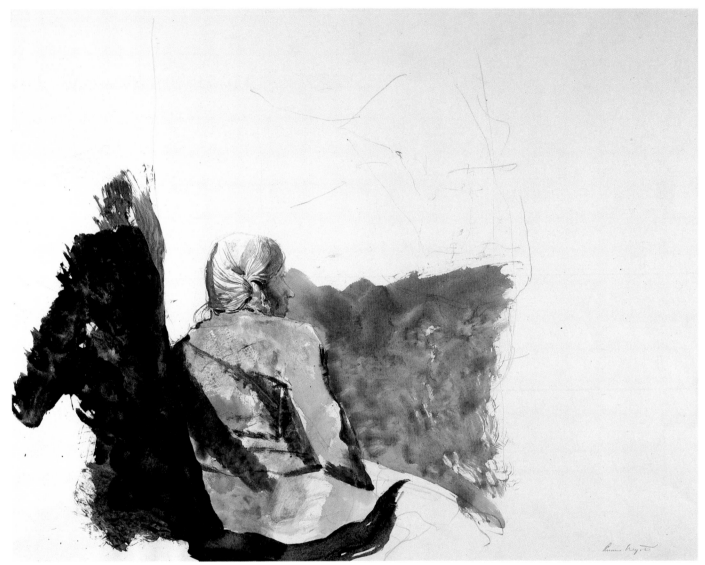

202

KNAPSACK

165

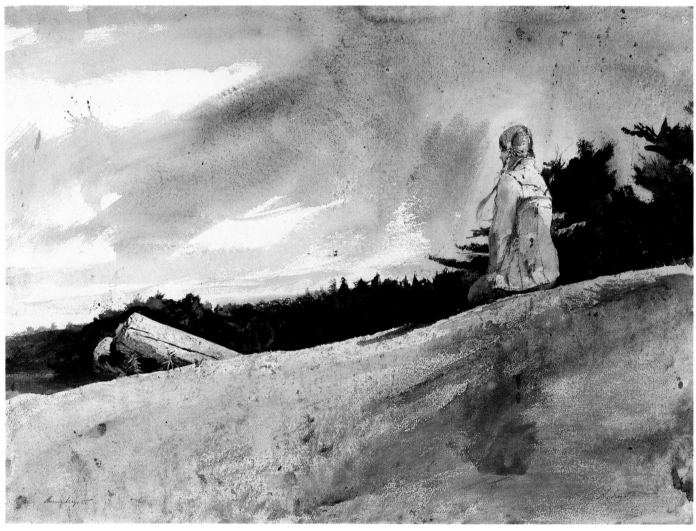

203

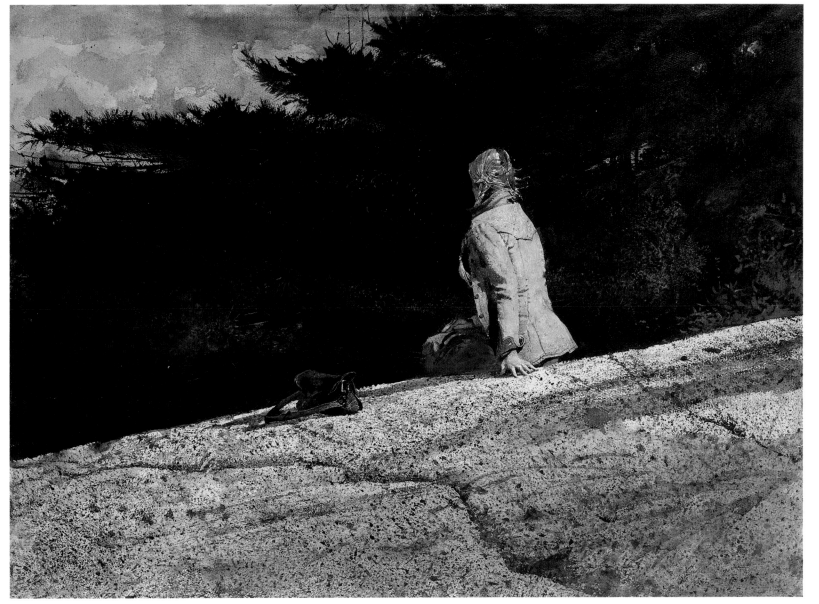

204

KNAPSACK

167

DAY DREAM

To be interested solely in technique would be a very superficial thing to me.
If I have an emotion, before I die, that's deeper than any emotion that I've ever had,
then I will paint a more powerful picture that will have nothing to do
with just technique, but will go beyond it.

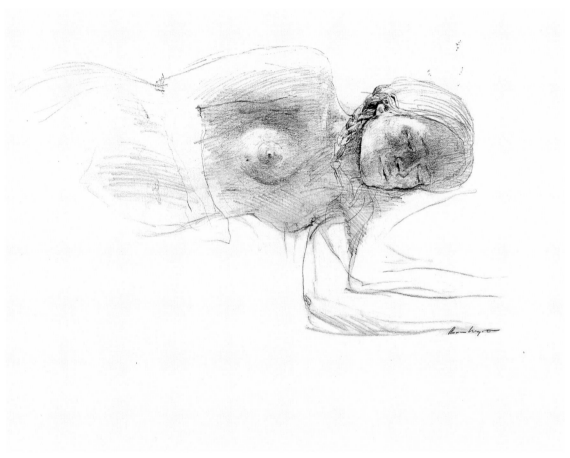

205

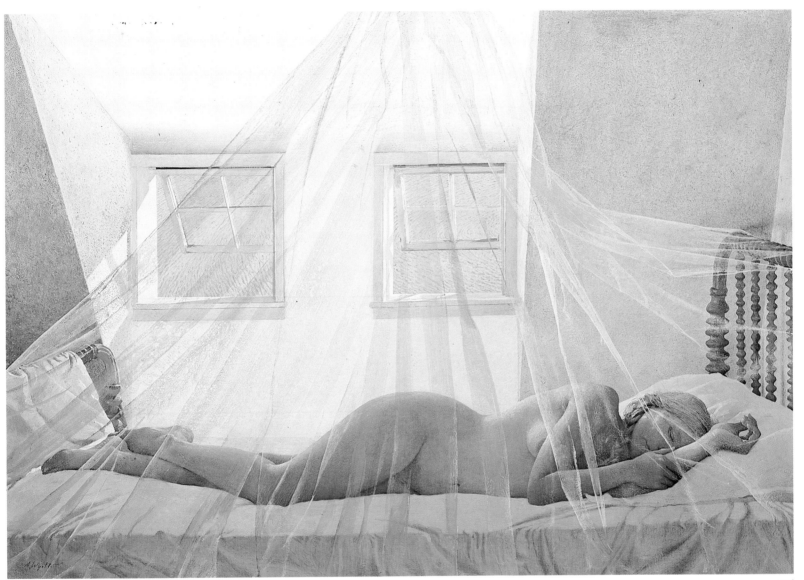

206

DAY DREAM

169

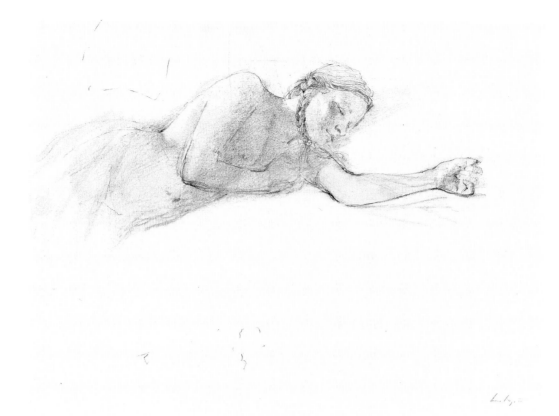

207

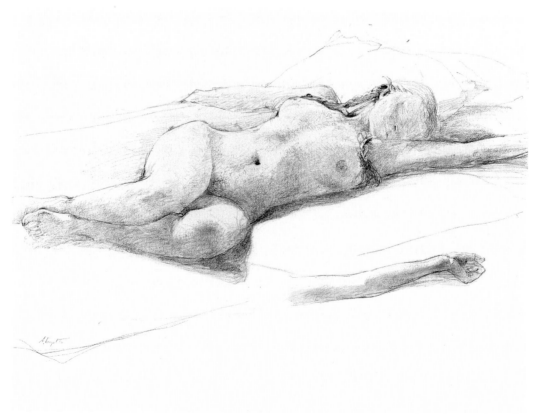

208

DAY DREAM

170

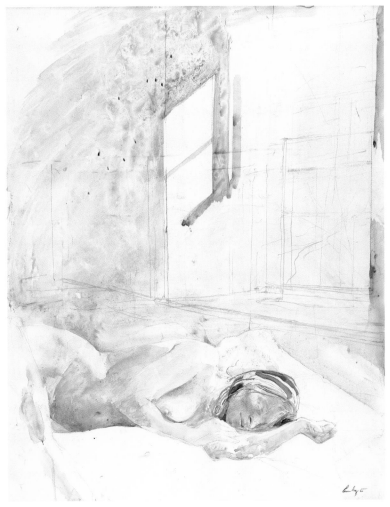

209

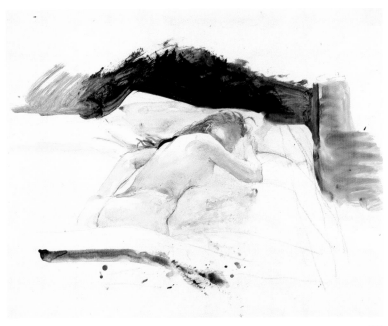

210

DAY DREAM

LOVERS

There is motion in Rembrandt – his people turning toward the light.
But it's frozen motion; time is holding its breath for an instant – and for eternity.
That's what I'm after.

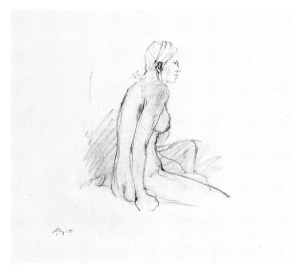

211

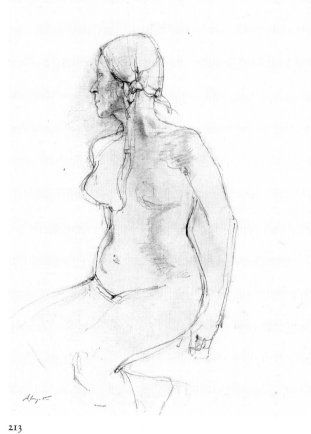

213

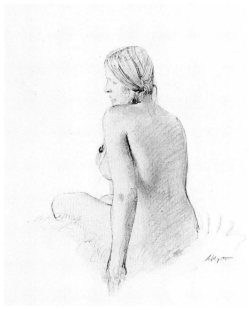

212

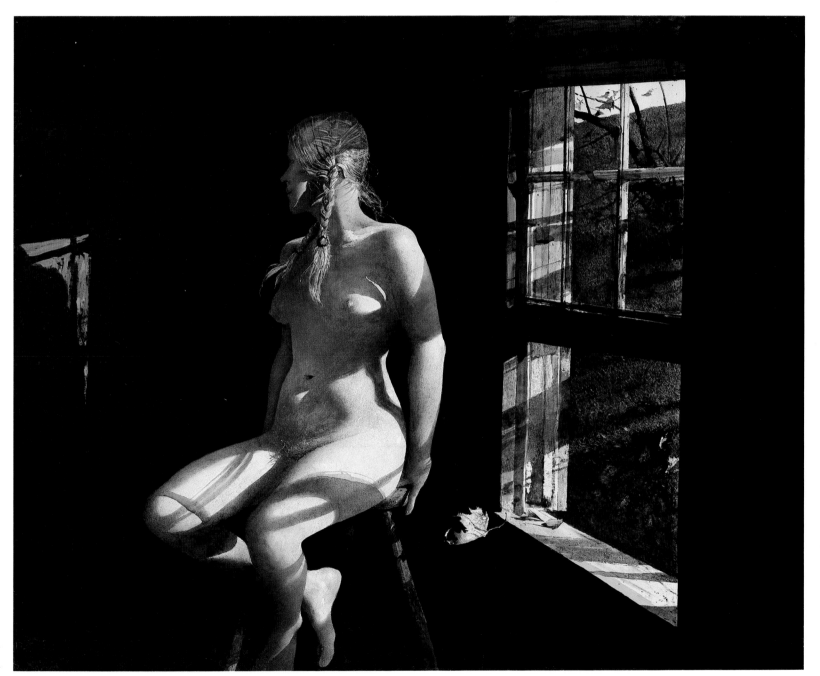

214

LOVERS

173

SUN SHIELD

I would like to try to paint so nothing is at rest in my work. Nothing is frozen.
I would like people to sense even in those paintings with brilliant passages of sunlight,
that the sunlight is not really still but that you can really see the passage of the sun.

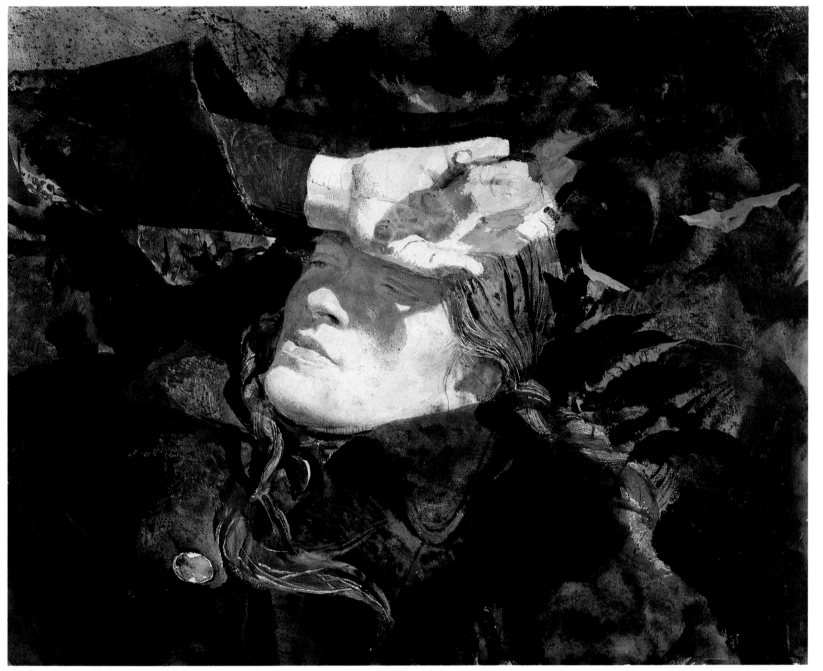

SUN SHIELD

175

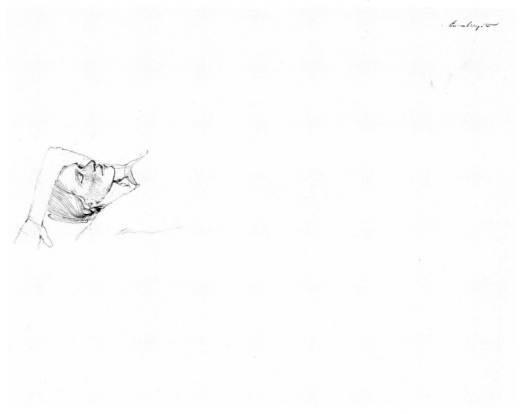

216

217

SUN SHIELD

176

218

SUN SHIELD

177

CAMPFIRE

After I get in the mood of a thing I'm painting, I love to work on the background.
. . . I love to dream, to think, about this thing that's going to live in that background.

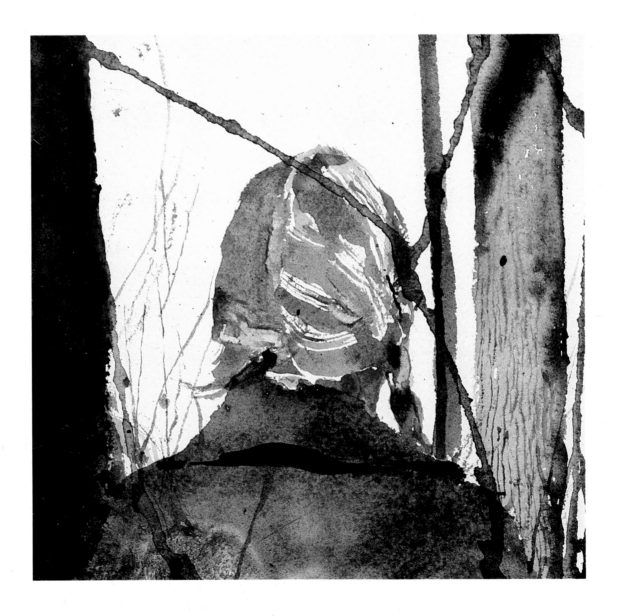

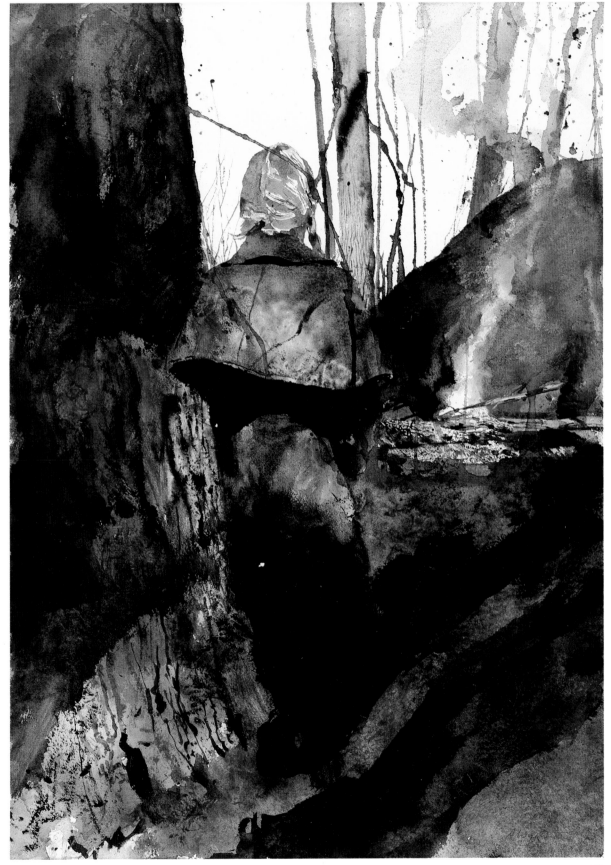

CAMPFIRE

179

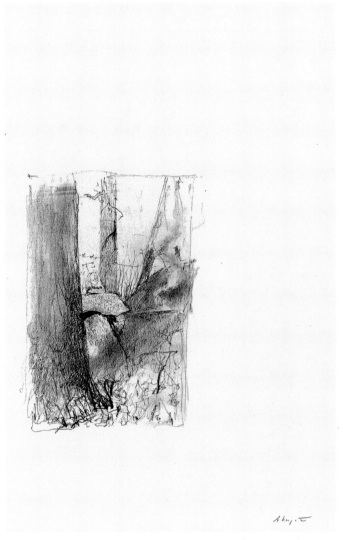

220

221

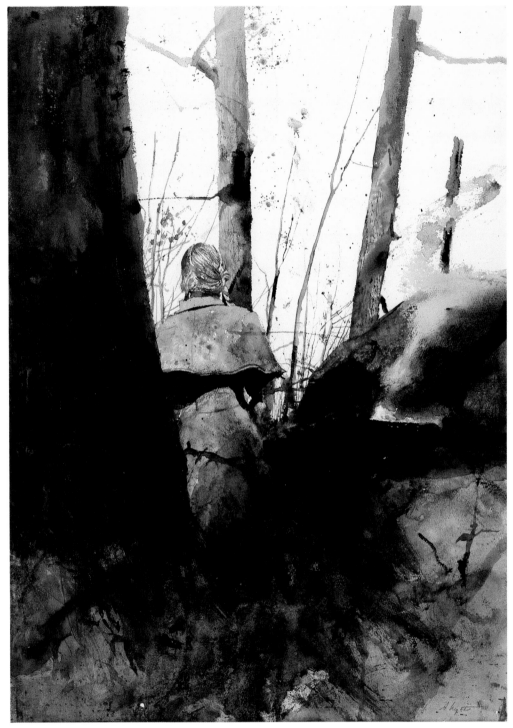

222

CAMPFIRE

CAPE COAT

I prefer winter and fall, when you feel the bone structure in the landscape –
the loneliness of it – the dead feeling of winter. Something waits beneath it –
the whole story doesn't show.

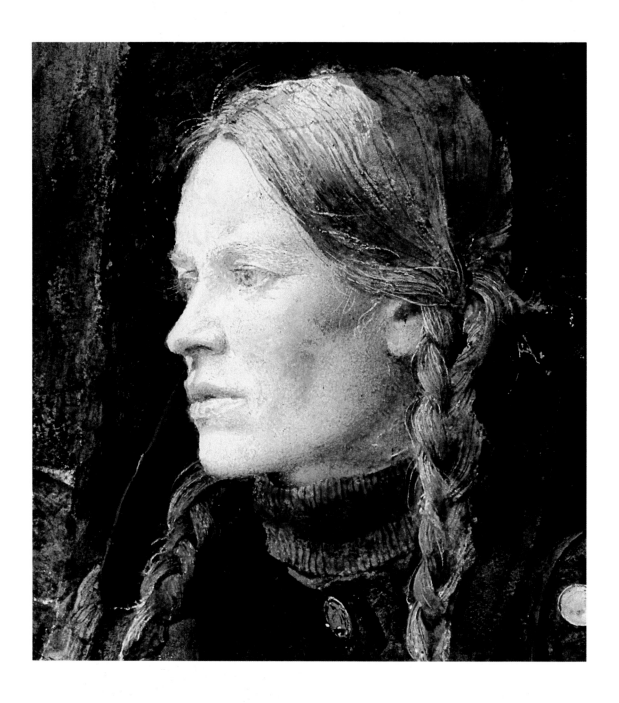

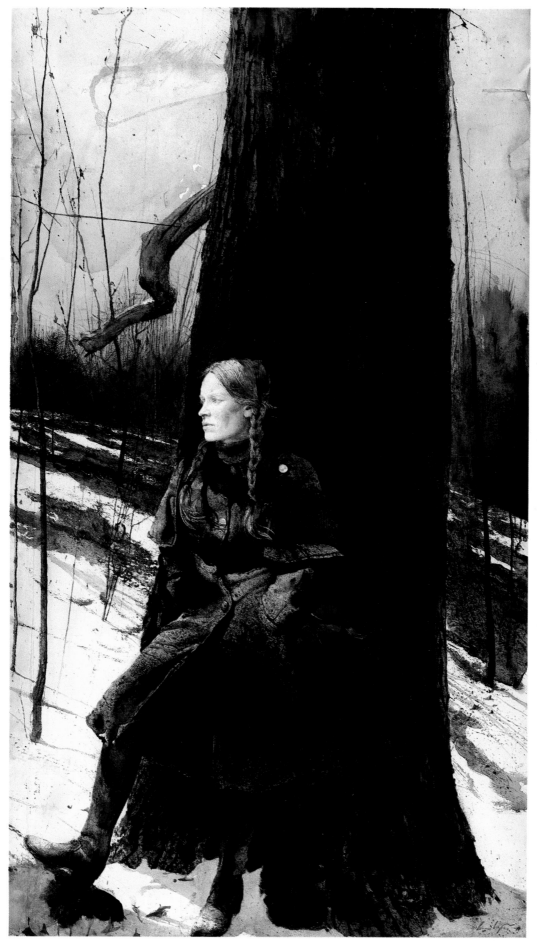

223

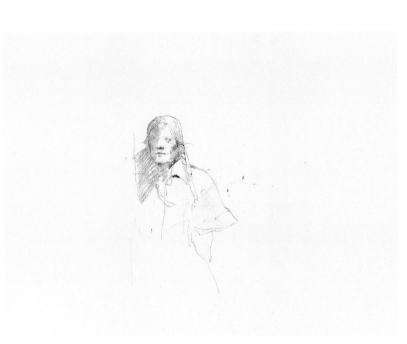

224

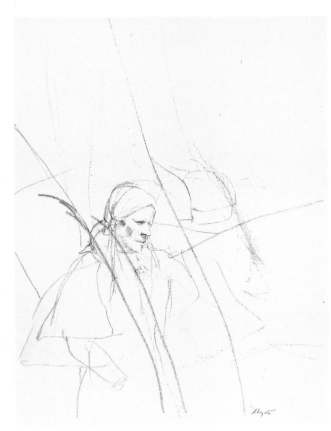

225

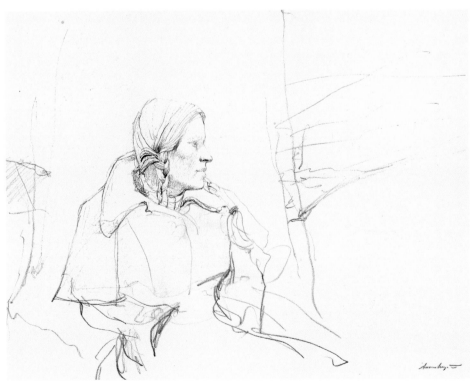

226

CAPE COAT

184

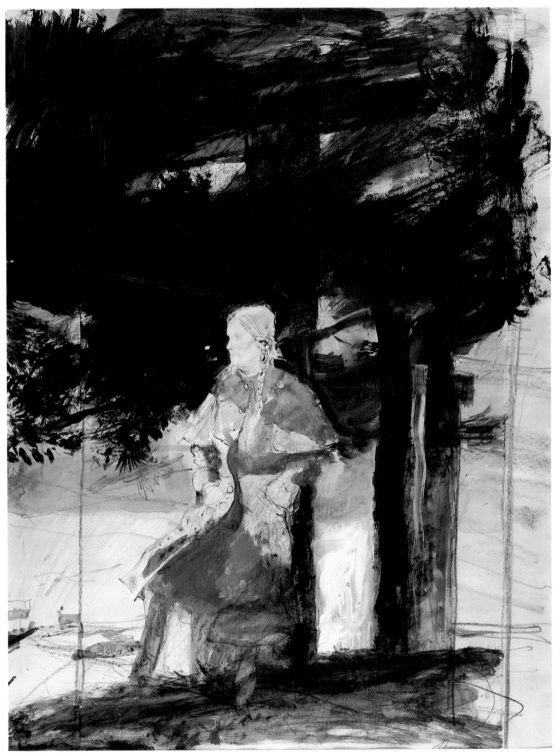

227

CAPE COAT

185

Finally, when you get far enough along in a thing, you feel as though you're living there – not working at a painting – but actually working in that valley. You're there.

228

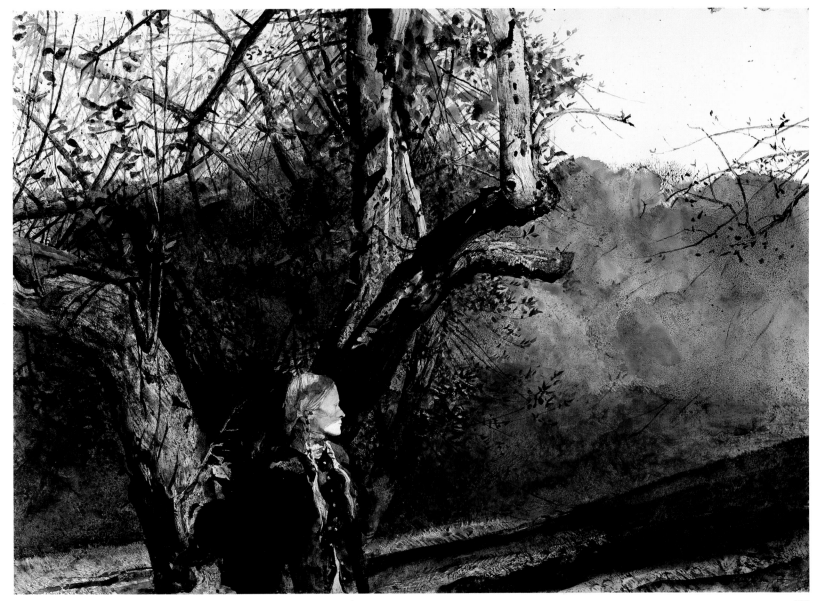

229

AUTUMN

187

REFUGE

If my paintings are worth anything – if they have quality –
that quality will find a way to preserve itself.
I paint for myself within the tenets of my own upbringing and my standards.

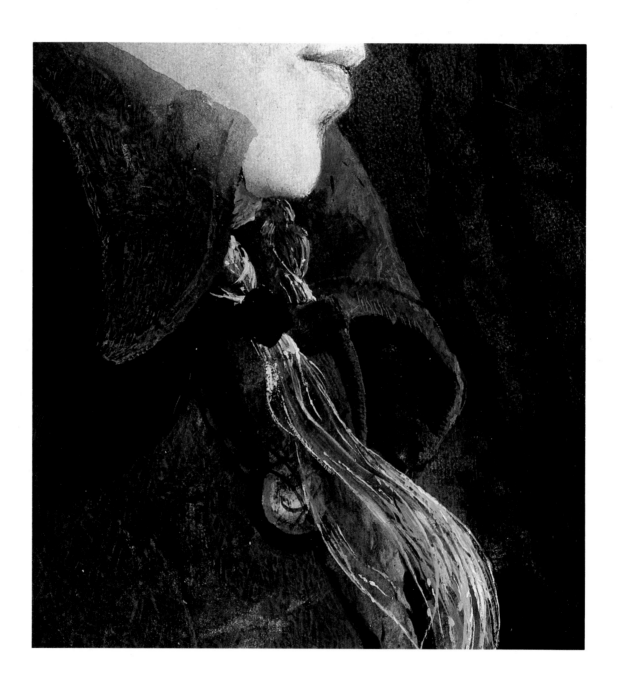

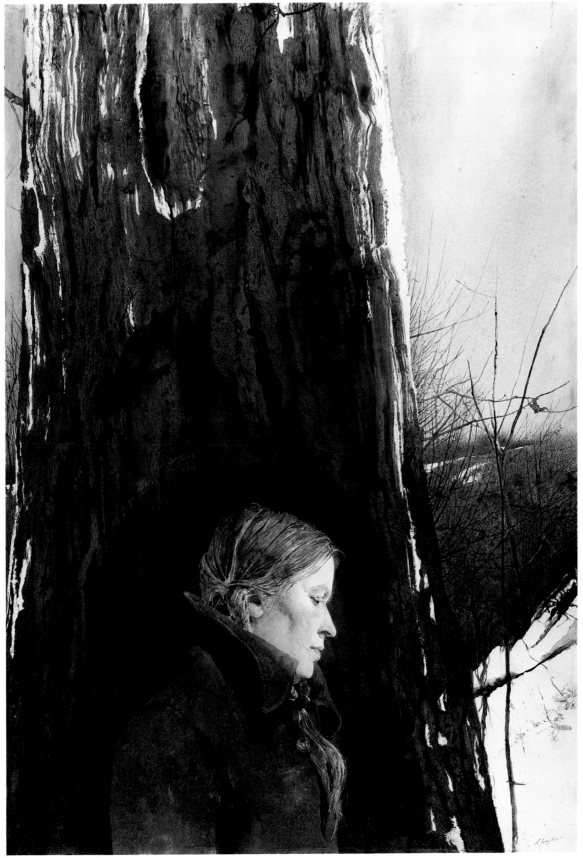

230

REFUGE

189

I've tried never to be easily satisfied, and I've been painting like fury now for forty years. . . . I have a feeling. You paint about as far as your emotions go, and that's about it.

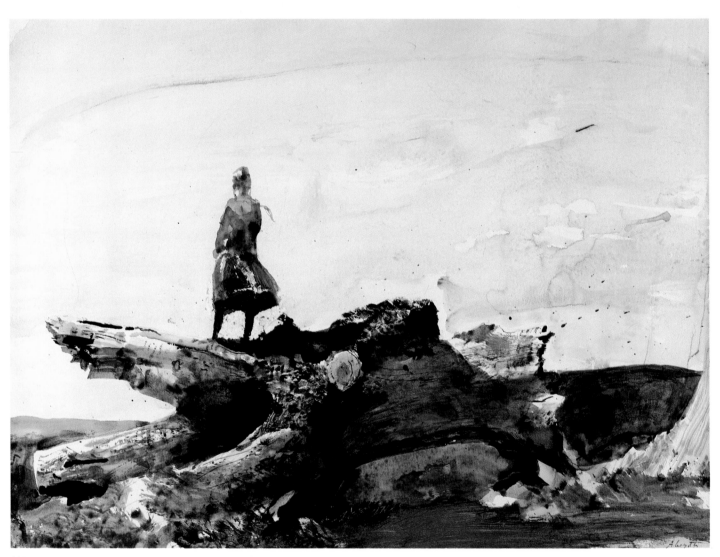

231

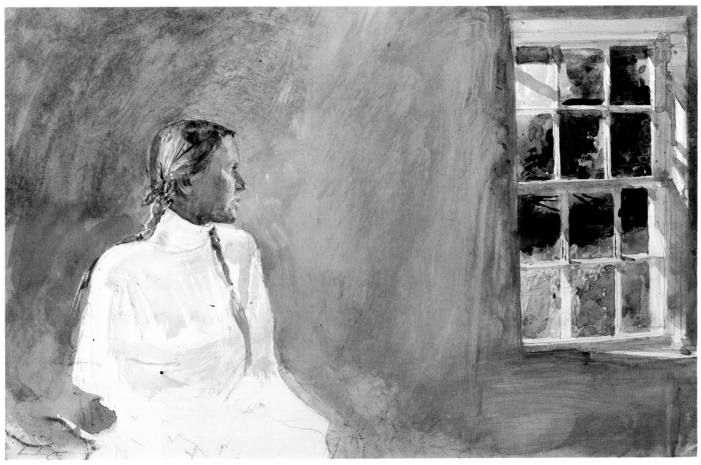

232

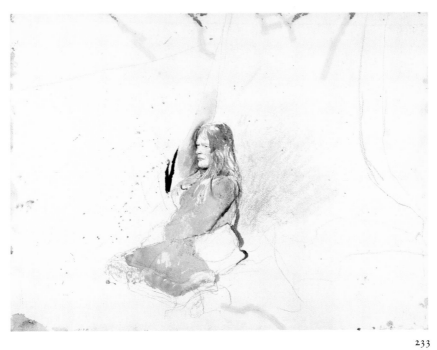

233

OTHER WORKS

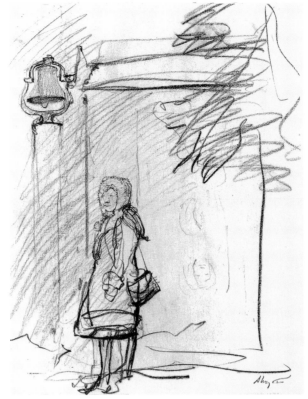

234

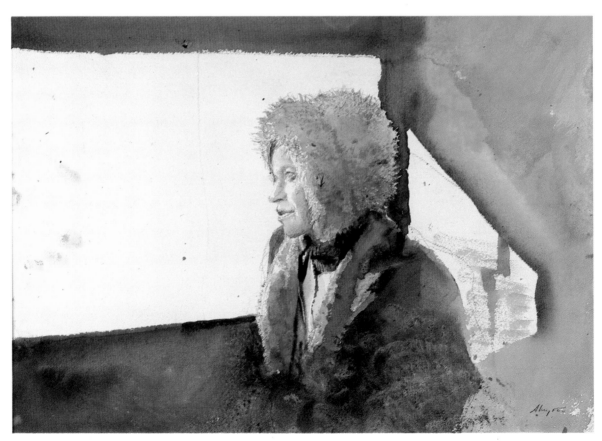

235

OTHER WORKS

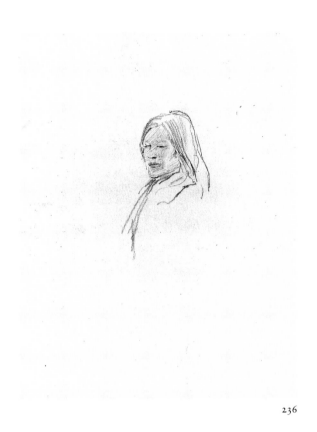

236

237

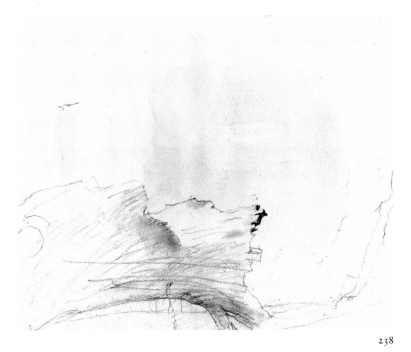

238

OTHER WORKS

LIST OF WORKS

Unless otherwise stated, all the works listed here are in the collection of Leonard E. B. Andrews.

This section contains a total of 238 paintings and drawings given in the order in which they appear in the book. In addition, for the sake of completeness, eight verso drawings of peripheral reference to the Helga pictures are also illustrated.

1. The first drawing
Pencil, 13½ × 10⅞ inches
1971
Signed, lower right: A. Wyeth

LETTING HER HAIR DOWN

2. Tempera, 25 × 28 inches
1972
Signed, upper left: Andrew Wyeth

3. Pencil, 25⅝ × 19⅞ inches
1977
Signed, lower right: A. Wyeth

4. Pencil, 25⅝ × 19⅞ inches
1977
(verso of no. 3)

5. Pencil, 25⅝ × 19⅞ inches
1977
Signed, lower right: A. Wyeth

6. Pencil, 14 × 17 inches
1972
Signed, lower left: A. Wyeth

7. Pencil, 18 × 21¾ inches
1972
Signed, lower left: A. Wyeth

8. Pencil, 13¾ × 11 inches
1980
Signed, lower left: A. Wyeth

9. Pencil, 10 × 13¾ inches
1972
Signed, lower right: A. Wyeth

PEASANT DRESS

10. Watercolor and pencil, 19⅞ × 29¾ inches
1972
Signed, lower right: Andrew Wyeth

11. Pencil, 13⅞ × 10⅞ inches
1972
Inscribed, lower right: Study for watercolor A. Wyeth

12. Pencil, 18 × 23¾ inches
1972
Signed, lower left: Andrew Wyeth

Verso of no. 12:
Pencil, 18 × 23¾ inches
1972

13. Pencil, 10⅞ × 13⅞ inches
1972
(verso of no. 11)

14. Pencil, 18 × 23¾ inches
1972
Signed, lower left: Andrew Wyeth

IN THE ORCHARD

15. Watercolor, 21½ × 29⅝ inches
1973
Signed, lower right: A. Wyeth

16. Watercolor, 23⅝ × 18 inches
1973
Signed, lower right: Andrew Wyeth

17. Pencil, 19¾ × 29¾ inches
1974
(verso of no. 22)

18. Pencil, 23¾ × 18 inches
1973
Signed, lower right: A. Wyeth

19. Pencil, 18 × 23¾ inches
1973
Signed, lower right: A. Wyeth

20. Watercolor, 20¾ × 29¼ inches
1974
Signed, lower right: Andrew Wyeth

21. Watercolor and pencil, 21⅝ × 29⅞ inches
1974
Signed, lower right: Andrew Wyeth

22. Watercolor, 19¾ × 29¾ inches
1974
Signed, upper right: Andrew Wyeth

23. Pencil, 18 × 23⅝ inches
1980
Signed, lower right: Andrew Wyeth

24. Watercolor, 16⅞ × 20⅞ inches
1980
Signed, lower right: Andrew Wyeth

25. Watercolor, 16⅞ × 20⅞ inches
1979
Signed, lower right: Andrew Wyeth

26. Pencil, 25¾ × 19⅞ inches
1977
Signed, lower right: A. Wyeth

27. Pencil, 11 × 13¾ inches
1980
Signed, lower right: A. Wyeth

28. Pencil, 21½ × 29¾ inches
1973
Signed, lower right: A. Wyeth

29. Watercolor and pencil, 17⅞ × 23⅝ inches
1982
Signed, lower left: Andrew Wyeth

30. Watercolor, 22 × 27¾ inches
1982
Signed, lower right: Andrew Wyeth
Verso, inscription by the artist:
February Snow

31. Watercolor, 21⅝ × 29¾ inches
1985
Signed, lower right: Andrew Wyeth
Verso, inscription by the artist:
Watercolor Spring

32. Pencil, 11 × 13¾ inches
1982
Signed, lower left: A. Wyeth

33. Pencil, 11 × 13¾ inches
1982
(verso of no. 32)

HER DAUGHTER

34. Pencil, 10⅞ × 13½ inches
1972
Signed, lower right: A. Wyeth

35. Pencil, 19¾ × 30¾ inches
1973
Signed, lower right: Andrew Wyeth

36. Watercolor and pencil, 19 ×
30 inches
1973
Signed, lower right: Andrew Wyeth

37. Watercolor, 21⅝ × 30 inches
1972
Signed, lower left: Andrew Wyeth

SKETCHPAD

38. Pencil, 14 × 16½ inches
1973
Signed, lower right: A. Wyeth

39. Pencil, 14 × 16½ inches
1973
Signed, lower right: A. Wyeth

40. Pencil, 14 × 16½ inches
1973
Unsigned

41. Pencil, 14 × 16½ inches
1973
Unsigned

42. Pencil, 14 × 16½ inches
1973
Signed, lower right: A. Wyeth

43. Pencil, 14 × 16½ inches
1973
Signed, lower left: A. Wyeth

44. Pencil, 14 × 16½ inches
1973
Unsigned

45. Pencil, 14 × 16½ inches
1973
Signed, lower left: A. Wyeth

BLACK VELVET

46. Drybrush, 21¼ × 39¼ inches
1972
Signed, lower right: Andrew Wyeth

47. Pencil, 18 × 23¾ inches
1972
Signed, lower right: A. Wyeth

48. Pencil, 18 × 23¾ inches
1972
Signed, lower right: A. Wyeth

49. Pencil, 18 × 24 inches
1978
Signed, lower right: A. Wyeth

50. Watercolor and pencil, 21½ ×
29½ inches
1972
Signed, lower right: Andrew Wyeth

51. Pencil, 18 × 23¾ inches
1972
Signed, lower right: A. Wyeth

SHEEPSKIN

52. Tempera, 33⅜ × 18 inches
1973
Signed, upper left, on backing board:
A. Wyeth

53. Pencil, 18 × 23¾ inches
1972
Signed, lower right: A. Wyeth

54. Pencil, 18 × 23¾ inches
1972
(verso of no. 53)

SEATED BY A TREE

55. Pencil, 14 × 16⅞ inches
1982
Signed, lower right: A. Wyeth

56. Watercolor, 21½ × 27⅝ inches
1973
(verso of no. 58)

57. Watercolor, 29⅞ × 21⅜ inches
1982
Signed, lower left: A. Wyeth

58. Watercolor, 21½ × 27⅝ inches
1973
Signed, lower right: Andrew Wyeth

59. Watercolor, 27⅞ × 21½ inches
1973
Signed, lower left: Andrew Wyeth

THE PRUSSIAN

60. Drybrush, 29½ × 21½ inches
1973
Signed, lower left: Andrew Wyeth

CROWN OF FLOWERS

61. Drybrush, 10¼ × 12¾ inches
1974
Signed, lower margin, right of center:
A. Wyeth

Verso of no. 61:
Pencil, 10¼ × 12¾ inches
1974

HER HEAD

62. Pencil, 20¼ × 30½ inches
1979
Signed, lower right: A. Wyeth

63. Pencil, 17⅞ × 23¾ inches
1973
Signed, lower right: A. Wyeth

64. Pencil, 10⅞ × 13½ inches
1971
Signed, lower right: A. Wyeth

65. Pencil, 13¾ × 16¾ inches
1974
Signed, lower right: A.W.

66. Pencil, 22½ × 30¾ inches
1979
Signed, lower left: Andrew Wyeth

67. Pencil, 14 × 16½ inches
1973
Signed, lower right: A. Wyeth

68. Pencil, 22½ × 30¾ inches
1979
(verso of no. 66)

69. Pencil, 14 × 16½ inches
1973
(verso of no. 67)

NUDES

70. Pencil, 27¼ × 21⅜ inches
1980
Signed, lower right: A. Wyeth

71. Watercolor, 21⅝ × 29½ inches
1973
Signed, upper left: Andrew Wyeth

72. Pencil, 13¾ × 16⅝ inches
1974
Signed, lower right: A.W.

73. Pencil, 19¾ × 25¼ inches
1973
Signed, lower right: A. Wyeth

74. Pencil, 19¾ × 25¾ inches
1973
(verso of no. 73)

75. Pencil, 18 × 23¾ inches
1974
Signed, lower right: A.W.

76. Pencil, 18 × 23⅝ inches
1984
Signed, lower left: A. Wyeth

77. Pencil, 17⅞ × 23⅝ inches
1976
Signed, lower right: A. Wyeth

78. Watercolor, 20⅝ × 28¾ inches
1976
Signed, lower right: Andrew Wyeth

79. Watercolor, 21½ × 29¼ inches
1978
Signed, lower right: A. Wyeth

80. Pencil, 13⅞ × 16¾ inches
1981
(verso of no. 83)

81. Pencil, 23 × 29 inches
1981
(verso of no. 82)

82. Pencil, 23 × 29 inches
1981
Signed, lower left: A. Wyeth

83. Pencil, 13⅞ × 16¾ inches
1981
Signed, lower left: A. Wyeth

84. Pencil, 13¾ × 16⅝ inches
1979
Signed, upper right: Andrew Wyeth

85. Watercolor, 13⅝ × 16⅝ inches
1981
Signed, lower left: A. Wyeth

86. Watercolor, 18⅛ × 24 inches
1981
Signed, lower right: A. Wyeth

EASTER SUNDAY

87. Pencil, 18⅝ × 22⅝ inches
1975
Signed, lower right: A. Wyeth

88. Pencil, 18 × 23¾ inches
1975
Signed, lower left: Andrew Wyeth

89. Pencil, 10⅝ × 14 inches
1975
Signed, lower right: A. Wyeth

Verso of no. 89:
Pencil, 10⅝ × 14 inches
1975

90. Watercolor, 28⅝ × 39½ inches
1975
Signed, upper left: Andrew Wyeth

Verso of no. 90:
Pencil, 39½ × 28⅝ inches
1975

ASLEEP

91. Pencil, 18 × 23⅝ inches
1975
Signed, upper left: Andrew Wyeth

92. Pencil, 18 × 23¾ inches
1975
Signed, upper left: A. Wyeth

93. Pencil, 18 × 23¾ inches
1975
Signed, upper left: Andrew Wyeth

94. Pencil, 13⅞ × 16⅝ inches
1984
Signed, lower right: Andrew Wyeth

95. Pencil, 13⅞ × 16⅝ inches
1984
Signed, lower right: A. Wyeth

96. Pencil, 13¾ × 16⅝ inches
1974
Signed, lower right: Andrew Wyeth

97. Pencil, 11 × 13¾ inches
1979
(verso of no. 98)

98. Pencil, 13¾ × 11 inches
1979
Signed, lower left: Andrew Wyeth

99. Watercolor and pencil, 21⅞ ×
29⅞ inches
1975
Signed, lower left: Andrew Wyeth

100. Watercolor and pencil, 25⅜ ×
26⅞ inches
1975
Signed, upper left: Andrew Wyeth

101. Pencil, 9 × 11¾ inches
1975
Signed, lower left: A. Wyeth

102. Pencil, 13¾ × 16⅝ inches
1975
Signed, lower left: A. Wyeth

103. Pencil, 13¾ × 16⅝ inches
1975
Signed, upper left: Andrew Wyeth

104. Pencil, 13¾ × 16⅝ inches
1975
Signed, upper right: A. Wyeth

105. Pencil, 13¾ × 16⅝ inches
1975
Signed, upper left: Andrew Wyeth

106. Pencil, 24¾ × 31 inches (two
sections)
1975
Signed, lower right: Andrew Wyeth

107. Pencil, 9 × 11¾ inches
1975
Signed, upper right: A. Wyeth

108. Pencil, 18 × 23¾ inches
1975
Signed, lower right: Andrew Wyeth

109. Watercolor, 15½ × 11⅝ inches
1975
Signed, upper right: Andrew Wyeth

110. Pencil, 18⅞ × 24 inches
1981
Signed, lower right: A. Wyeth

111. Pencil, 18⅞ × 24 inches
1976
Signed, lower right: A. Wyeth

112. Pencil, 17⅞ × 23⅝ inches
1978
Signed, lower right: A. Wyeth

113. Pencil, 18⅞ × 24 inches
1978
Signed, lower right: A. Wyeth

114. Watercolor, 21½ × 29½ inches
1976
Signed, lower left: Andrew Wyeth

115. Pencil, 16 × 19¾ inches
1976
Signed, lower left: Andrew Wyeth

116. Pencil, 18 × 23⅝ inches
1976
Signed, lower left: A. Wyeth

117. Pencil, 11½ × 9 inches
1974
Signed, lower right: A. Wyeth

118. Pencil, 11¾ × 9 inches
1974
Signed, lower right: A. Wyeth

119. Pencil, 18 × 23¾ inches
1981
Signed, lower right: Andrew Wyeth

120. Pencil, 13¾ × 11 inches
1979
(verso of no. 166)

121. Pencil, 19⅞ × 25⅝ inches
1985
Signed, lower right: A. Wyeth

122. Pencil, 17⅞ × 23⅝ inches
1979
Signed, lower right: Andrew Wyeth

123. Pencil, 19⅞ × 25⅝ inches
1985
(verso of no. 121)

124. Pencil and watercolor, 22¾ ×
28⅝ inches
1973
Signed, lower left: A. Wyeth

125. Drybrush, 19¾ × 25⅝ inches
1976
Signed, upper left: Andrew Wyeth

BARRACOON

126. Drybrush and watercolor,
19¾ × 25⅛ inches
1976
Signed, lower left: Andrew Wyeth

127. Pencil, 18 × 23 inches
1972
Signed, lower right: Andrew Wyeth

128. Pencil, 18 × 23¾ inches
1972
Signed, lower right: A. Wyeth

129. Pencil, 18 × 23¾ inches
1976
Signed, lower left: Andrew Wyeth

ON HER KNEES

130. Drybrush, 29¾ × 21¾ inches
1977
Signed, lower right: Andrew Wyeth

131. Pencil, 23⅝ × 18 inches
1977
(verso of no. 134)

132. Pencil, 23⅝ × 17⅞ inches
1977
Signed, lower right: Andrew Wyeth

133. Pencil, 23⅝ × 18 inches
1977
Signed, lower right: A. Wyeth

134. Pencil, 23⅝ × 18 inches
1977
Signed, lower right: A. Wyeth

135. Watercolor, 29⅞ × 21⅜ inches
1977
Signed, lower right: Andrew Wyeth

136. Watercolor, 24⅜ × 19⅞ inches
1977
Signed, lower right: A. Wyeth

137. Watercolor, 25½ × 19¾ inches
1977
Signed, lower right: Andrew Wyeth

138. Pencil, 18⅝ × 24½ inches
1977
Signed, lower right: A. Wyeth

139. Pencil, 18 × 23⅝ inches
1977
Signed, lower right: A. Wyeth

DRAWN SHADE

140. Drybrush and watercolor, 23 ×
28 inches
1977
Signed, upper right: Andrew Wyeth

141. Pencil, 22⅞ × 28⅞ inches
1977
Signed, lower right: A. Wyeth

142. Pencil, 23 × 29 inches
1977
Signed, lower right: Andrew Wyeth

143. Pencil, 11 × 13⅞ inches
1977
Signed, lower right: A. Wyeth

144. Pencil, 10⅝ × 14 inches
1977
Signed, lower left: A. Wyeth

OVERFLOW

145. Drybrush, 23 × 29 inches
1978
Signed, upper right: Andrew Wyeth

146. Pencil, 18 × 23¾ inches
1978
Signed, lower left: Andrew Wyeth

147. Pencil, 18⅞ × 24¾ inches
1978
Signed, lower left: Andrew Wyeth

148. Pencil, 18 × 23⅝ inches
1978
Signed, lower left: Andrew Wyeth

149. Pencil, 18¾ × 24 inches
1976
Signed, lower right: Andrew Wyeth

150. Watercolor, 22⅞ × 28⅞ inches
1976
Signed, lower left: Andrew Wyeth

151. Watercolor, 21⅝ × 30 inches
1978
Signed, lower left: Andrew Wyeth

152. Pencil, 17⅞ × 23¾ inches
1976
Signed, lower right: A. Wyeth

153. Pencil, 17⅞ × 23¾ inches
1976
(verso of no. 152)

154. Pencil, 18 × 24 inches
1978
Signed, lower right: A. Wyeth

155. Pencil, 18 × 24 inches
1978
Signed, lower left: A. Wyeth

156. Pencil, 18¾ × 24⅝ inches
1978
(verso of no. 157)

157. Pencil, 18¾ × 24⅝ inches
1978
Signed, lower right: A. Wyeth

158. Pencil, 18 × 23⅝ inches
1978
Signed, lower left: Andrew Wyeth

159. Watercolor, 22¾ × 28¾ inches
1978
Signed, upper left: Andrew Wyeth

160. Pencil, 25⅝ × 36½ inches
1978
(verso of no. 163)

161. Pencil, 25¾ × 36¾ inches
1978
(verso of no. 164)

162. Pencil, 25⅝ × 36⅝ inches
1978
Signed, lower left: Andrew Wyeth

163. Pencil, 25⅝ × 36½ inches
1978
Signed, lower left: Andrew Wyeth

164. Pencil, 25¾ × 36¾ inches
1978
Signed, lower left: Andrew Wyeth

FARM ROAD

165. Tempera, 21 × 25¼ inches
1979
Signed, lower left: A.W.

WALKING IN HER CAPE COAT

166. Pencil, 11 × 13¾ inches
1979
Signed, lower right: A. Wyeth

167. Pencil, 18¾ × 11½ inches
1982
Signed, lower right: A. Wyeth

168. Pencil, 23⅝ × 18 inches
1979
Signed, lower right: A.W.

169. Watercolor, 23 × 28¾ inches
1979
Signed, upper left: A. Wyeth

LODEN COAT

170. Watercolor, 29 × 21¼ inches
1978
Signed, lower right: Andrew Wyeth

171. Pencil, 17¾ × 12 inches
1978
Signed, lower right: A. Wyeth

172. Watercolor, 30 × 22 inches
1978
Signed, lower right: Andrew Wyeth
Collection Arthur Magill. Copyright
Mr. and Mrs. Joseph E. Levine

BRAIDS

173. Tempera, 16½ × 20½ inches
1979
Signed, upper right: W.

174. Pencil, 18 × 23¾ inches
1979
Signed, lower right: A. Wyeth

175. Pencil, 18 × 23¾ inches
1979
Signed, lower right: A. Wyeth

176. Pencil, 18 × 23¾ inches
1979
Signed, lower right: Andrew Wyeth

177. Pencil, 23¾ × 18 inches
1979
Signed, lower left: Andrew Wyeth

NIGHT SHADOW

178. Pencil, 18 × 24 inches
1979
Signed, lower right: A. Wyeth

179. Drybrush, 19⅝ × 25⅜ inches
1979
Signed, lower left: Andrew Wyeth
Collection Mr. and Mrs. Andrew
Wyeth

180. Pencil, 18 × 24 inches
1979
Signed, lower right: A. Wyeth

181. Pencil, 18 × 23⅝ inches
1979
Signed, lower right: A. Wyeth

182. Pencil, 18 × 23¾ inches
1979
Signed, lower right: Andrew Wyeth

183. Watercolor, 21⅛ × 29⅞ inches
1973
Signed, lower left: Andrew Wyeth

WITH NELL

184. Watercolor and pencil, 14 ×
22 inches
1979
Signed, lower right: A. Wyeth

185. Pencil, 14 × 22 inches
1979
Signed, lower right: A. Wyeth

186. Pencil, 14 × 22 inches
1979
(verso of no. 185)

187. Pencil, 14 × 22 inches
1979
Signed, lower right: A. Wyeth

188. Pencil, 14 × 22 inches
1979
Signed, lower right: A.W.

PAGEBOY

189. Drybrush, 16⅜ × 19¾ inches
1980
Signed, lower right: Andrew Wyeth

190. Pencil, 13⅝ × 11 inches
1980
(verso of no. 193)

191. Pencil, 13¾ × 11 inches
1980
Signed, lower right: A. Wyeth

192. Watercolor, 16½ × 12⅜ inches
1982
Signed, lower left: A. Wyeth

193. Watercolor and pencil, 13⅝ ×
11 inches
1980
Signed, lower left: Andrew Wyeth

194. Watercolor, 13⅝ × 11 inches
1980
Signed, lower left: A. Wyeth

FROM THE BACK

195. Pencil, 14 × 17 inches
1981
Signed, lower right: A. Wyeth

196. Watercolor, 20⅞ × 17 inches
1981
Signed, lower left: A. Wyeth

197. Watercolor, 23¾ × 18⅝ inches
1981
Signed, upper right: A. Wyeth

IN THE DOORWAY

198. Watercolor, 23⅝ × 18 inches
1981
Signed, upper left: A. Wyeth

Verso of no. 198:
"Dr. Syn"
Pencil, 18 × 23⅝ inches
1981

199. Watercolor, 23¾ × 17⅞ inches
1981
Signed, lower left: A. Wyeth

Verso of no. 199:
"Dr. Syn"
Pencil, 17⅞ × 23¾ inches
1981

200. Watercolor, 23¾ × 18⅝ inches
1981
Signed, upper left: A.W.

KNAPSACK

201. Watercolor, 19½ × 25⅜ inches
1980
Signed, lower right: Andrew Wyeth

202. Watercolor, 19⅝ × 24⅞ inches
1980
Signed, lower right: Andrew Wyeth

203. Watercolor, 21½ × 29⅞ inches
1980
Signed, lower left: Andrew Wyeth

204. Watercolor, 21⅛ × 29⅜ inches
1980
Signed, lower right: Andrew Wyeth
Collection Tomas Payan

DAY DREAM

205. Pencil, 18 × 23¾ inches
1978
Signed, lower right: Andrew Wyeth

206. Tempera, 18⅝ × 26⅞ inches
1980
Signed, lower left: A. Wyeth
The Armand Hammer Collection

207. Pencil, 18 × 23¾ inches
1978
Signed, lower right: Andrew Wyeth

208. Pencil, 17⅞ × 23⅝ inches
1978
Signed, lower left: A. Wyeth

209. Watercolor and pencil, 28⅞ ×
22⅞ inches
1975
Signed, lower right: Andrew Wyeth
(verso of no. 210)

210. Watercolor and pencil, 22⅞ ×
28⅞ inches
1975
Signed, lower right: Andrew Wyeth

LOVERS

211. Pencil, 14 × 16¾ inches
1981
Signed, lower left: A. Wyeth

212. Pencil, 16⅞ × 14 inches
1981
Signed, lower right: A. Wyeth

213. Pencil, 23¾ × 16½ inches
1981
Signed, lower left: A. Wyeth

214. Drybrush, 22½ × 28½ inches
1981
Signed, upper right: A.W.
Collection Mr. and Mrs. Andrew
Wyeth

SUN SHIELD

215. Watercolor, 18¾ × 23½ inches
1982
Signed, upper left: Andrew Wyeth

216. Pencil, 18 × 23⅝ inches
1978
Signed, upper right: Andrew Wyeth

217. Pencil, 18 × 23¾ inches
1982
Signed, lower right: A. Wyeth

218. Pencil, 18 × 23¾ inches
1982
Signed, lower center: A. Wyeth

CAMPFIRE

219. Watercolor, 29⅞ × 21⅝ inches
1982
Signed, lower right: A. Wyeth

Verso of no. 219:
Pencil, 21⅝ × 29⅞ inches
1982
Inscribed, at left: No. 1 Campfire
watercolor

220. Pencil, 17¾ × 12 inches
1982
Signed, lower right: A. Wyeth

221. Pencil, 17¾ × 12 inches
1982
(verso of no. 220)

222. Watercolor, 29¾ × 21⅝ inches
1982
Signed, lower right: A. Wyeth
Verso, inscription by the artist:
Campfire No. 2

CAPE COAT

223. Drybrush, 53 × 31 inches
1982
Signed, lower right: Andrew Wyeth

224. Pencil, 18 × 23⅝ inches
1982
Signed, lower right: A. Wyeth

225. Pencil, 28⅞ × 22½ inches
1982
Signed, lower right: A. Wyeth

226. Pencil, 18 × 23¾ inches
1982
Signed, lower right: Andrew Wyeth

227. Watercolor and pencil, 23¾ ×
18 inches
1982
Signed, lower right: A. Wyeth

AUTUMN

228. Pencil, 16¾ × 14 inches
1982
Signed, lower right: Andrew Wyeth

229. Watercolor, 21 × 29½ inches
1984
Signed, lower right: Andrew Wyeth
Collection Mr. and Mrs. Andrew
Wyeth

REFUGE

230. Drybrush, 39½ × 27 inches
1985
Signed, lower right: A. Wyeth

OTHER WORKS

231. Watercolor, 20 × 27⅛ inches
1979
Signed, lower right: A. Wyeth

232. *White Dress*
Watercolor, 17⅝ × 23⅝ inches
1980
Signed, lower left: Andrew Wyeth

Verso of no. 232:
Watercolor, 23⅝ × 17⅝ inches
1980

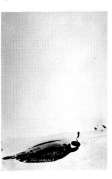

233. Watercolor, 21⅝ × 29½ inches
1973
(verso of no. 71)

234. Pencil, 13¾ × 11 inches
1973
Signed, lower right: A. Wyeth

235. Watercolor, 14 × 19⅞ inches
1973
Signed, lower right: A. Wyeth

236. Pencil, 13¾ × 11 inches
1973
(verso of no. 234)

237. Pencil, 24¾ × 18¾ inches
1980
Signed, lower right: A. Wyeth

238. Pencil, 13⅝ × 11 inches
1980
(verso of no. 194)

CHRONOLOGY OF EXHIBITIONS

The chronology for the years 1937 through 1971 first appeared in Wanda M. Corn's *The Art of Andrew Wyeth* (Boston, New York Graphic Society, 1973), copyright © by The Fine Arts Museums of San Francisco, and is reprinted by permission of the Museums. Mary Adam Landa, Curator, Wyeth Private Collection, supplied information for the subsequent years.

I. *One-Man Gallery Exhibitions*

MACBETH GALLERY, NEW YORK

1937 *First Exhibition of Water Colors by Andrew Wyeth*
October 19–November 1

1939 *Second Exhibition of Water Colors by Andrew Wyeth*
October 10–October 30

1941 *Third Exhibition of Water Colors by Andrew Wyeth*
October 7–October 27

1943 *Temperas and Water Colors by Andrew Wyeth*
November 1–November 20

1945 *Temperas and Water Colors by Andrew Wyeth*
October 29–November 17

1948 *Andrew Wyeth*
November 15–December 4

1950 *Andrew Wyeth*
November 21–December 9

1952 *Andrew Wyeth*
November 6–November 29

DOLL & RICHARDS, BOSTON

1938 *Water Colors by Andrew Wyeth*
October 24–November 5

1940 *Water Colors by Andrew Wyeth*
November 29–December 14

1942 *Third Exhibition of Water Colors by Andrew Wyeth*
December 7–December 26

1944 *Water Colors by Andrew Wyeth*
December 4–December 23

1946 *Water Colors by Andrew Wyeth*
November 18–December 7

1950 *Water Colors by Andrew Wyeth*
April 17–April 29

M. KNOEDLER AND CO., NEW YORK

1953 *Exhibition of Paintings by Andrew Wyeth*
October 26–November 14

1958 *Exhibition of Paintings by Andrew Wyeth*
October 28–November 22

LEFEVRE GALLERY, LONDON

1974 *Andrew Wyeth*
May 23–June 22

THE ART EMPORIUM, VANCOUVER, BRITISH COLUMBIA

1977 *Andrew Wyeth: Recent Works*
October 4–October 18

GALERIE CLAUDE BERNARD, PARIS

1980 *Andrew Wyeth: Tempéras, Aquarelles, Dry Brush, Dessins*
December 2, 1980–January 31, 1981

FUNABASHI GALLERY, TOKYO

1984 *Andrew Wyeth: Tempera, Drawings, Prints*
Summer exhibition

GALLERY IIDA, TOKYO

1984 *Andrew Wyeth*
December 1–December 31

II. *Other One-Man Exhibitions and Group Exhibitions with Major Wyeth Participation*

1936 Art Alliance, Philadelphia
Exhibition of thirty watercolors by Andrew Wyeth.

1938 Currier Gallery of Art, Manchester, New Hampshire
Exhibition of Water Colors by Andrew Wyeth

1939 Delaware Art Center, Wilmington

1941 Baldwin Galleries, Wilmington
Exhibition of Water Colors and Drawings by Andrew Wyeth
February 10–February 24

St. Andrew's School, Middletown, Delaware
Exhibition of the Work of Andrew Wyeth
April 1–April 22

Art Institute of Chicago
The Twentieth International Exhibition of Water Colors
July 17–October 5
Eighteen Andrew Wyeth watercolors were shown in a separate room of the exhibition.

Corcoran Gallery of Art, Washington, D.C.
Joint exhibition of Andrew Wyeth and Peter Hurd.

1943 Museum of Modern Art, New York
American Realists and Magic Realists
Eight works by Andrew Wyeth exhibited.

1944 Colby College, Waterville, Maine
*Exhibition of Water Colors and Temperas by
Andrew Wyeth*
October 10–October 23

1945 E. B. Crocker Art Gallery, Sacramento, California
Andrew Wyeth Water Colors
July 1–July 28
Organized by The Western Association of Art
Museums. Exhibited also at the Seattle Art
Museum.

1946 Portraits, Inc., New York
*An Exhibition of Portraits, Landscapes and Figure
Compositions by the Painter Members of the Wyeth
Family*
October 22–November 9
A memorial exhibition to N. C. Wyeth.

1947 American Academy of Arts and Letters and
National Institute of Arts and Letters, New York
Annual Award Exhibition
May 22–June 30
The artist received the Award of Merit in this year.
He exhibited nine works in the show.

Pennsylvania Academy of the Fine Arts, Philadelphia
October 13–October 26

1948 Carnegie Institute, Pittsburgh
Painting in the United States, 1948
October 14–December 12

Berkshire Museum, Pittsfield, Massachusetts
Water Colors by Andrew Wyeth

1950 Institute of Contemporary Arts, London
Symbolic Realism in American Painting, 1940–1950
July 18–August 18
Included three Andrew Wyeth temperas.

1951 Delaware Art Center, Wilmington
January 9–January 29
A Wyeth family exhibition; forty-seven works total,
twelve by Andrew Wyeth.

Currier Gallery of Art, Manchester, New Hampshire,
and William A. Farnsworth Library and Art
Museum, Rockland, Maine
Paintings and Drawings by Andrew Wyeth
July 7–August 4 at the Currier; August 10–September 8 at the Farnsworth
First major museum retrospective; sixty-eight works
included.

Berlin, The Berlin Cultural Festival
Amerikanische Malerei, Werden und Gegenwart
September 20–October 24
Two Wyeth temperas included.

1952 Institute of Contemporary Art, Boston
Summer exhibition of Andrew Wyeth and Waldo
Pierce.

1954 Contemporary Arts Museum, Houston
Americans from the Real to the Abstract
January 10–February 11
Exhibition of Andrew Wyeth, Ben Shahn, Abraham
Rattner, and Robert Motherwell.

1955 Worcester Art Museum, Massachusetts
Five Painters of America
February 17–April 3
Andrew Wyeth, Louis Bouché, Edward Hopper, Ben
Shahn, and Charles Sheeler.

Museum of Art of Ogunquit, Maine
Third Annual Exhibition
July 1–September 11

1956 M. H. de Young Memorial Museum, San Francisco
Andrew Wyeth
July 12–August 12
Also exhibited at Santa Barbara Museum of Art,
California, August 28–September 23

1957 Delaware Art Center, Wilmington
January 8–February 3

1960 Dallas Museum of Fine Arts
Famous Families in American Art
October 8–November 20
Works by ten members of the Wyeth family were
exhibited.

Hayden Gallery, M.I.T., Cambridge, Massachusetts
*Andrew Wyeth: A Retrospective Exhibition of
Temperas and Water Colors*
November 9–December 4

1962 Town Hall, Islesboro, Maine
*Exhibition of Dry Brush and Water Colors by
Andrew Wyeth*
July 21–August 6

Albright-Knox Art Gallery, Buffalo, New York
*Andrew Wyeth: Temperas, Water Colors and
Drawings*
November 3–December 9
Large museum retrospective of 143 works.

1963 University of Arizona Art Gallery, Tucson
Andrew Wyeth
March 16–April 14

Fogg Art Museum, Harvard University, Cambridge, Massachusetts
Andrew Wyeth: Dry Brush and Pencil Drawings
Also exhibited at Pierpont Morgan Library, New York; Corcoran Gallery of Art, Washington, D.C.; William A. Farnsworth Library and Art Museum, Rockland, Maine
Seventy-three works exhibited.

1964 Brandywine Lions Club, Chadds Ford, Pennsylvania
Andy Wyeth Day
May 30

Swarthmore College, Swarthmore, Pennsylvania
Three Generations of Wyeths

Boardwalk Art Exhibit, Ocean City, New Jersey
Special Wyeth Exhibit

Wilmington Society of Fine Arts, Delaware
The William and Mary Phelps Collection of Paintings and Drawings by Andrew Wyeth
October 14–November 6

1965 Schauffler Memorial Library, Mount Hermon School, Massachusetts
Wyeth Exhibit
May 8–May 23
Exhibition of N. C., Andrew, and James Wyeth.

1966 Parrish Art Museum, Southampton, New York
Loan Exhibition of Paintings by the Wyeth Family
July 30–August 22

Pennsylvania Academy of the Fine Arts, Philadelphia
Andrew Wyeth
October 5–November 27
Also exhibited at the Baltimore Museum of Art, December 11, 1966–January 22, 1967; Whitney Museum of American Art, New York, February 6–April 12, 1967; Art Institute of Chicago, April 21–June 4, 1967
Retrospective of 222 works.

1967 Wichita Art Museum, Kansas
Wyeth's World
September 15–November 15

Virginia Museum of Fine Arts, Richmond
A Wyeth Portrait
November 13, 1967–January 14, 1968
This exhibition of one tempera and its fourteen prestudies traveled throughout the state of Virginia in an Artmobile during 1968.

Oklahoma Museum of Art, Oklahoma City
The Wonder of Andrew Wyeth
December 3–December 24

1968 Los Angeles County Museum of Art
Eight American Masters of Water Color
April 23–June 16
Also exhibited at M. H. de Young Museum, San Francisco, June 28–August 18; Seattle Art Museum, September 5–October 13

Delaware Art Center, Wilmington
The Phelps Collection
May 10–October 20

William A. Farnsworth Library and Art Museum, Rockland, Maine
Summer exhibition of twenty-five Maine paintings by the artist.

Chadds Ford Historical Society, Chadds Ford, Pennsylvania
The Chadds Ford Art Heritage, 1898–1968
Chadds Ford Mill, September 6–September 15
Exhibition of the Brandywine artists.

1969 Chadds Ford Historical Society, Chadds Ford, Pennsylvania
Chadds Ford Reflections of a Culture
Tri-County Conservancy Mill, July 4–July 6

Bamberger's, Newark, New Jersey
November 17–December 27

1970 Washington County Museum of Fine Arts, Hagerstown, Maryland
Andrew Wyeth, Temperas, Watercolors and Drawings
February 8–March 22

The White House, Washington, D.C.
February 19–March 31

Museum of Fine Arts, Boston
Andrew Wyeth
Retrospective of 170 works.

1971 Brandywine River Museum, Chadds Ford, Pennsylvania
The Brandywine Heritage
Exhibition of Howard Pyle, various Howard Pyle students, N. C., Andrew, and James Wyeth.

Delaware Art Center, Wilmington
Brandywine Tradition Artists
October 1971–October 1972

1973 M. H. de Young Memorial Museum, San Francisco
Andrew Wyeth
June 16–September 3

1974 The National Museum of Modern Art, Tokyo, Japan
Works of Andrew Wyeth
April 6–May 19
Also exhibited at The National Museum of Modern Art, Kyoto, May 25–June 30

Museum of Art, Science & Industry, Bridgeport,
Connecticut
*Brandywine Heritage '74: Pyle • Wyeth • Wyeth •
Wyeth*
April 20–May 28

1976 The Metropolitan Museum of Art, New York
The Two Worlds of Andrew Wyeth
October 16, 1976–February 6, 1977

1977 United Bank of Denver
Andrew Wyeth in Facsimile
September 16–October 14

1978 Greenville County Museum of Art, Greenville,
South Carolina
Andrew Wyeth: In Southern Collections
February 1–March 31

Portland Museum of Art, Portland, Maine
Andrew Wyeth in Maine
February 3–March 5

Mitsukoshi Main Store, Nihombashi, Tokyo
Andrew Wyeth
October 24–November 5
Also exhibited at Mitsukoshi Sapporo Branch Store,
Sapporo, November 14–November 19; Mitsukoshi
Kobe Branch Store, Kobe, November 21–December 3

1979 Greenville County Museum of Art, Greenville,
South Carolina
*Works by Andrew Wyeth from the Holly and Arthur
Magill Collection*
September 12–continuous exhibition

San Jose Museum of Art, San Jose, California
Paintings by Andrew Wyeth
November 17, 1979–January 9, 1980

1980 Royal Academy of Arts, London
Andrew Wyeth
June 7–August 31

1981 Southern Alleghenies Museum of Art, Loretto,
Pennsylvania
*The 1981 Hazlett Memorial Awards Exhibition for
the Visual Arts*
May 9–June 7
Also exhibited at Pittsburgh Plan for Art, June 20–
July 19; Allentown Art Museum, Allentown, Penn-
sylvania, August 1–September 6

Brandywine River Museum, Chadds Ford,
Pennsylvania
*Working at Olsons: Watercolors & Drawings by
Andrew Wyeth from the Holly & Arthur Magill
Collection*
May 30–September 7
Also exhibited at Madison-Morgan Cultural Center,
Madison, Georgia, November 1, 1981–January 31,
1982; Greenville County Museum of Art, Green-
ville, South Carolina, February 18–April 25, 1982

1982 Virginia Art Museum, Richmond
*Collectors of the Year—Works from the Holly &
Arthur Magill Collection*
February 16–March 7

1983 The Peck School, Morristown, New Jersey
Three Generations of Wyeth
May 6 (one-day exhibition)

Museum of Art, Fort Lauderdale, Florida
Andrew Wyeth from Public and Private Collections
January 12–February 28

Memphis Brooks Museum of Art, Tennessee
*Howard Pyle and the Wyeths: Four Generations of
American Imagination*
September 1–October 23
Also exhibited at Montgomery Museum of Fine
Arts, Alabama, November 12, 1983–January 2,
1984; North Carolina Museum of Art, Raleigh,
February 4–April 1

Portland Museum of Art, Portland, Maine
Maine Temperas by Andrew Wyeth
May 14–September 4

1984 Greenville County Museum of Art, Greenville,
South Carolina
Andrew Wyeth: A Trojan Horse Modernist
March 9–April 15

Brandywine River Museum, Chadds Ford,
Pennsylvania
Andrew Wyeth from the Wyeth Collection
Opening show of the new wing, September 15–
November 18; new shows mounted semiannually
since 1984

1985 Quinlan Art Center and Gainesville Junior College,
Gainesville, Georgia
Works by Andrew Wyeth at the Quinlan
February 1–March 1

The Canton Art Institute, Canton, Ohio
Andrew Wyeth from Public and Private Collections
September 15–November 3

SELECTED BIBLIOGRAPHY

Exhibition Catalogues
(in chronological order)

New York, Museum of Modern Art, 1943
American Realists and Magic Realists
Foreword Dorothy C. Miller, introduction Lincoln Kirstein

London, Institute of Contemporary Arts, 1950
Symbolic Realism in American Painting, 1940–1950
Introduction Lincoln Kirstein

Manchester, N.H., Currier Gallery of Art, and William A.
Farnsworth Library and Art Museum, Rockland, Me., 1951
Paintings and Drawings by Andrew Wyeth
Introduction Samuel M. Green

New York, M. Knoedler and Co., 1953
Exhibition of Paintings by Andrew Wyeth
Introduction Robert G. McIntyre

New York, Whitney Museum of American Art, 1959
The Museum and Its Friends: Eighteen Living American Artists Selected by the Friends of the Whitney Museum
Including statement by Andrew Wyeth

Cambridge, Massachusetts Institute of Technology, Hayden Gallery, 1960
Andrew Wyeth: A Retrospective Exhibition of Temperas and Watercolors

Dallas Museum of Fine Arts, 1960
Famous Families in American Art
Text by J. Bywaters

Buffalo, N.Y., Fine Arts Academy, Albright-Knox Art Gallery, 1962
Andrew Wyeth: Temperas, Water Colors and Drawings
Foreword Gordon M. Smith, introduction Joseph Verner Reed

Cambridge, Harvard University, Fogg Art Museum, 1963
Andrew Wyeth: Dry Brush and Pencil Drawings
Introduction Agnes Mongan

Tucson, University of Arizona Art Gallery, 1963
Andrew Wyeth: Impressions for a Portrait
Introduction Paul Horgan

Philadelphia, Pennsylvania Academy of the Fine Arts, 1966
Andrew Wyeth: Temperas, Watercolors, Dry Brush, Drawings, 1938 to 1966
Text by Edward P. Richardson

Oklahoma City, Oklahoma Museum of Art, 1967
The Wonder of Andrew Wyeth

Wichita Art Museum, 1967
Wyeth's World

Los Angeles County Museum of Art, 1968
Eight American Masters of Watercolor
Text by Larry Curry

Boston, Museum of Fine Arts, 1970
Andrew Wyeth
Introduction David McCord

Chadds Ford, Pa., Brandywine River Museum, 1971
The Brandywine Heritage: Howard Pyle, N. C. Wyeth, Andrew Wyeth, James Wyeth
Introduction Richard M. McLanathan

Wilmington, Delaware Art Museum, 1971–72
Brandywine Tradition Artists
Introduction Rowland Elzea

London, Lefevre Gallery, 1974
Andrew Wyeth

Greenville County Museum of Art, S.C ., 1974
Andrew Wyeth in Southern Collections
Introduction Edwin Ritts, Jr.

Tokyo, National Museum of Modern Art, 1974
Works of Andrew Wyeth
Text in Japanese only

Greenville County Museum of Art, S.C., 1979
Works by Andrew Wyeth from the Holly and Arthur Magill Collection

London, Royal Academy of Arts, 1980
Andrew Wyeth

Paris, Galerie Claude Bernard, 1980
Andrew Wyeth: Tempéras, Aquarelles, Dry Brush, Dessins

Fort Lauderdale, Fla., Museum of Art, 1983
Andrew Wyeth from Public and Private Collections
Introduction John H. Surovek

Memphis Brooks Museum of Art, Tenn., 1983
Howard Pyle and the Wyeths: Four Generations of American Imagination
Texts by Douglas K. S. Hyland and Howard P. Brokaw

Books and Articles in Periodical Publications
(alphabetically arranged according to author or, in the case of unsigned articles, by name of publication)

Alloway, Lawrence. "Critique: The Other Andy." *Arts Magazine,* vol. 41, no. 6 (Apr. 1967), pp. 20–21.

"Three Generations of the Wyeth Family" (special issue). *American Artist,* vol. 39, Feb. 1975, pp. 70–75, 109–17.

"Artists in Focus: Documenting the Life and Work of Three Painters." *American Artist,* vol. 48, Aug. 1984, p. 71.

Ammons, A. R. "For Andrew Wyeth" [a poem]. *The New York Times Book Review,* Oct. 27, 1968, p. 56.

"Andrew Wyeth, in Debut, Wins Critics' Acclaim." *Art Digest,* vol. 12, no. 3 (Nov. 1937), p. 15.

"Hoving's Wyethworld." *Art in America,* vol. 64, Nov. 1976, p. 160.

"Andrew Wyeth." *Artist Jr.,* vol. 9, no. 5 (March 1968), pp. 1–8.

Ashby, Neal. "Reunion in a Gallery: Three Generations of Wyeths." *The New York Times,* Sept. 19, 1971, sec. 10, p. 3.

Baur, John I. H. "Andrew Wyeth," in: *New Art in America.* Greenwich, Conn.: New York Graphic Society, 1957, pp. 277–81.

Beaumont, M. R. "Andrew Wyeth: Poetic Realist?" *Art and Artists,* no. 15 (Aug. 1980), pp. 22–25.

Berenson, R. "Sandy and Andy." *National Review,* vol. 28, Dec. 24, 1976, pp. 1409–10.

Bristow, B. "Andrew Wyeth: Oracle of the Ordinary." *Christianity Today,* vol. 21, Feb. 4, 1977, pp. 27–28.

Buckley, W. F. "Betsy and Andrew Wyeth in Maine: A Sea Change for Their Island Lighthouse." *Architectural Digest,* no. 45 (June 1986), pp. 116–25.

Canaday, John. "Natural Wonder." *The New York Times,* Oct. 11, 1959, sec. 2, p. 16.

————. "A Phenomenon of Contradiction: Wyeth's Work to Be Shown in Buffalo." *The New York Times,* Nov. 1, 1962, p. 28.

————. "Kline and Wyeth." *The New York Times,* Nov. 4, 1962, sec. 2, p. 23.

————. "The Wyeth Menace." *The New York Times,* Feb. 12, 1967, sec. 2, p. 17.

————. "Andrew Wyeth Faces First News Conference." *The New York Times,* Feb. 14, 1967, p. 40.

————. "In Boston: Fine Wyeth Retrospective." *The New York Times,* July 16, 1970, p. 38.

————. "Wyeth's Nostalgia for a Vanished America Is Still a Best-Seller." *The New York Times,* July 26, 1970, sec. 2, p. 19.

————. "Homely Virtue Depicted by a Dynasty." *The New York Times,* June 2, 1971, p. 32.

————. "A Doubleheader Down East." *The New York Times,* Aug. 1, 1971, sec. 2, p. 17.

————. "Andrew Wyeth: Rising above the Scorn." *Art Gallery* (USA), vol. 22, pt. 4 (May 1979), pp. 102–14, 126.

Clark, Eliot. "Andrew Wyeth: America's Most Popular Painter." *The Studio,* vol. 160, no. 812 (Dec. 1960), pp. 206–9, 234–35.

Cohen, Hennig. "Wyeth's World." *The Reporter,* vol. 35, no. 10 (Dec. 15, 1966), pp. 56–60.

Corn, Wanda M. *The Art of Andrew Wyeth.* With contributions by Brian O'Doherty, Richard Meryman, E. P. Richardson. Boston: New York Graphic Society, 1973.

Davis, Douglas. "World of Wyeth: Exhibition in Boston." *Newsweek,* vol. 76, Aug. 24, 1970, pp. 54–57.

————. "The Brandywine School." *Newsweek,* vol. 77, no. 26 (June 28, 1971), p. 93.

De Kooning, Elaine. "Andrew Wyeth Paints a Picture." *Art News,* vol. 49, March 1950, pp. 38–41, 54–56.

Donohoe, Victoria. "Besides Eroticism, Scholarly Exoticism." *Art News,* vol. 74, Summer 1975, p. 88.

Goodrich, Lloyd. *The Four Seasons: Paintings and Drawings by Andrew Wyeth.* New York: Art in America, 1962. Most of these plates are reproduced in "The Four Seasons: Dry Brush Drawings by Andrew Wyeth." *Art in America,* vol. 50, March 1962, pp. 32–49.

Hines, Diane C. "The Living Legends of American Watercolor: Profiles of Fourteen Celebrated American Artists Who Have Influenced Generations of Watercolorists." *American Artist,* vol. 47, Feb. 1983, pp. 68–76.

"Andrew Wyeth Turns His Attention from Landscapes to Portraits." *Horizon,* vol. 9, no. 2 (Spring 1967), pp. 86–87.

Hoving, Thomas. *Two Worlds of Andrew Wyeth: Kuerners and Olsons.* New York: Metropolitan Museum, 1976. Variant edition: *Two Worlds of Andrew Wyeth: A Conversation with Andrew Wyeth.* Boston: Houghton Mifflin Co., 1978.

———. "The 'Prussian': Andrew Wyeth's Secret Paintings (1972–85)." *Connoisseur,* vol. 216, no. 896 (Sept. 1986), pp. 84–87.

Hughes, Robert. "Fact as Poetry." *Time,* vol. 102, no. 10 (Sept. 3, 1973), pp. 54–55.

———. "Wyeth's Cold Comfort: Exhibition at the Metropolitan Museum." *Time,* vol. 108, no. 18 (Nov. 1, 1976), p. 69.

Ingersoll, Bob. "Wyeth, Giant among Artists, Says He's Never Satisfied." *Evening Journal* (Wilmington, Del.), May 14, 1963.

Jacobs, Jay. "Andrew Wyeth: An Unsentimental Reappraisal." *Art in America,* vol. 55, Jan.–Feb. 1967, pp. 24–31. Letters responding to this article: *Art in America,* vol. 55, May 1967, p. 126.

Janson, Donald. "Wyeth's Art to Open Museum in Mill: New Works by Andrew Wyeth Will Be in Show." *The New York Times,* June 2, 1971, p. 32.

Koethe, E. John. "The Wyeth Craze." *Art News,* vol. 69, Oct. 1970, p. 30.

Larson, Kay. "Andrew Wyeth: Monotone in a Minor Key." *Art News,* vol. 75, Dec. 1976, pp. 42–44.

Lehmann-Haupt, Christopher. Review of *Christina's World: Paintings and Pre-studies of Andrew Wyeth. The New York Times,* Dec. 6, 1982, p. C22.

"Andrew Wyeth, An American Realist Paints What He Sees." *Life,* vol. 24, no. 20 (May 17, 1948), pp. 102–6.

"Artist Paints a Ghostly House." *Life,* vol. 35, no. 4 (July 27, 1953), pp. 80–83.

Logsdon, Gene. *Wyeth People: A Portrait of Andrew Wyeth as He Is Seen by His Friends and Neighbours.* Garden City, N.Y.: Doubleday & Co., 1971.

Loucheim, Aline B. "Wyeth – Conservative Avant-Gardist." *The New York Times Magazine,* Oct. 25, 1953, sec. 6, pp. 28ff.

McBride, Henry. "Wyeth: Serious Best-Seller." *Art News,* vol. 52, Nov. 1953, pp. 38–67.

Meryman, Richard. "Andrew Wyeth: An Interview." *Life,* vol. 58, no. 19 (May 14, 1965), pp. 92–116, 121–22.

———. *Andrew Wyeth.* Boston: Houghton Mifflin Co., 1968.

———. "The Wyeths' Kind of Christmas Magic." *Life,* vol. 71, no. 25 (Dec. 17, 1971), pp. 122–29.

Meyer, Susan E. "Three Generations of the Wyeth Family: N. C. Wyeth, Peter Hurd, Henriette Wyeth, Carolyn Wyeth, John W. McCoy, Andrew Wyeth, George Weymouth, James Wyeth." *American Artist,* vol. 39, Feb. 1975, pp. 37–119.

———. "Editorial Random Thoughts on the Most Famous Painter in America." *American Artist,* vol. 41, Feb. 1977, pp. 6–7.

Mortenson, C. Walter. *The Illustrations of Andrew Wyeth: A Checklist.* West Chester, Pa.: Aralia Press, 1977.

"Wyeth at Work." *Newsweek,* vol. 60, no. 20 (Nov. 12, 1962), p. 94.

"Wyeth's World." *Newsweek,* vol. 69, no. 10 (March 6, 1967), pp. 76–79.

"The World of Wyeth." *Newsweek,* vol. 76, no. 8 (Aug. 24, 1970), pp. 54–57.

O'Connor, John J. "Kline and Wyeth: Disparate Realists." *Wall Street Journal,* Feb. 28, 1967, p. 18.

O'Doherty, Brian. "Andrew Wyeth: Art Loner." *The New York Times,* March 30, 1963, p. 5.

———. "Wyeth Drawings Are Displayed." *The New York Times,* April 1, 1963, p. 55.

———. "Andrew Wyeth." *Show,* vol. 5, no. 4 (May 1965), pp. 46–55, 72–75.

———. "Wyeth and Emerson: Art as Analogy." *Art and Artists* (London), vol. 2, no. 1 (April 1967), pp. 12–15.

———. *American Masters: The Voice and the Myth.* New York: Random House, [1974]. With photographs by Hans Namuth.

Pitz, Henry C. "Andrew Wyeth." *American Artist,* vol. 12, Nov. 1958, pp. 26–33, 65–66.

———. *The Brandywine Tradition.* Boston: Houghton Mifflin Co., 1969.

Plimpton, George, and Donald Stewart. "An Interview with Andrew Wyeth." *Horizon,* vol. 4, no. 1 (Sept. 1961), pp. 88–101.

Porter, Fairfield. "Andrew Wyeth." *Art News,* vol. 57, Dec. 1958, p. 13.

Raoul, Rosine. "Weber and Wyeth: A Study in Opposites." *Apollo,* vol. 78, no. 19 (Sept. 1963), pp. 222–23.

Ratcliff, Carter. "Wyeth, the Art World and Class Unconsciousness." *Art in America,* vol. 65, Jan. 1977, p. 15. Reply with rejoinder by M. R. Wilson: *Art in America,* vol. 65, May 1977, p. 5.

Reed, Judith Kaye. "The Wyeth Family Honors Its Sire." *Art Digest,* vol. 21, no. 1 (Oct. 15, 1946), p. 10.

Richardson, E. P. "Andrew Wyeth." *Atlantic Monthly,* vol. 208, no. 6 (June 1964), pp. 62–71.

Rodman, Seldon. "Andrew Wyeth," in: *Conversations with Artists.* New York: Capricorn Books, 1961, pp. 211–21.

"Brandywine: A Triumph of Spirit and Strength." *The Saturday Evening Post,* vol. 243, no. 2 (Fall 1971), pp. 68–73.

Schaire, Jeffrey. "The Unknown Andrew Wyeth." *Art & Antiques,* Sept. 1985, pp. 46–57.

———. "Andrew Wyeth's Secret Paintings: An American Treasure Revealed." *Art & Antiques,* Sept. 1986, pp. 68–79.

Schroeder, Fred E. H. "Andrew Wyeth and the Transcendental Tradition." *American Quarterly,* vol. 17, no. 3 (Fall 1965), pp. 559–67.

Seelye, John. "Wyeth and Hopper." *New Republic,* vol. 166, no. 11 (March 11, 1972), pp. 18, 22–24.

Shirey, David. "Brandywine Museum Honors Three Wyeths with Display." *The New York Times,* June 19, 1971, p. 18.

Stewart, Patrick L., Jr. "Andrew Wyeth and the American Descriptivist Tradition." Unpublished master's thesis (Binghamton: State University of New York, 1972).

Talmey, Allene. "Andrew Wyeth." *Vogue,* vol. 140, no. 9 (Nov. 15, 1962), pp. 118–21, 160–61. With photographs by Henri Cartier-Bresson.

"American Realist." *Time,* vol. 58, no. 3 (July 16, 1951), pp. 72–75.

"Andy's World." *Time,* vol. 82, no. 26 (Dec. 27, 1963), cover and pp. 44–52.

"Appalled and Amazed." *Time,* vol. 89, no. 8 (Feb. 24, 1967), p. 68.

Tunley, Raoul. "The Wonderful World of Andrew Wyeth." *Woman's Day,* Aug. 1963, pp. 33–37, 67–68.

Tyler, Parker. "The Dream of Perspective in Andrew Wyeth." *American Artist,* vol. 14, Jan. 1950, pp. 35–38.

Wainwright, Loudon. "The Mass Sport of Wyeth Watching." *Life,* vol. 62, no. 10 (March 10, 1967), p. 27.

Wyeth, Andrew. "Note on *The Trodden Weed.*" *Art News,* vol. 51, March 1952, p. 6.

Wyeth, Betsy James. *Wyeth at Kuerners.* Boston: Houghton Mifflin, 1976. Works by Andrew Wyeth at the Kuerner farm, Pennsylvania, covering the years 1936–75. Selected, arranged, and with text by Betsy James Wyeth.

———. *Christina's World: Paintings and Pre-studies of Andrew Wyeth.* Boston: Houghton Mifflin, 1982. Works by Andrew Wyeth at the Olson farm, Maine, with text by Betsy James Wyeth.

Young, Mahonri Sharp. "Wyeth and Manet in Philadelphia." *Apollo,* vol. 84 (Nov. 1966), pp. 403–6.

———. "Letter from USA: Sublime and Beauteous Shapes." *Apollo,* vol. 86 (July 1967), pp. 65–66.

INDEX

Numbers in *italics* refer to illustrations.